REPRODUCTIONS

A selective, illustrated collection of fine prints.

THIRD EDITION - 1978
Revised and Enlarged

PUBLISHED BY HADDAD'S FINE ARTS, INC.

Showroom: 3855 East Mira Loma Avenue
Anaheim, California 92806, U.S.A.
Mailing Address: Post Office Box 3016-C
Anaheim, California 92803, U.S.A.
Telephone: (714) 996-2100

The illustrated reproduction shown on the front cover of this catalog is:

Katsushika Hokusai 1760-1849
Puppies in the Snow (detail)
Freer Gallery of Art
Smithsonian Institution, Washington, D.C.

Library of Congress Catalog Card Number 78-67201
I.S.B.N. 0-88445-006-6

All prices quoted in this catalog are in United States currency. They do not necessarily apply to any other country. Please note that the publisher reserves the right to add or discontinue any title or size, revise prices without prior notification at any time.

TABLE OF CONTENTS

Yellow

Red

Yellow + Red

Blue

Yellow + Red + Blue

Black Yellow + Red + Blue + Black

R. Bradford Johnson "Dusk In The High Country"

This example is typical of the four color process. Each color being a separate plate. Further colors are used to enhance tone or densities.

PRINTING:

Pictographs, dating back 30,000 years, and Hieroglyphics, appearing about 2500 B.C., were the earliest pictures. Printing from movable type was wide-spread in the 11th century in China and Korea. Metal (bronze) type came in during the 1200's. The oldest known printed text was from Korea, 1397 A.D. Fifty years later Johann Gutenberg invented separated letters of type on a movable platform press. Before this everything was done by hand. Rumor has it that his wife invented movable type.

The Chinese invented paper in 105 A.D. and the paper milling industry was well developed by Gutenberg's time. The Chinese also perfected inks. Gutenberg's invention combined all the prior knowledge and came out with the multi-copied image. Many different printing techniques have evolved. The following glossary is arranged roughly in chronological order.

GLOSSARY

WOOD CUTS - date from the mid 800's in China. They were used for book illustrations, competing with illuminated manuscripts. They are drawn on the block and then the excess material is cut away to yield the design. Wood engraving is a sister to wood cuts. It also was widely used for books, periodicals etc. in the 1800's. Work was done with a burin or graver tool in fine lines or dots. Wood engraving gave way to the half tone screen for copying original works. Wood cuts, however, continue to be used by many artists of today.

ETCHING - A "Biting" of a design onto a metal plate with acid, a process used for ornamental embellishment of armor, dating from the 13th century and coming into use for printing about 1500. The biting action is controlled by coating various portions of the design to inhibit further attack by the acid, dark parts becoming deeper.

CONTINUED ON THE NEXT PAGE

ENGRAVING - the design is carved on the surface of metal, stone or wood. Two methods are used: Intaglio - the design is cut into the surface with the engraved lines lower than the surface. When inked the carved out areas hold the ink for printing and the surface is cleaned. Placed in a press the paper is moulded to the engraved lines and the image is transferred to the paper. Relief Engraving - the design remains on the surface and the background is removed. When inked and pressed only the raised areas touch the paper. This is the manner in which the photo-gravure printings are made. Steel engravings, copper plate engravings and mezzotints are of the Intaglio type. Mezzotints are by definition half-tint, allowing reproduction of the middle tones. It is a difficult and expensive method of reproduction especially in multi-color.

AQUATINT - reproduces the tonal effects of wash drawing - watercolor, etc., dates from the mid-eighteenth century. Flower of Sulphur was used to ''Bite'' the plate originally. Later a spirit ground on rosin and alcohol was allowed to dry on the plate to create textures.

SILKSCREEN-SERIGRAPH - a stencil print. A separate stencil is used for each color. A squeegee pushes the pigment through the stencil-like screen to the paper.

POCHOIR - the same as above except finer grid screens and water color pigments are generally used.

GRAVURE (Intaglio) - this process uses a reversed or depressed surface for the image. The plate rotates in a bath of ink, and is wiped so that ink remains only in the depressions, thus forming the printing image.

COLLOTYPE: A photo gelatin process requiring no screen, dating from 1854. Direct size negative from original art (glass or stainless steel plates). Gelatin applied to the glass plate with slight heat, then photo sensitized and exposed to the original negative and light. The transmission of the light through the varying densities of color cause the gelatin to hold ink in the same manner.

LETTERPRESS (relief) - In this process the ink touches only the raised surfaces, thus printing only that portion of the image. This is printed directly on to the paper.

LITHOGRAPH - an image is drawn on stone or zinc plates with a grease crayon. The plate is water dampened and inked. The ink holds to the grease but not to the wet portions, thus making a printable image. Contemporarily the method is used for small editions. However, in the 1800's much of the high volume illustrated periodical printing was done by this medium.

OFFSET LITHOGRAPHY - a more modern method of utilizing the same basic concepts of the lithograph. The exception being that the image is transferred from the inked plate to a rubber blanket causing an ''Offset'' from the plate to the paper. The rubber blanket causes a more precisely controlled image than any other printing form. This is the most universally used method of printing today. Offset lithography presently requires the use of a screen to show the image and therefore is recognized by its dot pattern. The other printing methods utilizing photochemical processes also have a distinct pattern. Fine Art printing uses ultra-fine screens which have to be magnified to be seen. The fineness of the screen causes the printed image to become finer and sharper. There are methods being developed to eliminate screens in offset lithography entirely.

FOREWORD

This catalog is our third edition, completely revised and
updated. It is also the edition which takes us into our
20th anniversary year. It is an accomplishment for which
we are very thankful. This edition is available world wide, quite
a change from our small, local start. We have many
people to thank: our customers, schools, libraries, bookstores,
galleries, museums, artists and the grand people who
work for us.

Haddad's is a family run business and has always tried
to present select reproductions, rather than quantity.
From the experience of handling every major publication
in the world, we have learned what is wanted.

This catalog, a fine arts book in itself, presents many
new reproductions and many new artists. It is hoped that
you will enjoy using it. We have enjoyed putting it together.

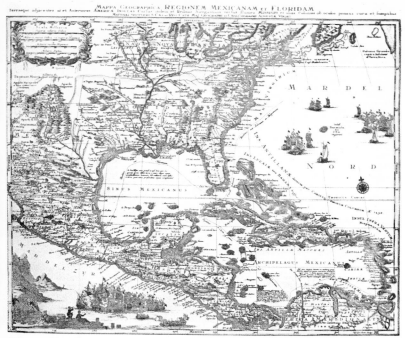

Blaeuw (Dutch, 1571-1638)
Map of South Eastern America
5144 19″ × 22″ (48 × 56 cm) $16.00

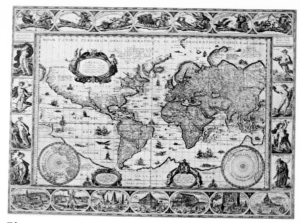

Blaeuw
Map of the World
5145 16½″ × 22″ (42 × 56 cm) $16.00

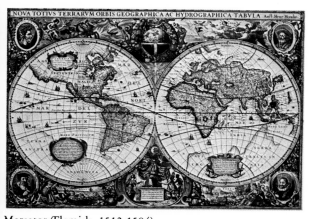

Mercator (Flemish, 1512-1594)
Map
9642 20¾″ × 29½″ (52.5 × 75 cm) $12.00

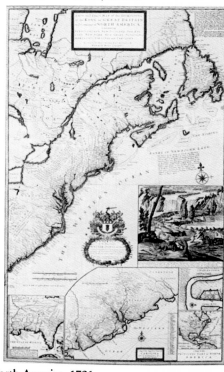

Herman Moll
Dominions-North America, 1721
5199 image size 23½″ × 14″ (60 × 35.5 cm) $18.00
sheet size 29″ × 23″ (74 × 58.5 cm)

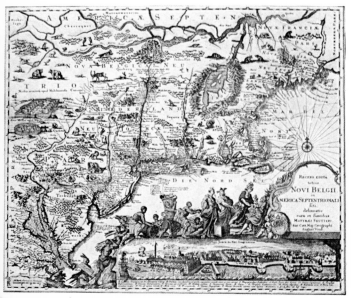

Blaeuw
Map of North Eastern America
5143 19″ × 22″ (48 × 56 cm) $16.00

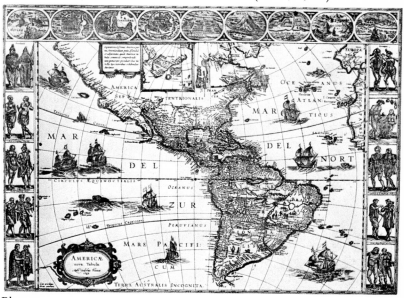

Blaeuw
Map of North and South America
5142 16½″ × 22″ (42 × 56 cm) $16.00

1

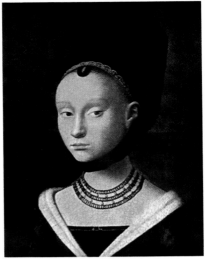

Petrus Cristus (Flemish, 1395-1472)
Young Maiden
Staatliche Sammlungen, Berlin
2031 11″ × 8½″ (28 × 21.5 cm) $6.00

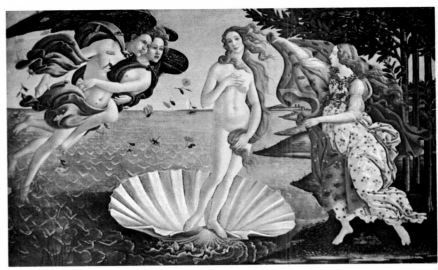

Sandro Botticelli (Italian, 1444-1510)
The Birth of Venus
Galleria degli Uffizi, Firenze
9302 15″ × 24¼″ (38 × 61 cm) $12.00
9018 11″ × 17¼″ (28 × 44 cm) $5.00
9019 17″ × 13¼″ (43 × 34 cm) (detail) $5.00

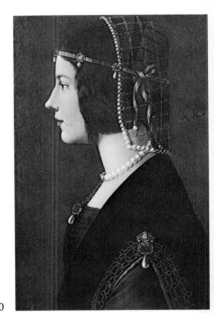

Sandro Botticelli
Beatrice-D'Este
4243 16″ × 10″ (40.5 × 25.5 cm) $6.00

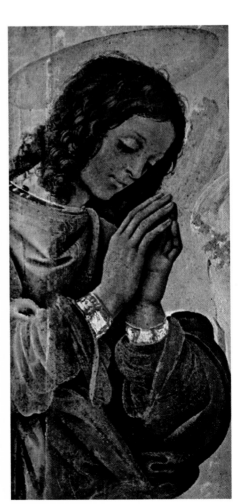

Filippino Lippi (Italian, 1406-1469)
Adoring Angel
National Gallery, England
4201 17¼″ × 8″ (44 × 20 cm) $7.50

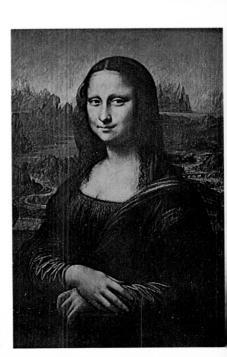

Leonardo Da Vinci (Italian, 1452-1519)
Mona Lisa, 1503
The Louvre Museum, Paris
5050 22″ × 14¾″ (56 × 37.5 cm) $9.00
4029 18″ × 12″ (46 × 31 cm) $5.00
1040 10″ × 6¾″ (25.5 × 17 cm) $1.50

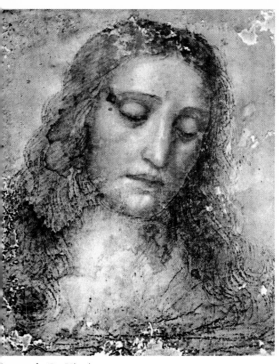

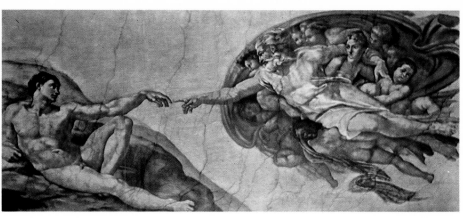

Michelangelo Buonarroti (Italian, 1475-1564)
Creation of Man, c.1510
Capella Sistina, Vaticano
9643 21½" × 46½" (54.5 × 118 cm) $25.00
9115 11" × 15" (28 × 38 cm) $5.00

Leonardo Da Vinci
Christ's Head
4175 14³/₈ × 11" (36.5 × 28 cm) $5.00

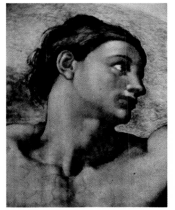

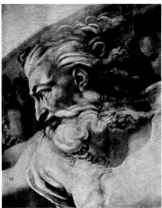

Michelangelo
Head of Adam
(detail from **Creation of Man**)
2002 14½" × 11" (37 × 28 cm) $5.00

Michelangelo
Head of God
(detail from **Creation of Man**)
2003 14½" × 11" (37 × 28 cm) $5.00

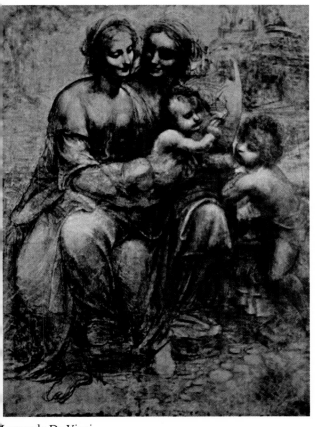

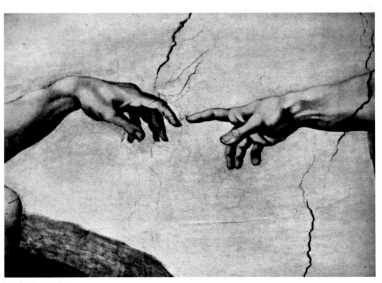

Leonardo Da Vinci
The Virgin and Child
with St. Anne and John the Baptist, c.1499
9237 21" × 15½" (53.5 × 39.5 cm) $12.00
9238 14" × 10¼" (35.5 × 26 cm) $4.00

Michelangelo
The Hands of God and Man
(detail from **Creation of Man**)
2001 11" × 14¾" (28 × 37.5 cm) $5.00

3

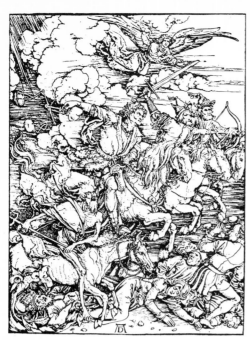

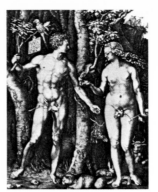

Albrecht Durer
Adam and Eve
*Victoria and Albert Museum,
London*
4068 20″ × 16″ (51 × 40 cm) $6.00
1077 10″ × 8″ (25 × 20 cm) $1.50

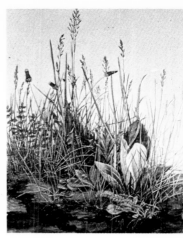

Albrecht Durer
Tall Grass
Graphische Sammlung Albertina, Wien
2038 12″ × 9¼″ (30.5 × 23.5 cm) $6.00

Albrecht Durer (German, 1471-1528)
Four Horsemen of the Apocalypse
5065 25¼″ × 18″ (64 × 45.5 cm) $7.50

Albrecht Durer
Short Grass
Graphische Sammlung Albertina, Wien
2036 4½″ × 5¾″ (11.5 × 15 cm) $4.50

Albrecht Durer
Three Herbs, c.1526
*Graphische Sammlung Albertina,
Wien*
2039 11″ × 5½″ (28 × 14 cm) $5.00

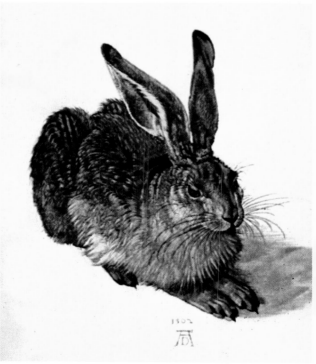

Albrecht Durer
Young Hare, 1502
Graphische Sammlung Albertina, Wien
2040 9½″ × 8¼″ (25 × 21 cm) $4.50

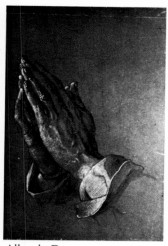

Albrecht Durer
Praying Hands, 1508-09
Graphische Sammlung Albertina, Wien
2034 11″ × 7½″ (28 × 19 cm) $3.00
2035 11″ × 7½″ (28 × 19 cm) $3.00 (sepia tone)

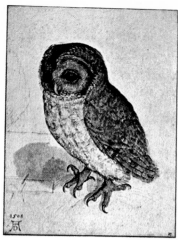

Albrecht Durer
Little Owl, c.1508
Graphische Sammlung Albertina, Wien
2033 7½″ × 5½″ (19.5 × 14 cm) $3.50

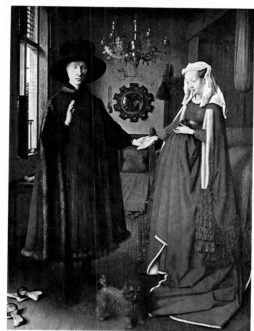

Jan Van Eyck (Flemish, 1370/1390-1441)
**The Marriage of Giovanni Arnolfini with
Giovanna Cenami, 1434**
The National Gallery, London
4159 16¼″ × 11¾″ (41 × 30 cm) $6.00

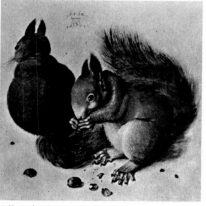

Albrecht Durer
Squirrels
Private Collection
2037 8¾″ × 8½″ (22 × 21.5 cm) $4.50

Albrecht Durer
Bouquet of Violets
Graphische Sammlung Albertina, Wien
2032 4¾″ × 4¼″ (12.5 × 10 cm) $4.50

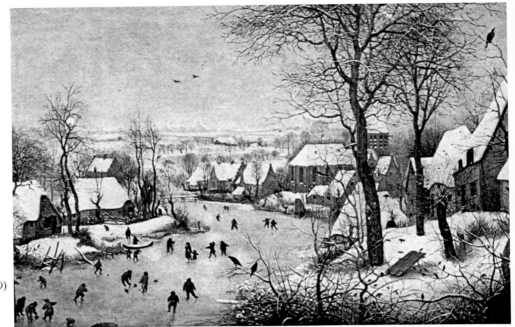

Pieter Brueghel, the Elder (Flemish, 1525-1569)
Winter Landscape
Museé Royaux des Beaux-Arts, Bruxelles
5220 16½″ × 24½″ (42 × 62 cm) $12.00

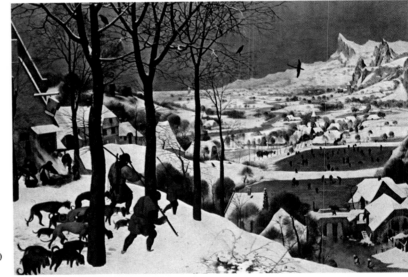

Pieter Brueghel, the Elder
Winter-Hunters in the Snow, 1565
Kunsthistorisches Museum, Wien
7124 18″ × 25″ (46 × 63.5 cm) $12.00
1063 7¼″ × 10″ (18.5 × 25 cm) $1.50

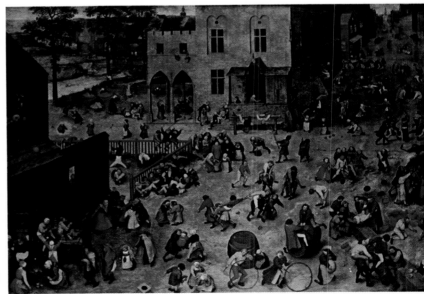

Pieter Brueghel, the Elder
Children's Games, 1560
Kunsthistorisches Museum, Wien
7064 21″ × 30″ (53.5 × 76 cm) $14.00
1059 7″ × 10″ (18 × 25 cm) $1.50

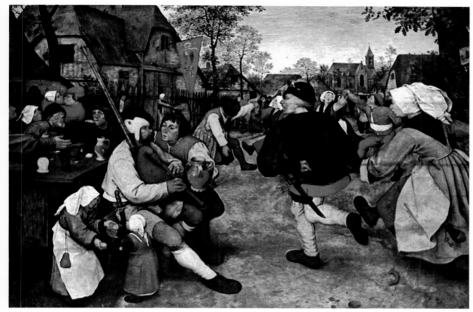

Pieter Brueghel, the Elder
Peasant's Dance
Kunsthistorisches Museum, Wien
7066 20″ × 30″ (52 × 76 cm) $14.00
2019 10¾″ × 15″ (27.5 × 38 cm) $4.00

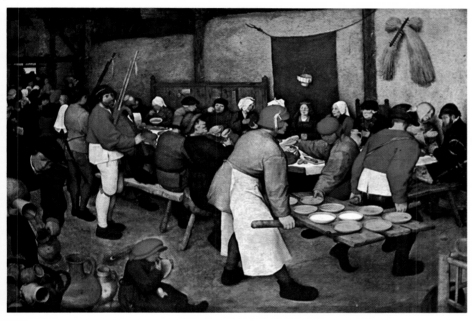

Pieter Brueghel, the Elder
Village Wedding Feast
Kunsthistorisches Museum, Wien
7067 20½″ × 30″ (52 × 76 cm) $14.00
2020 10½″ × 15″ (27 × 38 cm) $4.00

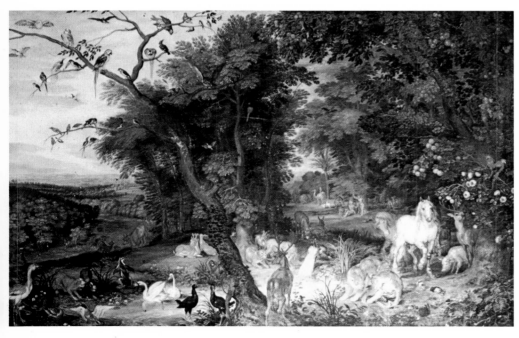

Jan Brueghel
The Garden of Eden
Victoria and Albert Museum, London
7065 20″ × 32″ (51 × 81.5 cm) $14.00
1060 6¼″ × 10″ (16 × 25cm) $1.50

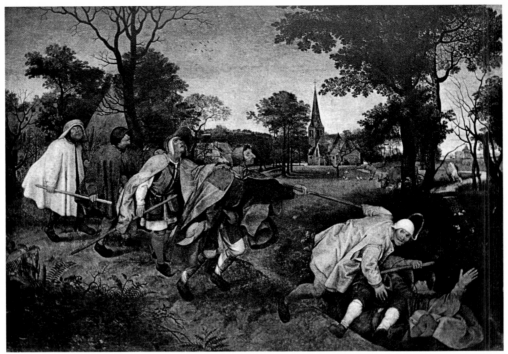

Pieter Brueghel, the Elder
The Blind Leading the Blind
The Louvre Museum, Paris
4050 15½" × 22" (39 × 56 cm) $10.00
2018 10½" × 15" (26 × 38 cm) $4.00
1058 7" × 10" (18 × 25.5 cm) $1.50

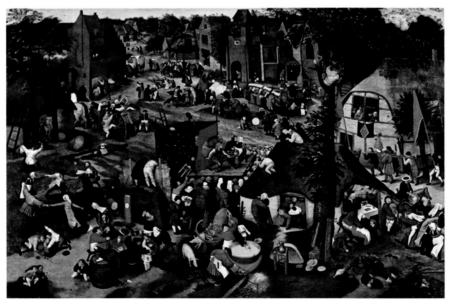

Pieter Brueghel, the Younger (Flemish, 1564-1638)
Flemish Fair
7061 20½" × 30" (52 × 76.5 cm) $14.00
1064 7" × 10" (17.5 × 25 cm) $1.50

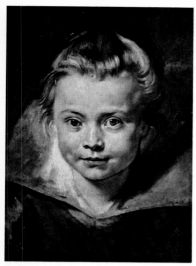

Peter Paul Rubens (Flemish, 1577-1640)
Child's Portrait
Liechtenstein Galerie, Vaduz, Liechtenstein
2063 10¾″ × 8″ (27.5 × 20 cm) $7.50

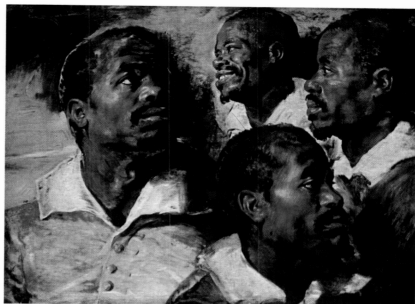

Peter Paul Rubens
Four Negro Heads
Museé Royaux des Beaux-Arts, Bruxelles
5033 18″ × 24″ (46 × 60.5 cm) $12.00
1145 7½″ × 10″ (19 × 25.5 cm) $1.50

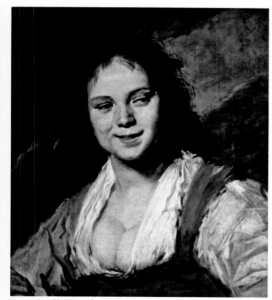

Frans Hals (Dutch, 1580-1666)
Bohemian Girl
The Louvre Museum, Paris
4164 18¼″ × 16″ (46 × 40.5 cm) $7.50
1027 9″ × 8″ (23 × 20 cm) $1.50

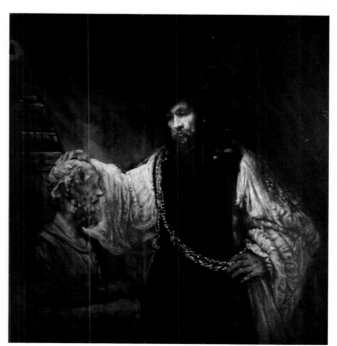

Rembrandt Harmensz Van Rijn (Dutch, 1606-1669)
Aristotle Contemplating the Bust of Homer
The Metropolitan Museum of Art, New York
9659 28½″ × 27″ (72.5 × 68.5 cm) $24.00

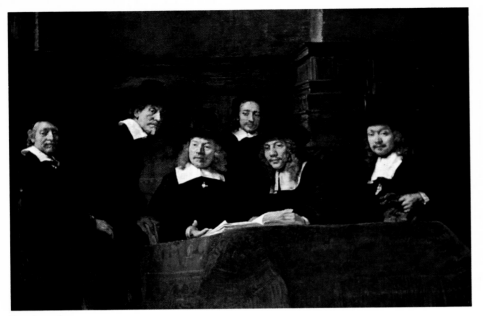

Rembrandt
Masters of the Cloth Guild, 1661
Rijksmuseum, Amsterdam
7039 18″ × 26¾″ (46 × 68 cm) $12.00

Rembrandt
Head of Christ
The Metropolitan Museum of Art, New York
9182 18½″ × 14½″ (47 × 36.5 cm) $8.00

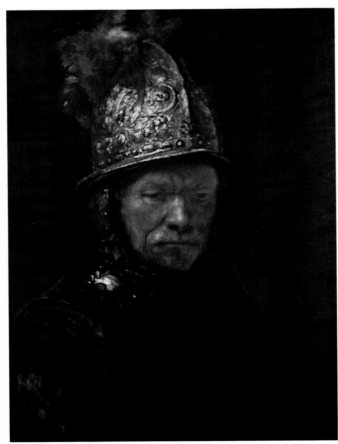

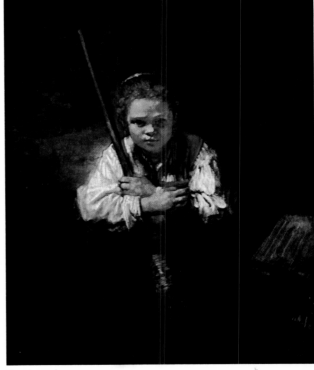

Rembrandt
Girl with a Broom, 1651
Andrew Mellon Collection,
National Gallery of Art, Washington
5114 20″ × 17″ (51 × 43.5 cm) $10.00
1128 9½″ × 8″ (24 × 20 cm) $1.50

Rembrandt
Man with Golden Helmet
Gemaldegalerie der Ehemals Staatlichen Museen,
Berlin-Dahlem
7038 26″ × 19½″ (66 × 49.5 cm) $20.00
5115 24″ × 18″ (61 × 46 cm) $8.00
4118 16″ × 12″ (40.5 × 30.5 cm) $4.00
1129 10″ × 7½″ (25.5 × 19 cm) $1.50

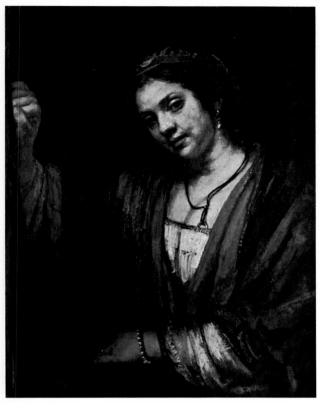

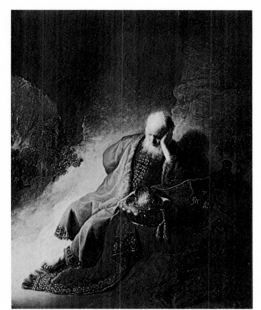

Rembrandt
The Prophet Jeremiah
Rijksmuseum, Amsterdam
5130 24″ × 18¾″ (61 × 47.8 cm) $14.00
1133 10″ × 8″ (25.5 × 20 cm) $1.50

Rembrandt
Portrait of Hendrikje Stoffels
Ehemals Staatliche Museen, Berlin-Dahlem
5116 24″ × 17½″ (61 × 47 cm) $12.00
1132 10″ × 7¾″ (25 × 19.5 cm) $1.50

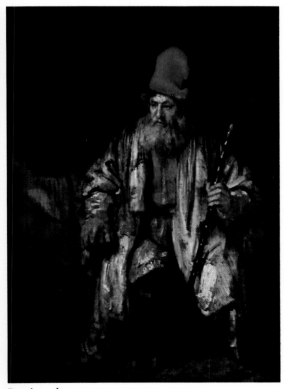

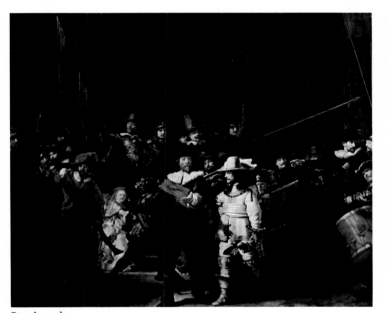

Rembrandt
The Old Man with the Red Cap
Ehemals Staatliche Museen, Berlin-Dahlem
4119 19½″ × 14″ (49 × 35.5 cm) $12.00
1131 10″ × 7″ (25 × 18 cm) $1.50

Rembrandt
The Night Watch, 1642
Rijksmuseum, Amsterdam
7040 19¾″ × 23¾″ (50 × 60 cm) $10.00
1130 8″ × 9½″ (20 × 24.5 cm) $1.50

Salomon Van Ruysdael (Dutch, 1600-1670)
Dutch Landscape
*Gemaldegalerie der Ehemals Staatlichen Museen,
Berlin-Dahlem*
7047 21½″ × 30″ (54.5 × 76 cm) $18.00
1151 7″ × 10″ (18 × 25 cm) $1.50

Paulus Potter (Dutch, 1625-1654)
The White Horse
The Louvre Museum, Paris
7037 20″ × 27½″ (51 × 70 cm) $12.00
1123 8″ × 9½″ (20 × 24.5 cm) $1.50

Salomon Van Ruysdael
Landscape with Farmyard, 1631
Ehemals Staatliche Museen, Berlin-Dahlem
7048 20″ × 31″ (51 × 79 cm) $18.00
1152 6½″ × 10″ (16 × 25 cm) $1.50

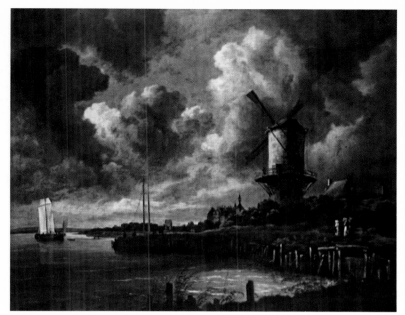

Jacob Van Ruysdael
Windmill Near Wijk, 1670
Rijksmuseum, Amsterdam
5037 19¾" × 24" (50 × 61 cm) $12.00
1150 8" × 9¾" (20 × 25 cm) $1.50

Jacob Van Ruysdael (Dutch, 1628-1682)
A Waterfall in a Rocky Landscape, c.1660
The National Gallery, London
9425 23" × 20" (58 × 51 cm) $14.00

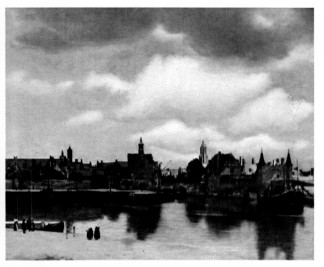

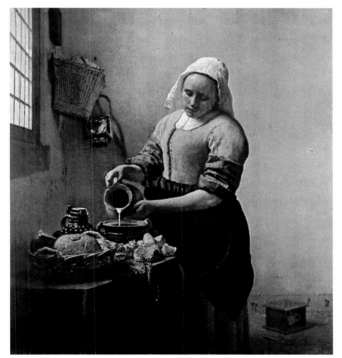

Jan Vermeer (Dutch, 1632-1675)
View of Delft
Mauritshuis, Den Haag, Nederland
4240 14" × 16¾" (35 × 43 cm) $8.00

Jan Vermeer
Milkmaid
Rijksmuseum, Amsterdam
4028 18¼" × 16½" (46.5 × 42 cm) $10.00
1039 9" × 8" (22.5 × 20 cm) $1.50

13

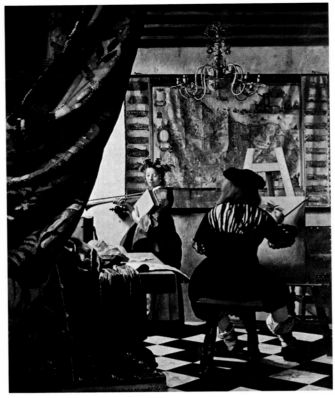

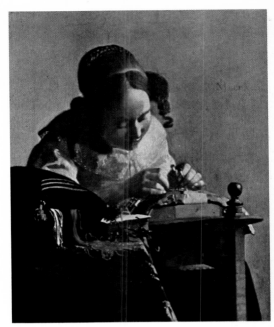

Jan Vermeer
The Lacemaker
The Louvre Museum, Paris
4239 18″ × 15″ (46 × 38 cm) $8.00
1235 9⅝″ × 8″ (24 × 20 cm) $1.50

Jan Vermeet
The Artist's Studio, 1665
Kunsthistorisches Museum, Wien
5049 22″ × 18¼″ (56 × 46.5 cm) $12.00
1037 9½″ × 8″ (24.5 × 20 cm) $1.50

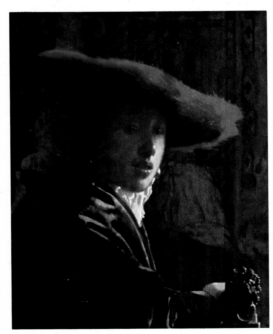

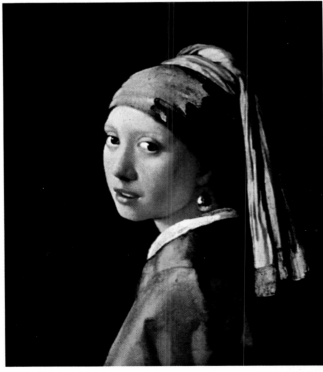

Jan Vermeer
Girl with a Red Hat
National Gallery of Art, Mellon Collection,
Washington D.C.
4027 18″ × 14⅛″ (46 × 36 cm) $10.00
1038 10″ × 7¾″ (25.5 × 19 cm) $1.50

Jan Vermeer
Maiden with a Pearl (Girl with Turban), 1660
Mauritshuis, Den Haag
4259 19″ × 15½″ (48 × 39.5 cm) $10.00

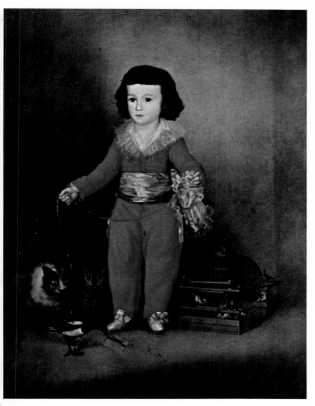

Francisco de Goya
Don Manuel Osorio De Zuniga, 1784
The Metropolitan Museum of Art, New York
9351 23″ × 17½″ (58.5 × 45 cm) $10.00

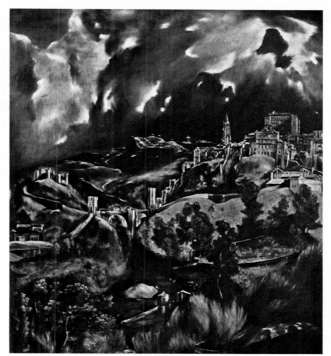

El Greco (Domenico Theotocopuli) (Spanish, 1541-1614)
View of Toledo, c.1600
The Metropolitan Museum of Art, New York-The
H.O. Havemeyer Collection
9334 22″ × 19½″ (56 × 49.5 cm) $12.00

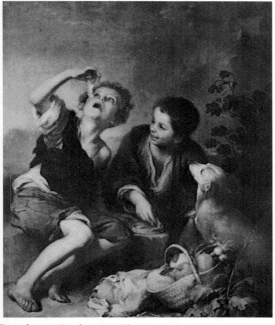

Bartolome′ Esteban Murillo (Spanish, 1618-1682)
The Pastry Eaters
Alte Pinakothek, Munich
4186 18″ × 15″ (45 × 38 cm) $8.00
1187 9⅝″ × 8″ (24 × 20 cm) $1.50

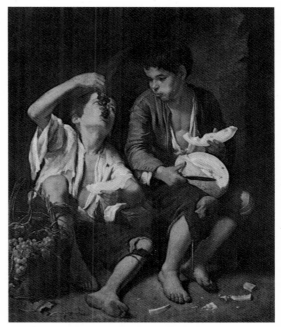

Bartolome′ Esteban Murillo
Grape and Melon Eaters
Alte Pinakothek, Munich
4185 18″ × 15″ (46 × 38 cm) $8.00
1186 9⅝″ × 8″ (24 × 20 cm) $1.50

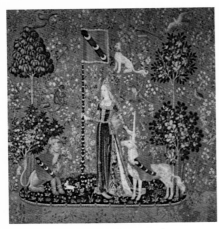

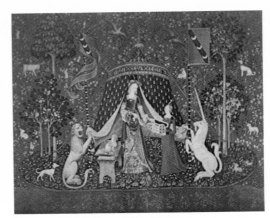

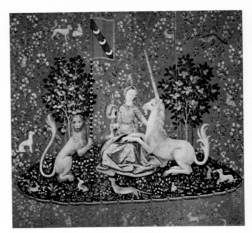

Tapestry-The Lady and The Unicorn
Le Toucher-Touch, c.1500
The Cluny Museum
4222 16″ × 14¾″ (40.5 × 37.5 cm) $8.00

Tapestry-The Lady and The Unicorn
A Mon Seul Desir
(My Only Desire) c.1500
The Cluny Museum
4220 14″ × 16¾″ (35.5 × 42.5 cm) $8.00

Tapestry-The Lady and The Unicorn
La Vue-Sight, c.1500
The Cluny Museum
4221 14″ × 14½″ (35.5 × 37 cm) $8.00

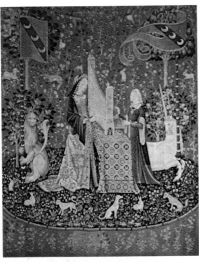

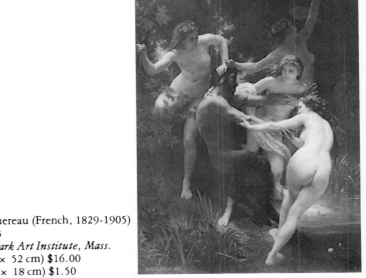

Tapestry-The Lady and The Unicorn
L'Ouie-Hearing, c.1500
The Cluny Museum
4219 16½″ × 12″ (42 × 30 cm) $8.00

Adolphe William Bouguereau (French, 1829-1905)
Nymphs and Satyr, 1873
Sterling and Francine Clark Art Institute, Mass.
7014 30″ × 20½″ (76 × 52 cm) $16.00
1008 10″ × 6⅞″ (25.5 × 18 cm) $1.50

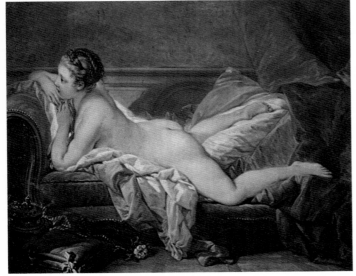

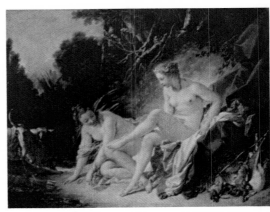

Francois Boucher - (French 1703-1770)
Girl Resting
Alte Pinakothek, Munich
4076 16″ × 20″ (40.5 × 51 cm) $10.00
1007 8″ × 10″ (20 × 25.5 cm) $1.50

Francois Boucher
Diana's Rest, 1742
The Louvre Museum, Paris
4014 14″ × 18″ (35.5 × 46 cm) $8.00

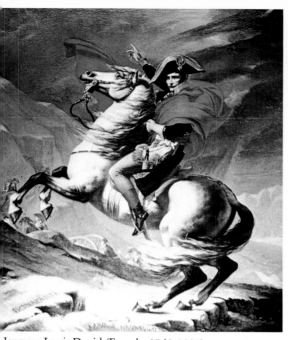

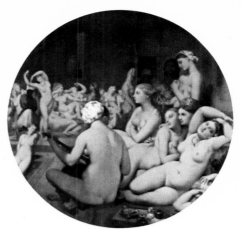

Jacques-Louis David (French, 1748-1825)
Bonaparte at Mont St. Bernard
The Versailles Museum, France
7012 27¾″ × 23½″ (70.5 × 60 cm) $18.00
4066 18″ × 15½″ (46 × 40 cm) $8.00
1070 9½″ × 8″ (24 × 20 cm) $1.50

Dominique Ingres
French 1780-1867
The Spring
The Louvre Museum, Paris
7020 30″ × 15″ (76 × 39 cm) $16.00
4096 15¼″ × 7¾″ (39 × 20 cm) $5.00

Dominique Ingres
The Turkish Bath
The Louvre Museum, Paris
5085 20″ × 20″ (51 × 51 cm) $12.00
4097 12″ × 12″ (30.5 × 30.5 cm) $5.00
1091 8″ × 8″ (20 × 20 cm) $1.50

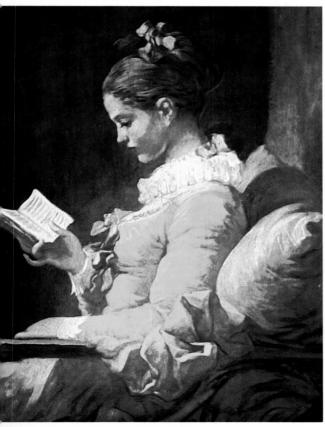

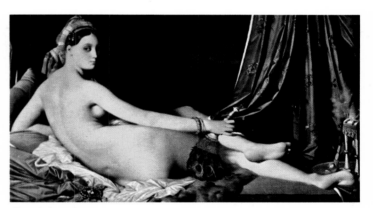

Dominique Ingres
Odalisque, 1814
The Louvre Museum, Paris
4095 10¾″ × 20″ (27 × 51 cm) $7.50
1090 5½″ × 10″ (14.5 × 25.5 cm) $1.50

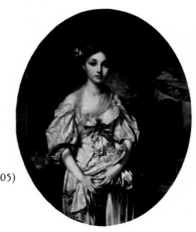

Jean-Honore Fragonard (French, 1732-1806)
A Young Girl Reading, 1776
The National Gallery of Art, Washington, D.C.
5071 24″ × 19″ (61 × 48.5 cm) $12.00
4071 16″ × 12¾″ (41 × 32.5 cm) $4.00
1082 10″ × 8″ (25 × 20 cm) $1.50

Jean-Baptiste Greuze (French, 1725-1805)
The Broken Jug
The Louvre Museum, Paris
5076 20″ × 16″ (51 × 41 cm) $10.00
2041 14″ × 11″ (36 × 28 cm) $4.50
1086 9½″ × 7½″ (24 × 19 cm) $1.50

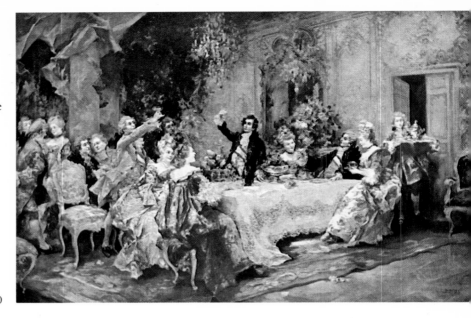

NOTE: Three other subjects of the same size and same price by de Paredes are available. They are: (1) **9655 Handel**, (2) **9656 Mozart a la Court de Marie Antoinette**, and (3) **9654 Benjamin Franklin**

De Paredes
The Favorite Party of Louis XV
9653 18″ × 27¼″ (46 × 69 cm) $36.00

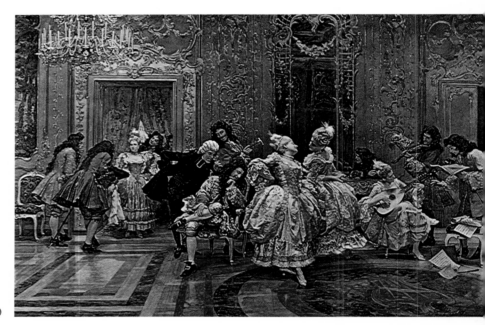

G. Pagliej
La Soiree
9652 24″ × 36″ (61 × 91.5 cm) $16.00

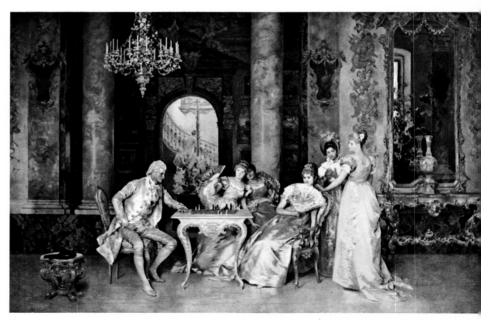

F. Beda
The Chess Game
9551 24″ × 36″ (61 × 91 cm) $12.00

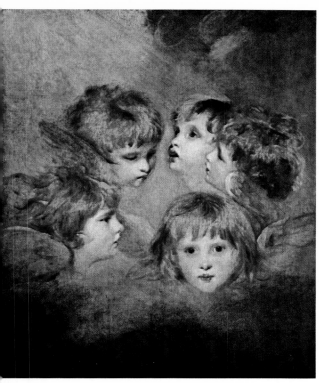

Sir Joshua Reynolds (British, 1723-1792)
Angel's Heads, c.1786-87
The Tate Gallery, London
9387 22″ × 18″ (55 × 46 cm) $10.00

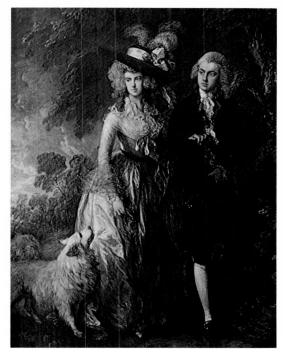

Thomas Gainsborough (British, 1727-1788)
The Morning Walk
The National Gallery, London
5072 24″ × 18″ (61 × 46 cm) $10.00

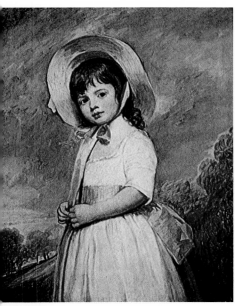

George Romney (British, 1734-1802)
Miss Willoughby
The National Gallery of Art, Mellon Collection,
Washington, D.C.
5131 20½″ × 16″ (52 × 40.5 cm) $10.00
1061 10″ × 7¾″ (25.5 × 19.5 cm) $1.50

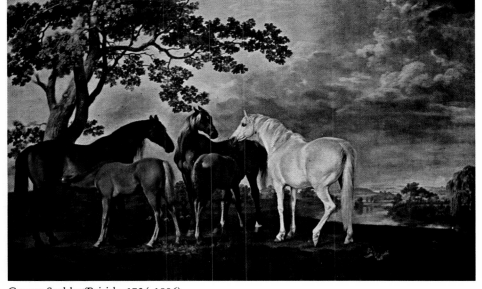

George Stubbs (British, 1724-1806)
Mares and Foals in a Landscape
The Tate Gallery, London
9709 18″ × 29½″ (47 × 75 cm) $16.00
9220 7½″ × 12″ (19 × 30 cm) $3.50

19

Joseph M. W. Turner (British, 1775-1851)
Sun Rising Through Vapor
The National Gallery, London
9413 18″ × 24″ (46 × 61 cm) $15.00

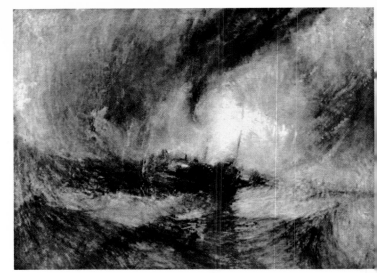

Joseph M. W. Turner
Steamer in a Snow Storm
The National Gallery, London
9412 18″ × 24″ (45 × 61 cm) $15.00

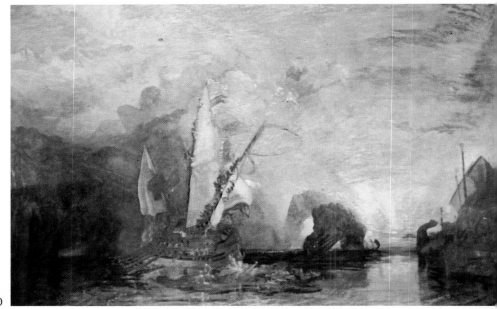

Joseph M. W. Turner
Ulysses Deriding Polyphemus, 1829
The National Gallery, London
9414 15½″ × 24″ (39 × 61 cm) $12.00

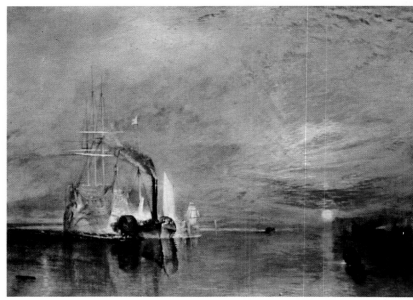

Joseph M. W. Turner
The Fighting ''Temeraire'', 1838
The National Gallery, London
9711 20″ × 27″ (51 × 69 cm) $16.00
9221 10½″ × 14″ (26 × 36 cm) $4.00

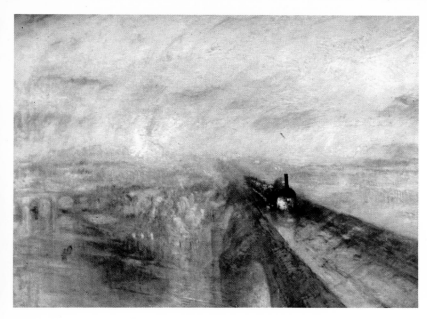

Joseph M. W. Turner
Rain, Steam and Speed
The National Gallery, London
5210 18″ × 24″ (46 × 61 cm) $15.00
1221 7½″ × 10″ (19 × 25.5 cm) $1.50

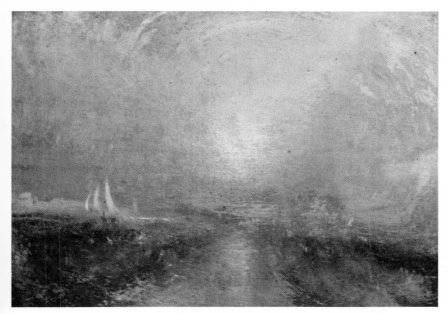

Joseph M. W. Turner
Yacht Approaching the Coast
The Tate Gallery, London
9415 18″ × 24¾″ (45 × 62 cm) $15.00

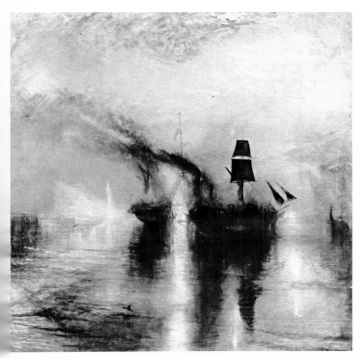

Joseph M. W. Turner
Burning of the Houses of Parliament, 1835
Philadelphia Museum of Art,
The John H. McFadden Collection
5209 17¾″ × 24″ (45 × 61 cm) $15.00
1220 7⅜″ × 10″ (19 × 25.5 cm) $1.50

Joseph M. W. Turner
Peace: Burial at Sea, 1841
The Tate Gallery, London
9411 20½″ × 20″ (51 × 51 cm) $15.00

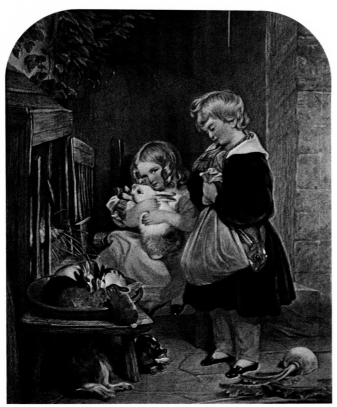

Sir Edwin Henry Landseer (British, 1802-1873)
Children with Rabbits
5249 21¾" × 17½" (55 × 44 cm) $18.00

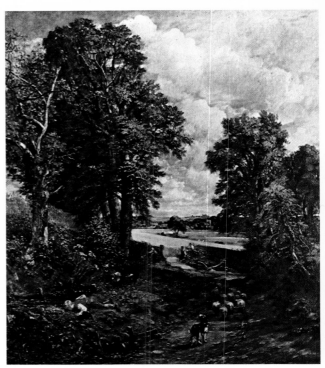

John Constable (British, 1776-1837)
The Cornfield, 1826
The National Gallery, London
9322 24" × 21" (61 × 54 cm) $14.00

John Constable
The Hay Wain
The National Gallery, London
9581 27¼" × 39" (69 × 99 cm) $24.00
9323 18¼" × 26" (46 × 66 cm) $12.00

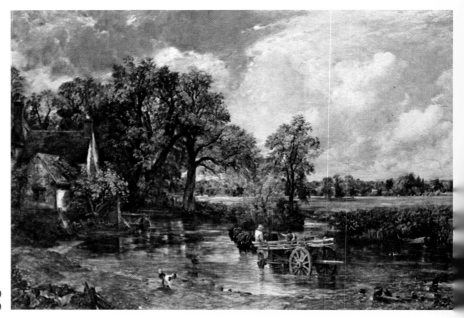

J. E. Meadows (British, 1828-1888)
Old Red Lion Inn
9743 26″ × 40″ (66 × 101.5 cm) $15.00

J. P. Beadle
The Captive Eagle (Waterloo)
(hand colored engraving)
9550 21½″ × 25½″ (54 × 64.5 cm) $65.00

W. B. Stone
Hay Wagon
9708 24″ × 47½″ (61 × 121 cm) $18.00

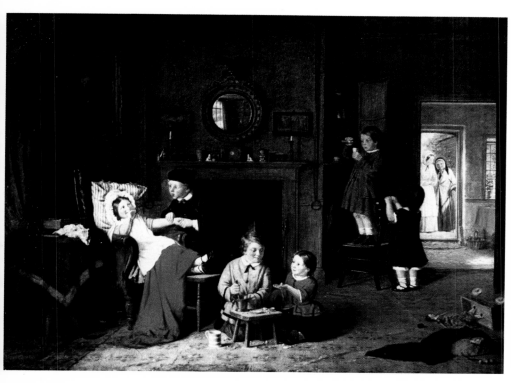

Frederick Daniel Hardy (British, 1826-1911)
Children Playing at Doctor's
Victoria and Albert Museum, London
5077 18″ × 24″ (46 × 61 cm) $10.00

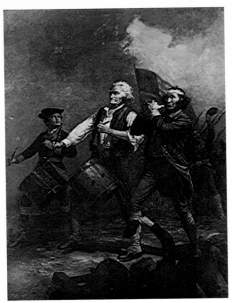

A. M. Willard
The Spirit of '76
(the original of this painting hangs in the Selectmen's Room,
Abbot Hall, Marblehead, Mass.)
4176 19″ × 14″ (48 × 35.5 cm) $7.50
1004 10″ × 7½″ (25.5 × 19 cm) $1.50

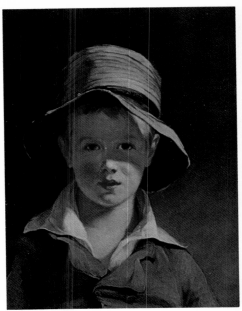

Thomas Sully
The Torn Hat
Museum of Fine Arts, Boston
Gift of Miss Belle Greene and H. C. Greene
in Memory of their Mother
4273 18¼″ × 14″ (46 × 35.5 cm) $8.00

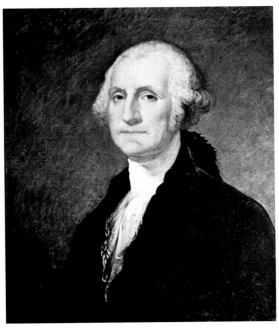

Rembrandt Peale (American, 1778-1860)
George Washington
Santa Barbara Museum of Art
5102 24″ × 20″ (61 × 51 cm) $12.00
4114 14″ × 11½″ (35.5 × 29.5 cm) $4.00

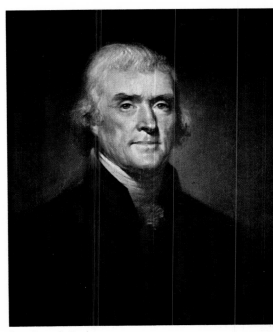

Rembrandt Peale
Thomas Jefferson, 1805
4261 17″ × 14″ (43 × 35.5 cm) $12.00

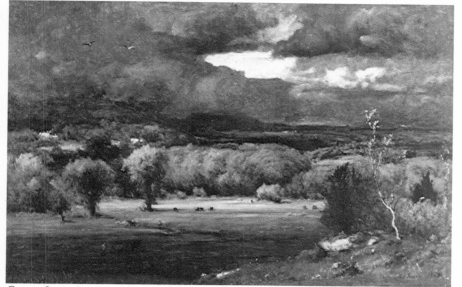

George Innes (1825-1894)
The Coming Storm 1878
Albright-Knox Art Gallery, Buffalo, N.Y.
Albert H. Tracy Fund
7092 20″ × 30″ (51 × 76 cm) $15.00
1170 6⅝″ × 10″ (17 × 25.5 cm) $1.50

Declaration of Independence
4265 sheet size 20″ × 16″ (51 × 40.5 cm) $4.00
2094 sheet size 16″ × 12″ (40.5 × 30.5 cm) $2.50

Asher B. Durand (American, 1796-1886)
Day of Rest
9599 28″ × 42″ (71 × 107 cm) $18.00

Jasper F. Cropsey (American, 1823-1900)
Old Red Mill
9582 26″ × 48″ (66 × 122 cm) $18.00
9037 12″ × 22″ (30.5 × 56 cm) $4.00

Jasper F. Cropsey
Susquehanna River
9583 26″ × 48″ (66 × 122 cm) $18.00
9038 12″ × 22″ (30.5 × 56 cm) $4.00

Walter Williams
Peaceful Glade
9714 24″ × 48″ (61 × 122 cm) $18.00

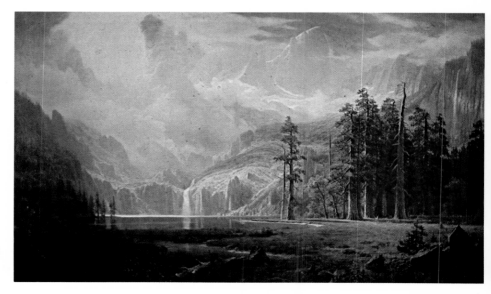

Albert Bierstadt (American, 1830-1902)
Grandeur of the Rockies
9552 28″ × 48″ (71 × 122 cm) $18.00

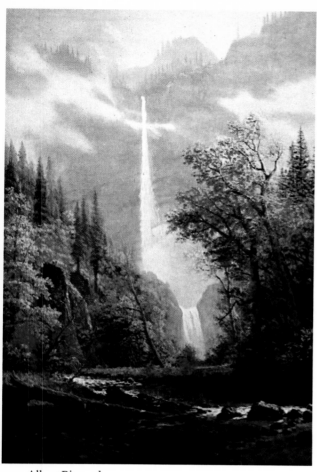

R. Knight
Rural Courtship
9630 30″ × 24½″ (76 × 62 cm) $12.00

Albert Bierstadt
Multnomah Falls
*Thomas Gilcrease Institute of American History
and Art, Tulsa, Oklahoma*
9553 36″ × 24″ (91 × 61 cm) $16.00

Albert Bierstadt
Sierra Nevada Morning
*Thomas Gilcrease Institute of American History
and Art, Tulsa, Oklahoma*
9554 25½″ × 39½″ (65 × 100.5 cm) $16.00

N. Currier
View of New York, 1849
4148 16¾″ × 11½″ (42.5 × 19 cm) $10.00

Currier & Ives (L. Maurer)
The Life of a Fireman-The Race
5152 18″ × 27½″ (46 × 70 cm) $12.00

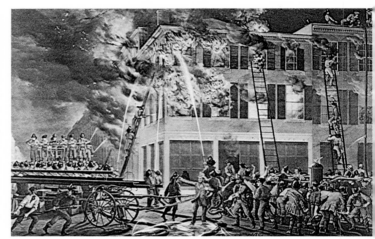

Currier & Ives (L. Maurer)
The Life of a Fireman-The Fire
5151 18″ × 27½″ (46 × 70 cm) $12.00

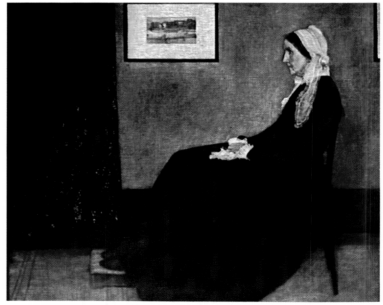

James McNeill Whistler (American, 1834-1903)
The Mother of the Artist
The Louvre Museum, Paris
5051 21¼″ × 24″ (54 × 61 cm) $10.00
4033 12½″ × 14″ (31.5 × 35.5 cm) $4.00
1044 8″ × 9″ (20 × 23 cm) $1.50

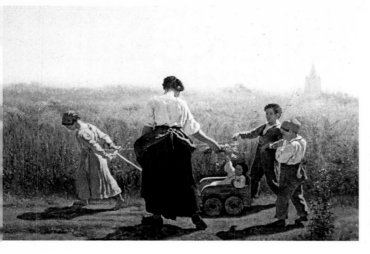

Eastman Johnson (American, 1824-1906)
The Baby Carriage
Santa Barbara Museum of Art
Preston Morton Collection
7025 20″ × 30½″ (51 × 77.5 cm) **$14.00**
4099 12″ × 18¼″ (30.5 × 46.5 cm) **$4.50**
1093 6½″ × 10″ (16.5 × 25 cm) **$1.50**

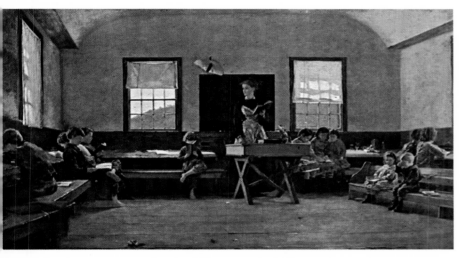

Winslow Homer (American, 1836-1910)
The Country School
City Art Museum of St. Louis
9361 13¼″ × 23¾″ (34 × 60 cm) **$8.00**

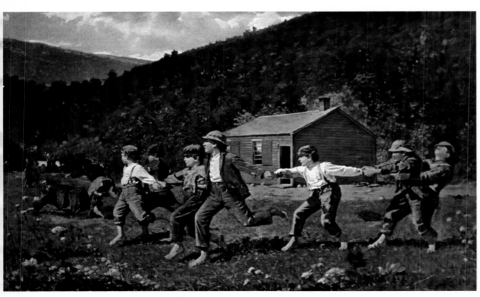

Winslow Homer
Snap the Whip
Butler Institute of American Art
9620 24″ × 38″ (61 × 96.5 cm) **$18.00**

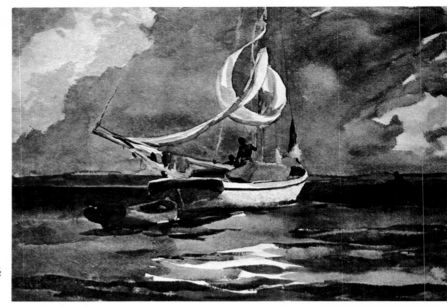

Winslow Homer
Sloop, Bermuda
The Metropolitan Museum of Art, New York
Lazarus Fund, 1910
4249 12½″ × 18¼″ (32 × 46.5 cm) $7.50

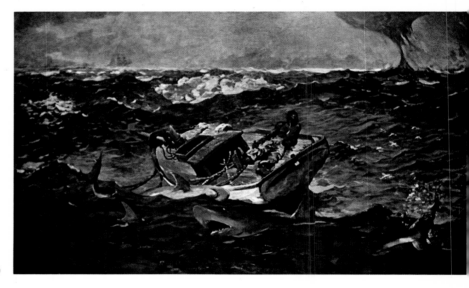

Winslow Homer
The Gulf Stream
The Metropolitan Museum of Art, New York
9619 18½″ × 30¼″ (46.5 × 77 cm) $12.00

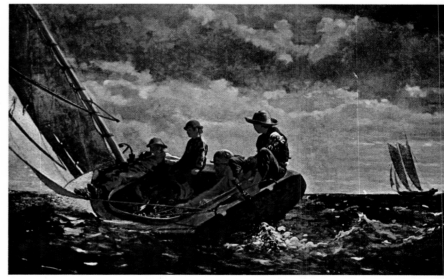

Winslow Homer
Breezing Up
The National Gallery of Art, Washington, D.C.
5079 15½″ × 24″ (39 × 61 cm) $10.00
1089 6½″ × 10″ (16 × 25.5 cm) $1.50

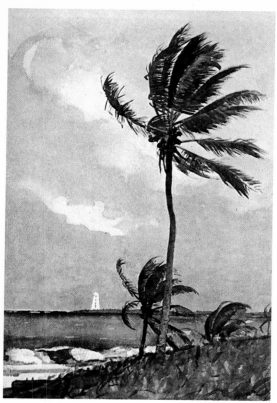

Winslow Homer
Palm Tree, Nassau
The Metropolitan Museum of Art, New York
Lazarus Fund, 1910
4166 18¼ ″ × 12¾ ″ (46.5 × 32.5 cm) **$7.50**
1122 10″ × 6⅞″ (25.5 × 17.5 cm) **$1.50**

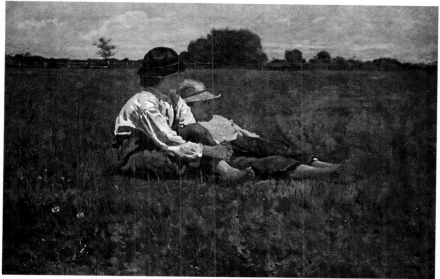

Winslow Homer
Boys in a Pasture, 1874
Museum of Fine Arts, Boston
9360 15¾ ″ × 22¾ ″ (40 × 58 cm) **$8.00**

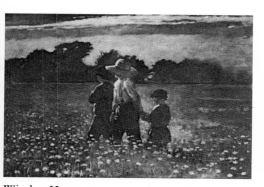

Winslow Homer
In The Mowing, 1874
Wichita Art Museum, Kansas
The Roland P. Murdock Coll.
4165 14″ × 21½ ″ (36 × 55 cm) **$8.00**
1113 6⅝″ × 10″ (17 × 25.5 cm) **$1.50**

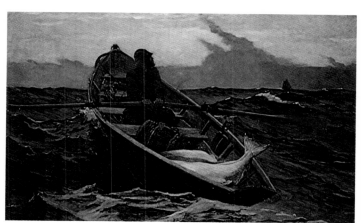

Winslow Homer
Fog Warning
Museum of Fine Arts, Boston
Otis Norcross Fund
4272 10″ × 20¼ ″ (25.5 × 51.5 cm) **$8.00**

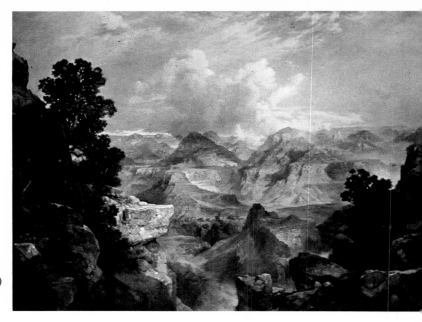

Thomas Moran (American, 1837-1926)
The Grand Canyon
9646 24″ × 32″ (61 × 81 cm) $15.00

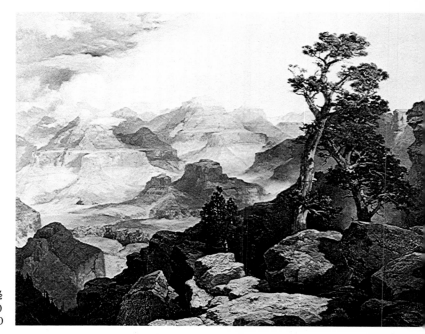

Thomas Moran
Clouds in the Canyon
Rockwell Foundation, Corning, New York
5101 19″ × 24″ (48 × 61 cm) $10.00
1119 7¾″ × 10″ (19.5 × 25.5 cm) $1.50

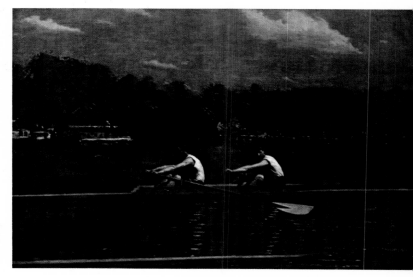

Thomas Eakins (American, 1844-1916)
The Biglen Brothers Racing
The National Gallery of Art, Washington, D.C.
5070 17¾″ × 26½″ (45 × 67 cm) $12.00
1079 6⅝″ × 10″ (17 × 25.5 cm) $1.50

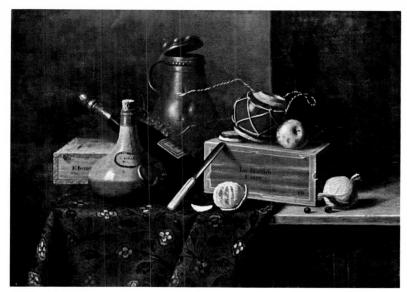

William M. Harnett (American, 1848-1892)
Still Life with Copper Tankard, Jugs and Fruit
Graham Gallery, New York
9352 17½″ × 23½″ (44 × 60 cm) **$8.00**

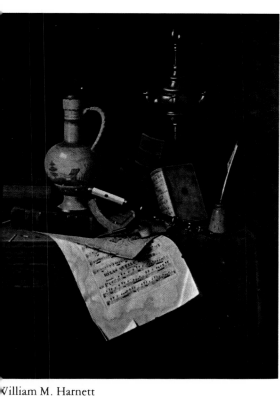

William M. Harnett
My Gems
National Gallery of Art, Washington D.C.
Gift of the Avalon Foundation
197 24″ × 18¾″ (61 × 48 cm) **$10.00**
178 10″ × 7¾″ (25.5 × 20 cm) **$1.50**

William Harnett
Just Dessert
Art Institute of Chicago
Friends of American Art Coll.
5226 18¼″ × 22″ (46 × 56 cm) **$10.00**
1028 8″ × 9½″ (20 × 24 cm) **$1.50**

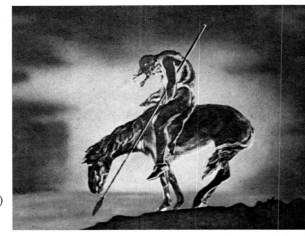

James Earle Fraser (American, 1876-1953)
End of the Trail
4075 14″ × 18″ (35.5 × 46 cm) **$5.00**

Unknown (anonymous), American
Buffalo Hunter, 1830
Santa Barbara Museum of Art, Buell Hammett Memorial Fund
5048 18½″ × 24″ (47 × 61 cm) **$12.00**
1054 7¾″ × 10″ (19.5 × 25 cm) **$1.50**

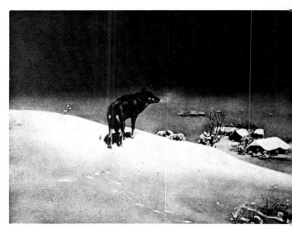

Alfred von Kowalski-Wierusz, 1849-1915
Lone Wolf, February
4103 14″ × 18″ (36 × 46 cm) **$5.00**

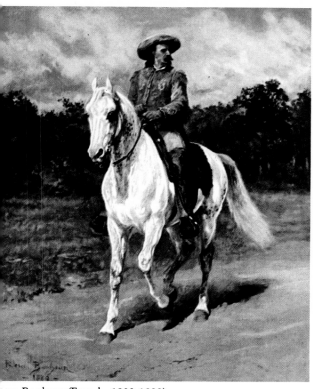

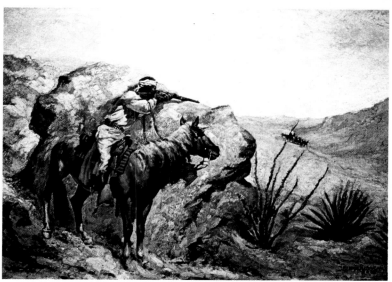

Frederic Remington
Apache
Rockwell Foundation, Corning, New York
5128 18" × 25⅛" (46 × 64 cm) **$10.00**
1134 7⅛" × 10" (18 × 25.5 cm) **$1.50**

Rosa Bonheur (French, 1822-1899)
Col. William F. Cody — Buffalo Bill, 1889
Whitney Gallery of Western Art, Wyoming
5017 20" × 16" (51 × 40.5 cm) **$8.00**

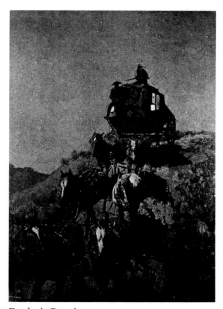

Frederic Remington
The Old Stagecoach of the Plains
Amon Carter Museum of Western Art
9663 30" × 20½" (76 × 52 cm) **$14.00**

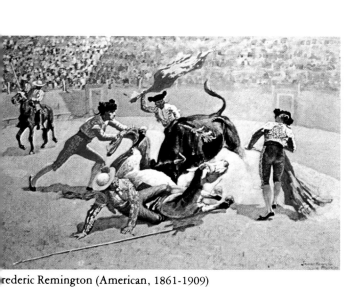

Frederic Remington (American, 1861-1909)
Corrida, 1889
Santa Barbara Museum of Art, Preston Morton Collection
5129 18" × 24" (46 × 61.5 cm) **$12.00**
1135 7½" × 10" (19 × 25 cm) **$1.50**

Frederic Remington
Coming and Going of the Pony Express
Thomas Gilcrease Institute of American History and Art, Tulsa, Oklahoma
9183 13½" × 20" (34.5 × 51 cm) **$6.00**

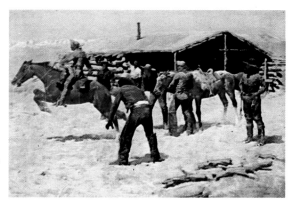

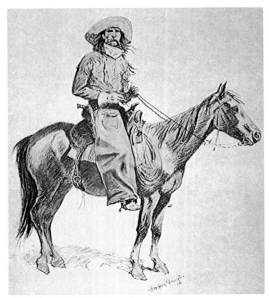

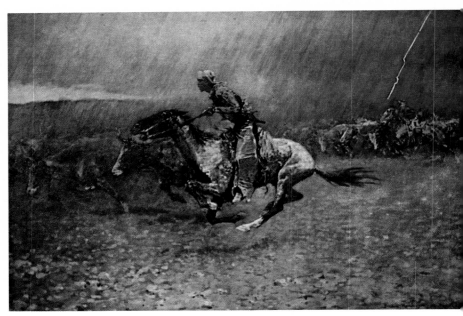

Frederic Remington
Arizona Cowboy
Rockwell Foundation, Corning, New York
5034 20″ × 17½″ (51 × 44.5 cm) $8.00
1146 10″ × 8″ (25.5 × 20 cm) $1.50

Frederic Remington
Stampeded by Lightning
Gilcrease Institute
9667 20″ × 30″ (51 × 76 cm) $14.00

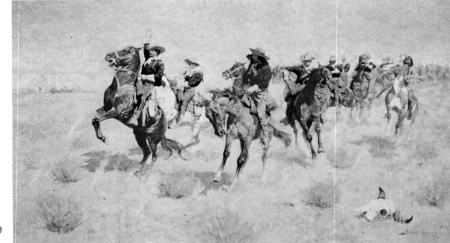

Frederic Remington
Halt-Dismount
*Timkin Art Gallery, The Putnam
Foundation, San Diego*
7076 17½″ × 30″ (44.5 × 76 cm) $14.00
1196 5¾″ × 10″ (15 × 25.5 cm) $1.50

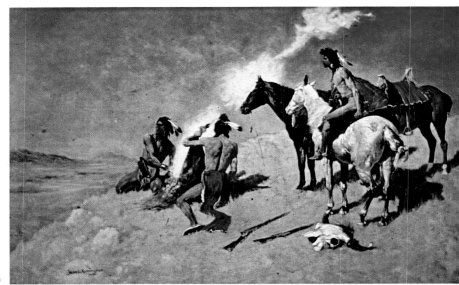

Frederic Remington
The Smoke Signal
Amon Carter Museum of Western Art
9666 24″ × 38½″ (61 × 98 cm) $18.00

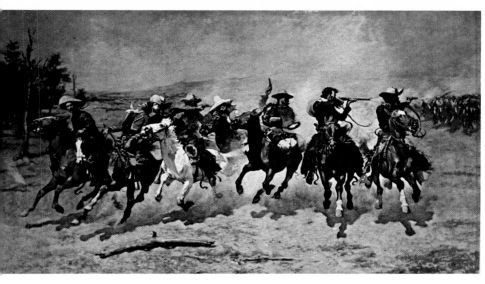

Frederic Remington
A Dash for Timber
Amon Carter Museum of Western Art
9660 22″ × 38½″ (56 × 98 cm) $18.00

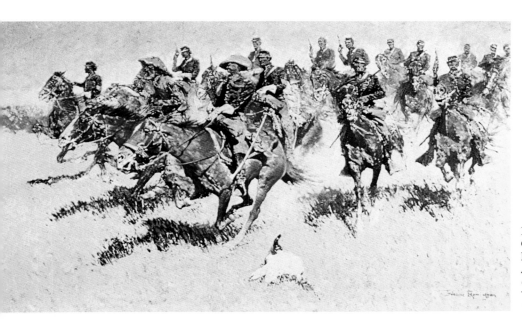

Frederic Remington
**Cavalry Charge on the Southern
Plains, 1907**
Metropolitan Museum of Art
Gift of Several Gentlemen, 1911
7063 17¾″ × 30″ (45 × 76 cm) $14.00
1194 5⅞″ × 10″ (15 × 25.5 cm) $1.50

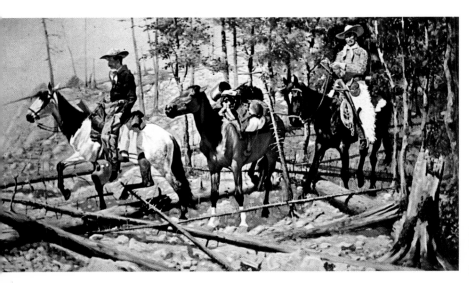

Frederic Remington
Prospecting for Cattle Range
Whitney Gallery of Western Art
9664 22″ × 38″ (56 × 96.5 cm) $18.00

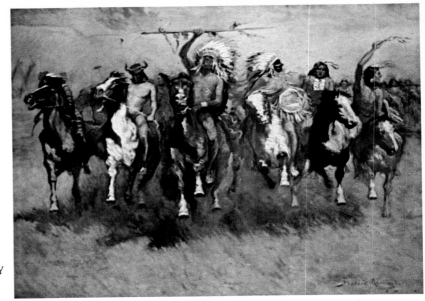

Frederic Remington
The Victory Dance
Thomas Gilcrease Institute of American History and Art, Tulsa, Oklahoma
9668 20½" × 28¾" (52 × 73 cm) $14.00

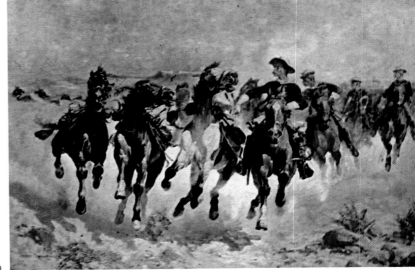

Frederic Remington
Dismounted: The Fourth Troopers Moving the Led Horses, 1890
Sterling and Francine Clark Art Institute, Mass.
5202 16½" × 24" (42 × 61 cm) $10.00
1195 6⅞" × 10" (17.5 × 25.5 cm) $1.50

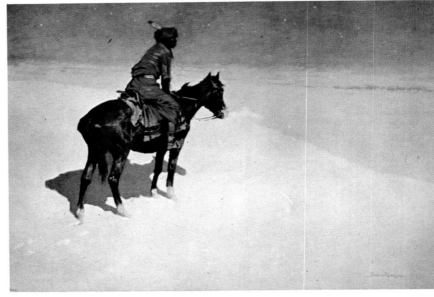

Frederic Remington
The Scout: Friends or Enemies, 1890
Sterling and Francine Clark Art Institute, Mass.
5203 16¼" × 24" (41 × 61 cm) $10.00
1197 6¾" × 10" (17 × 25.5 cm) $1.50

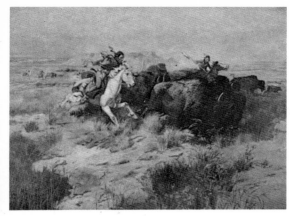

Charles M. Russell (American, 1864-1926)
Indian Buffalo Hunt, 1897
Wichita Art Museum, Kansas
The M. C. Naftzger Collection
4213 16″ × 21¼″ (41 × 54 cm) **$10.00**
1206 7⅝″ × 10″ (19 × 25.5 cm) **$1.50**

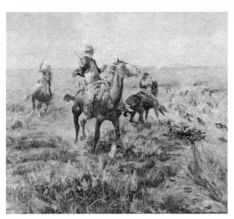

Charles M. Russell
Smokin 'Em Out, 1912
Wichita Art Museum, Kansas
The M. C. Naftzger Collection
4214 18½″ × 20″ (47 × 51 cm) **$10.00**
1207 8″ × 8⅝″ (20 × 22 cm) **$1.50**

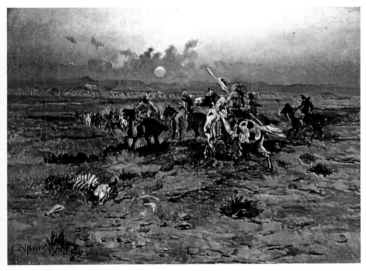

Charles M. Russell
Stolen Horses
The Rockwell Foundation, Corning, New York
5035 18″ × 24″ (46 × 61 cm) **$10.00**
1147 7½″ × 10″ (19 × 25 cm) **$1.50**

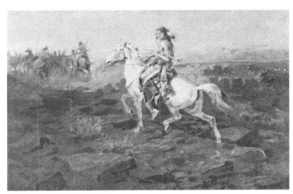

Charles M. Russell
Pony Raid, 1896
Wichita Art Museum, Kansas
The M. C. Naftzger Collection
Given in Memory of M. C. Naftzger
by The Southwest National Bank
2012 8″ × 12″ (20 × 30.5 cm) **$4.00**

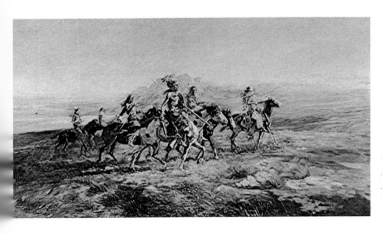

Charles M. Russell
Sun River War Party
Rockwell Foundation, Corning, New York
7046 16″ × 28″ (41 × 71 cm) **$10.00**
1148 5⅝″ × 10″ (14 × 25.5 cm) **$1.50**

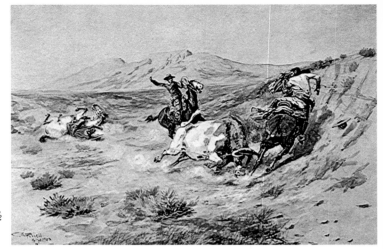

Charles M. Russell
One Down, Two to Go
The Rockwell Foundation, Corning, New York
5036 16½″ × 24″ (42 × 61 cm) $10.00
1149 6⅞″ × 10″ (17 × 25.5 cm) $1.50

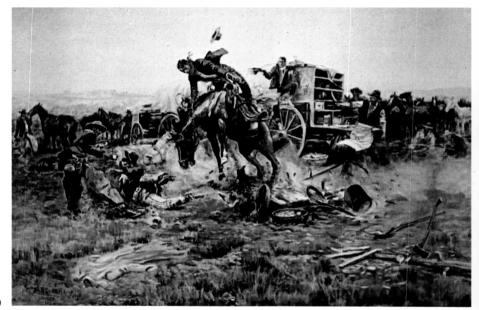

Charles M. Russell
The Camp Cook's Troubles
Gilcrease Institute, Tulsa
9209 13½″ × 20″ (34.5 × 51 cm) $6.00

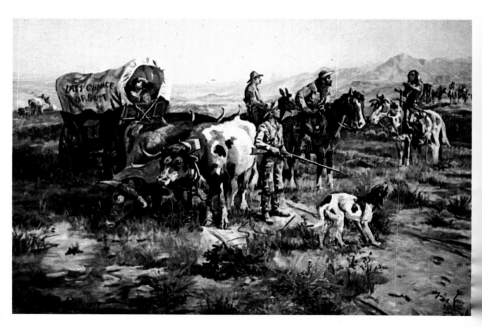

Charles M. Russell
The Doubtful Visitor
Gilcrease Institute, Tulsa
9211 13½″ × 20″ (34.5 × 51 cm) $6.00

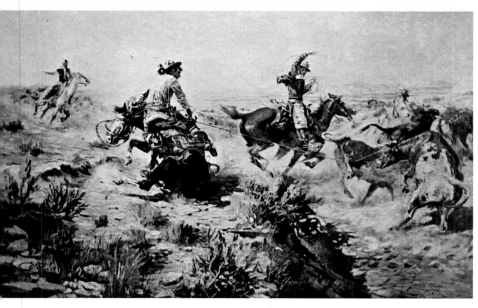

Charles M. Russell
Jerked Down
Gilcrease Institute, Tulsa
9213 12½″ × 20″ (32 × 51 cm) $6.00

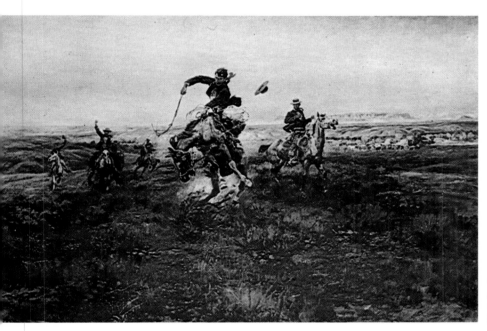

Charles M. Russell
A Bad One
Gilcrease Institute, Tulsa
9392 16″ × 24″ (40.5 × 61 cm) $10.00

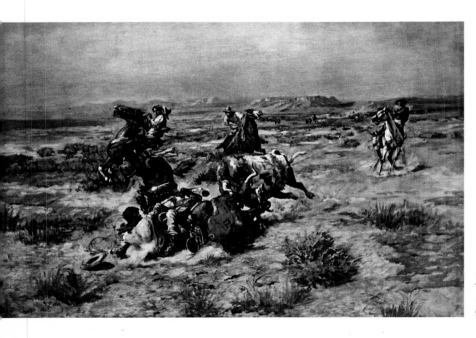

Charles M. Russell
The Strenuous Life
Gilcrease Institute, Tulsa
9393 16″ × 24″ (40.5 × 61 cm) $10.00

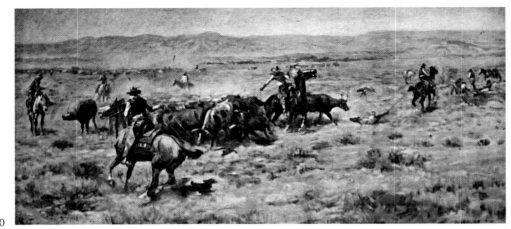

Charles M. Russell
The Roundup
Historical Society of Montana
9690 14″ × 30″ (35.5 × 76 cm) $12.00

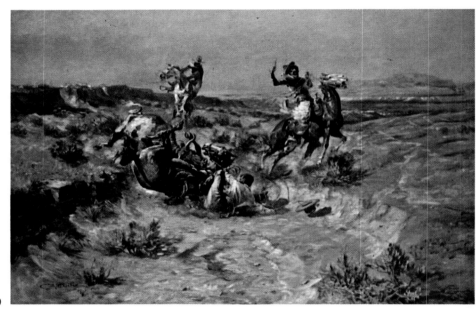

Charles M. Russell
The Broken Rope
Amon Carter Museum
9678 20″ × 30½″ (51 × 77.5 cm) $14.00

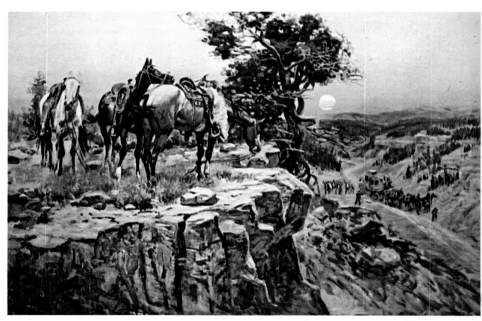

Charles M. Russell
Innocent Allies
Gilcrease Institute
9212 14″ × 21″ (35.5 × 53.5 cm) $6.00

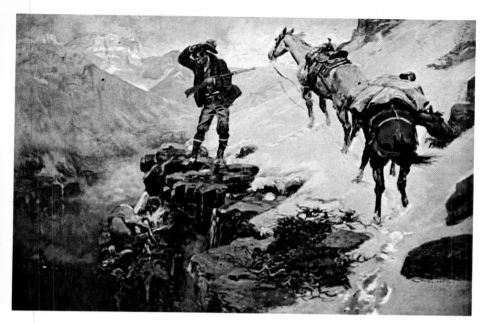

Charles M. Russell
Meat's not Meat 'til its in the Pan
Gilcrease Institute
9214 14″ × 21″ (35.5 × 53.5 cm) $6.00

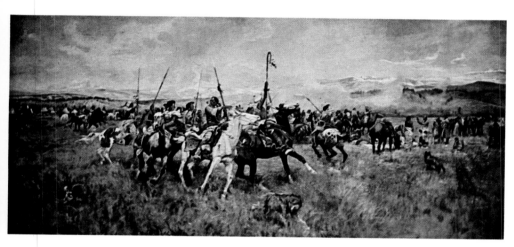

Charles M. Russell
Lewis and Clark Meeting the Flatheads
Montana State Capitol
9685 14″ × 30″ (35.5 × 76 cm) $12.00

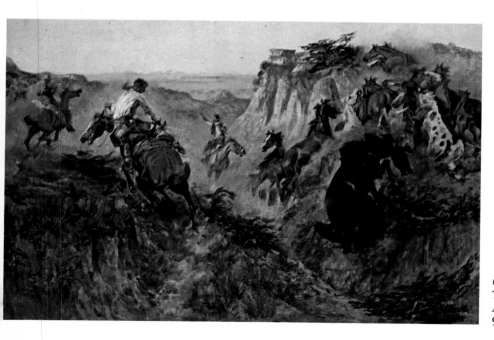

Charles M. Russell
The Wild Horse Hunters
Amon Carter Museum
9697 20″ × 31½″ (51 × 80 cm) $14.00

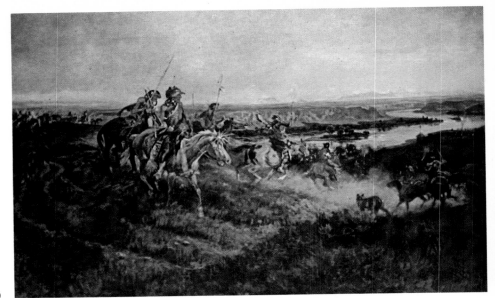

Charles M. Russell
Salute to the Robe Trade
Gilcrease Institute, Tulsa
9688 22½″ × 36″ (57.5 × 91.5 cm) $16.00

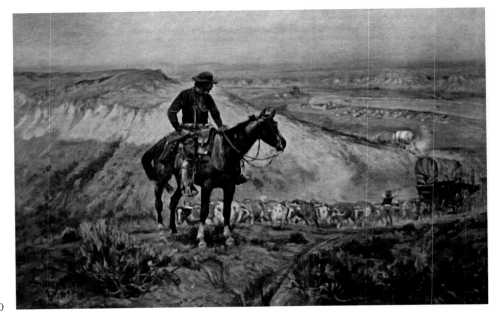

Charles M. Russell
The Wagon Boss
Gilcrease Institute, Tulsa
9693 23½″ × 36″ (60 × 91.5 cm) $16.00

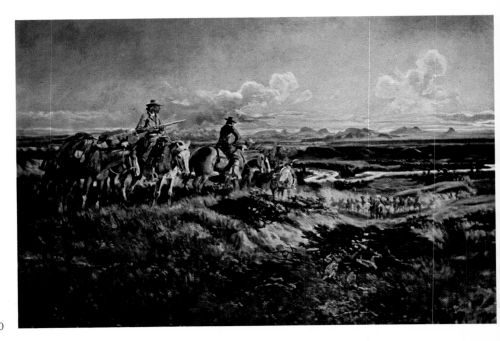

Charles M. Russell
Where Guns were their Passports
Gilcrease Institute, Tulsa
9696 24″ × 36″ (61 × 91.5 cm) $16.00

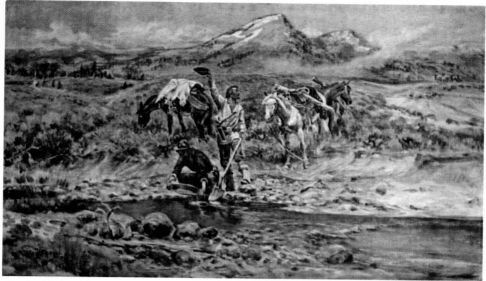

Charles M. Russell
Discovery of Last Chance Gulch
Gilcrease Institute, Tulsa
9680 18″ × 30″ (46 × 76 cm) $14.00

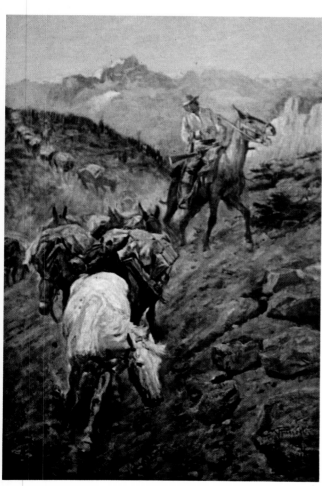

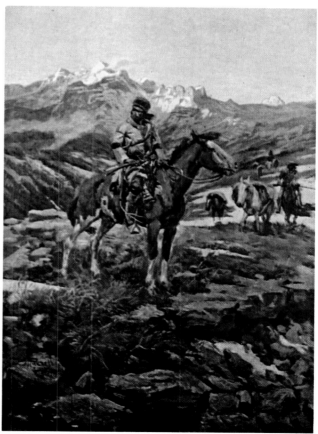

Charles M. Russell
Free Trappers
Montana Historical Society
9681 31¼″ × 22¼″ (79.5 × 56.5 cm) $15.00

Charles M. Russell
Bell Mare
Gilcrease Institute, Tulsa
9677 30″ × 20″ (76 × 51 cm) $14.00

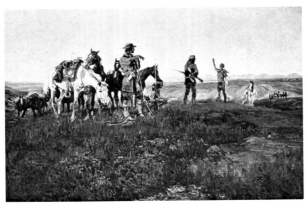

Charles M. Russell
Pipe of Peace
National Cowboy Hall of Fame
9687 20″ × 30″ (51 × 76 cm) $14.00

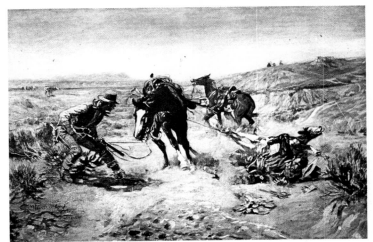

Charles M. Russell
Cinch Ring
National Cowboy Hall of Fame
9679 24″ × 36″ (61 × 91 cm) $16.00

Charles M. Russell
A Doubtful Handshake
Gilcrease Institute
9210 16″ × 16″ (41 × 41 cm) $6.00

Charles M. Russell
Laugh Kills Lonesome
Montana Historical Society
9684 18″ × 30″ (46 × 76 cm) $14.00

NOTE: There are approximately 100 subjects by
Russell available in small prints — average size:
8″ × 10″ (20.5 × 25.5 cm) $2.00 each
List supplied upon request.

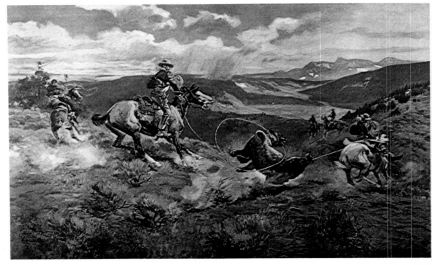

Charles M. Russell
Loops & Swift Horses are Surer than Lead
Amon Carter Museum of Western Art
9686 24″ × 38½″ (61 × 98 cm) $18.00

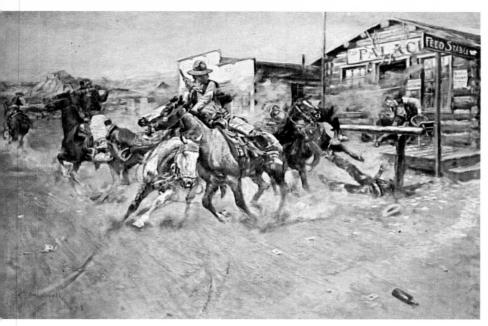

Charles M. Russell
Smoke of a .45
Amon Carter Museum
9689 20″ × 30″ (51 × 76 cm) $14.00

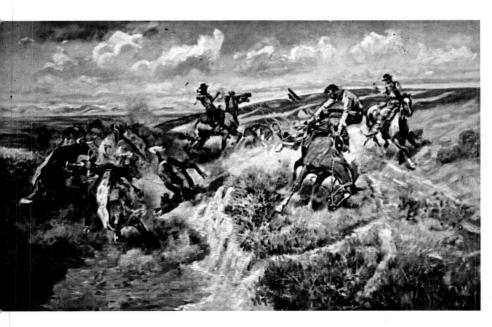

Charles M. Russell
In Without Knocking
Amon Carter Museum
9683 20″ × 30″ (51 × 76 cm) $14.00

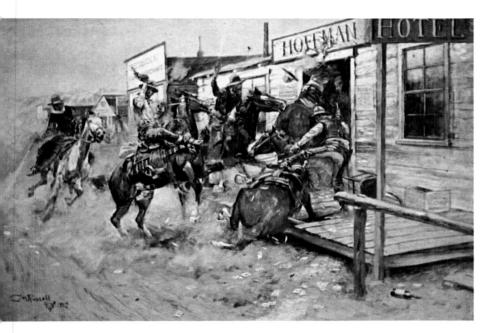

Charles M. Russell
A Tight Dally and a Loose Latigo
Amon Carter Museum
9691 25″ × 40″ (63.5 × 101.5 cm) $18.00

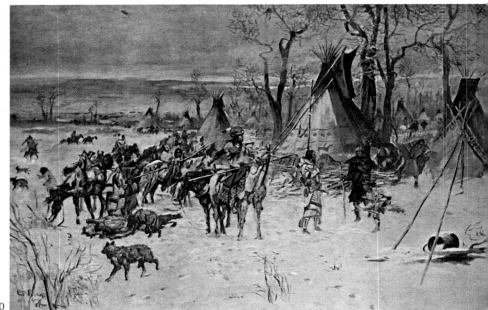

Charles M. Russell
Indian Hunter's Return
Montana Historical Society
9682 22″ × 33¼″ (56 × 84.5 cm) $16.00

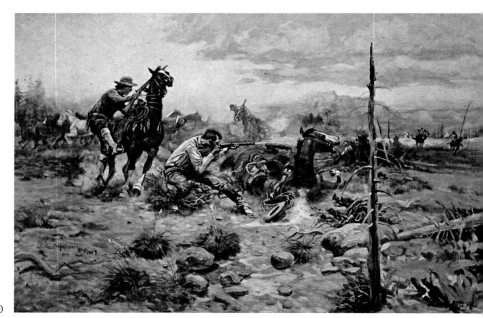

Charles M. Russell
When Horse Flesh Comes High
9695 24″ × 36″ (61 × 91.5 cm) $16.00

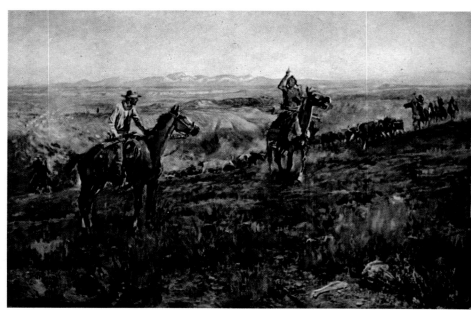

Charles M. Russell
Toll Collectors
Montana Historical Society
9692 20″ × 30″ (51 × 76 cm) $14.00

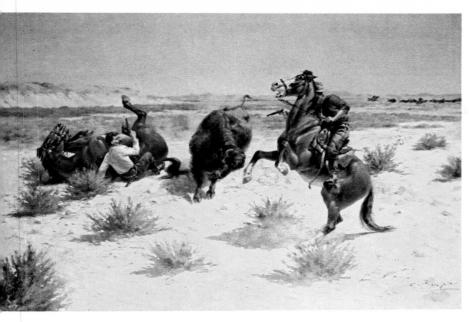

H. W. Hansen
Buffalo Trouble
7112 24" × 36" (61 × 91.5 cm) $16.00

lfred Owles
rifter
000 18" × 25" (46 × 63.5 cm) $10.00

Alfred Owles
Traveling Medicine Man
5002 18" × 25" (46 × 63.5 cm) $10.00

Olaf Seltzer, 1877-1957
Indian Espionage
Rockwell Foundation, Corning, New York
7050 20" × 30" (51 × 76.5 cm) $12.00
1023 6⅝" × 10" (17 × 25.5 cm) $1.50

49

Joseph H. Sharp
Prayer to the Spirit of a Buffalo
Rockwell Foundation, Corning, New York
5040 17¾" × 24" (45 × 61 cm) $10.00
1024 7⅜" × 10" (19 × 25.5 cm) $1.50

Eangar Irving Couse, 1866-1936
Early Picture Makers
Rockwell Foundation, Corning, New York
5059 24" × 18" (61 × 45 cm) $10.00
1068 10" × 7½" (25.5 × 19 cm) $1.50

William Leigh (American, 1866-1955)
Buffalo Hunt
Rockwell Foundation, Corning, New York
7029 20" × 32½" (51 × 82.5 cm) $12.00
1094 6⅛" × 10" (15.5 × 25.5 cm) $1.50

William Leigh
Master of his Domain
Rockwell Foundation, Corning, New York
5090 24″ × 18″ (61 × 46 cm) $10.00
5095 10″ × 7⅜″ (25.5 × 19 cm) $1.50

See the Photography section at the back of book
for more American Indian material.

William Leigh
The Warning Shadow
Rockwell Foundation, Corning, New York
5091 25¾″ × 18″ (65.5 × 46 cm) $10.00
1096 10″ × 7″ (25.5 × 18 cm) $1.50

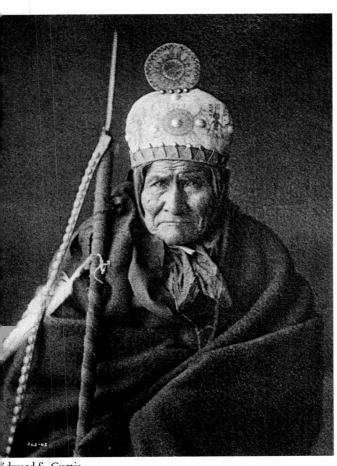

Edward S. Curtis
**Geronimo as an Old Man with
Ceremonial Hat and Lance**
Southwest Museum, Los Angeles
5060 15″ × 11″ (38.5 × 28 cm) $5.00
5112 10″ × 7¼″ (25 × 18.5 cm) $1.50

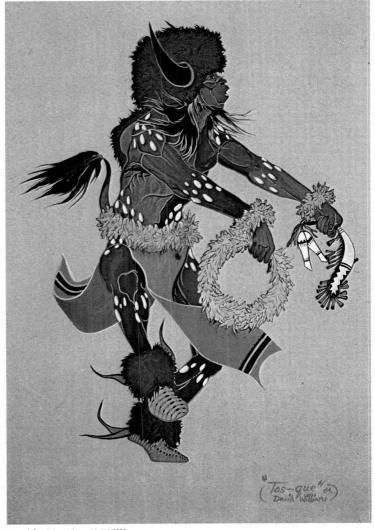

David "Tos-Que" Williams
Mandan Buffalo Dancer
Southwest Museum, Los Angeles
5120 24″ × 16½″ (61 × 42 cm) $10.00
1048 10″ × 6¾″ (25 × 17 cm) $1.50

51

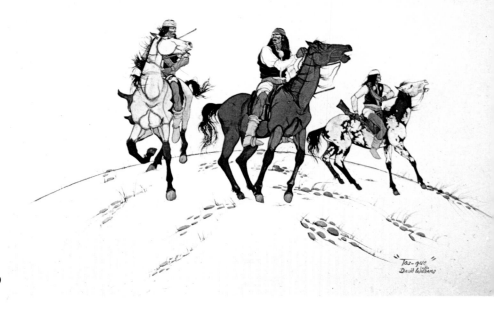

David ''Tos-Que'' Williams
Apaches
Carl S. Dentzel Collection
5118 18″ × 25½″ (46 × 65 cm) **$10.00**
1045 7″ × 10″ (18 × 25 cm) **$1.50**

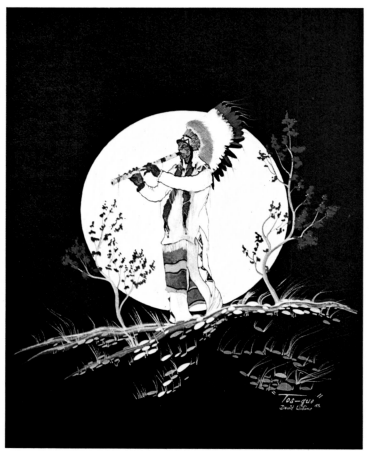

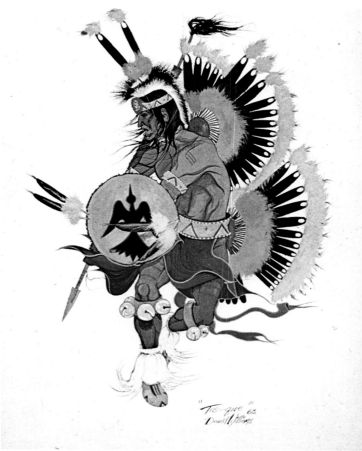

David ''Tos-Que'' Williams
Cheyenne Flute Player
Carl S. Dentzel Collection
5119 20″ × 16″ (51 × 41 cm) **$8.00**
1046 10″ × 8″ (25 × 20 cm) **$1.50**

David ''Tos-Que'' Williams
Plains Indian War Dance
Southwest Museum, Los Angeles
5121 20″ × 16″ (51 × 41 cm) **$8.00**
1047 10″ × 8″ (25 × 20 cm) **$1.50**

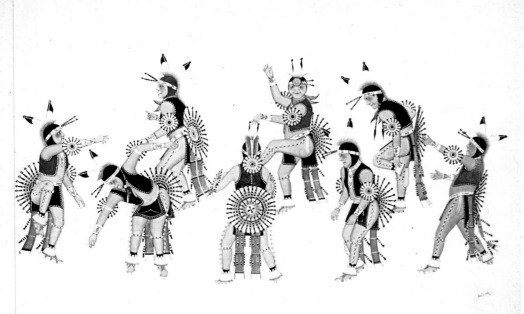

Awa Tsireh
Kiowa Shamans Dance
Southwest Museum, Los Angeles
5047 14″ × 22″ (36 × 56 cm) $10.00
1035 6½″ × 10″ (16 × 25 cm) $1.50

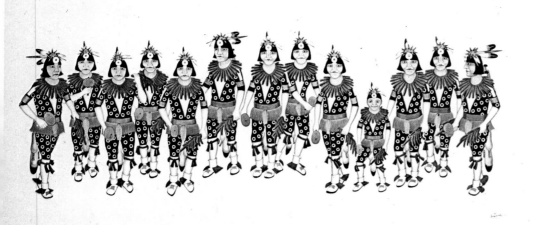

Awa Tsireh
Flute Playing Ceremony and Dance
Southwest Museum, Los Angeles
5046 13½″ × 22″ (35 × 56 cm) $10.00
1034 6¼″ × 10″ (16 × 25 cm) $1.50

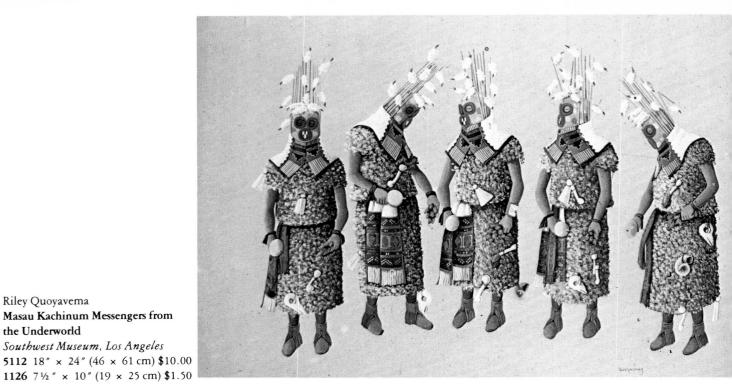

Riley Quoyavema
**Masau Kachinum Messengers from
the Underworld**
Southwest Museum, Los Angeles
5112 18″ × 24″ (46 × 61 cm) $10.00
1126 7½″ × 10″ (19 × 25 cm) $1.50

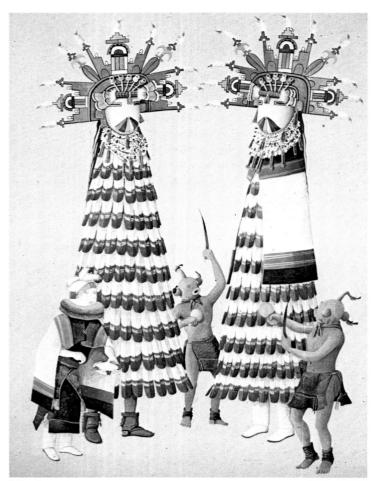

Riley Quoyavema
Hopi Shalako Kachinas
Southwest Museum, Los Angeles
5111 24″ × 18″ (61 × 46 cm) $10.00
1125 10″ × 7½″ (25 × 19 cm) $1.50

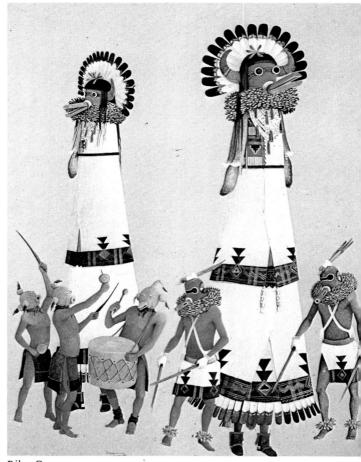

Riley Quoyavema
**Zuni Shalako Kachinas with
Salamokia and Mudheads**
Southwest Museum, Los Angeles
5113 24″ × 18″ (61 × 46 cm) $10.00
1127 10″ × 7½″ (25 × 19 cm) $1.50

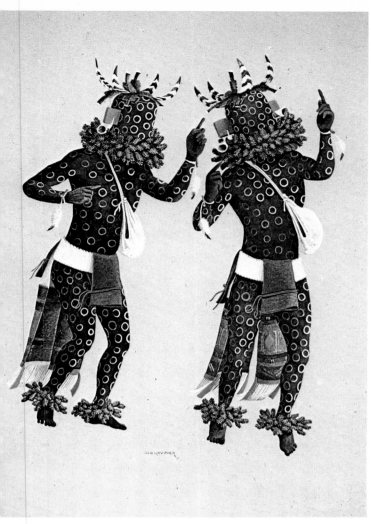

Riley Quoyavema
Avaeh Hoy Am Kachinas
Southwest Museum, Los Angeles
4117 16½″ × 12″ (42 × 30.5 cm) **$6.00**
1124 10″ × 7¼″ (25 × 18.5 cm) **$1.50**

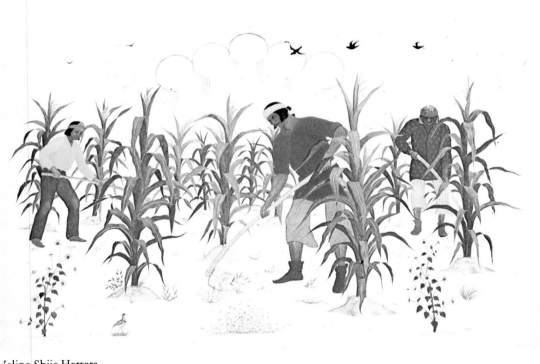

Velino Shije Herrera
**Pueblo Farmer Hoeing
in the Cornfield**
Southwest Museum, Los Angeles
5078 13½″ × 22″ (35 × 56 cm) **$10.00**
088 6¼″ × 10″ (16 × 25 cm) **$1.50**

Mopope
Kiowa Round Dance
Carl S. Dentzel Collection
4113 9″ × 20″ (23 × 51 cm) $7.50
1118 4½″ × 10″ (11.5 × 25 cm) $1.50

See the Photography section at the back of book for more American Indian material.

Eustace P. Ziegler
Indian Mother and Child (Tanana)
9741 24″ × 36″ (61 × 91.5 cm) $16.00

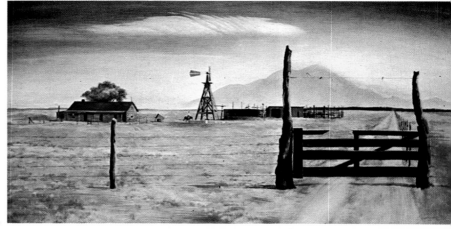

Peter Hurd (American, 1904-)
The Gate and Beyond
Roswell Museum, Roswell, New Mexico
9362 12¼″ × 23¾″ (31 × 60 cm) $8.00

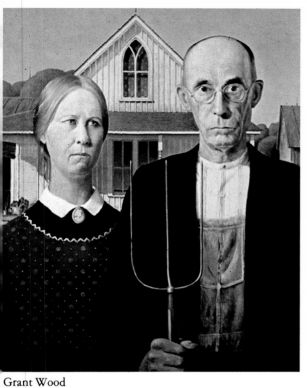

Grant Wood
American Gothic, 1930
The Art Institute of Chicago
Friends of American Art Collection
4241 20″ × 16″ (51 × 40.5 cm) $10.00
1236 10″ × 8″ (25.5 × 20 cm) $1.50

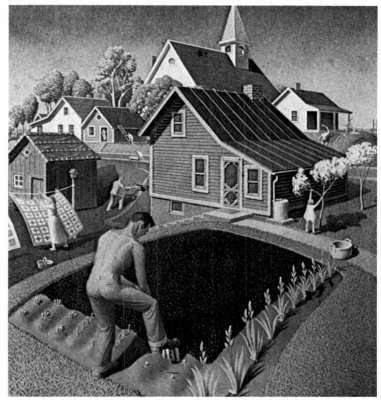

Grant Wood
Spring in Town
Sheldon Swope Art Gallery, Indiana
5133 20″ × 18¼″ (51 × 46.5 cm) $8.00

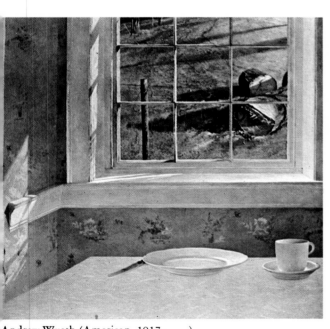

Andrew Wyeth (American, 1917-)
Ground Hog Day
Philadelphia Museum
9258 17¾″ × 18¼″ (45 × 46.5 cm) $8.00

Andrew Wyeth
Spindrift
The Currier Gallery of Art, Manchester,
New Hampshire
9737 15″ × 36″ (38 × 91 cm) $14.00
9261 6½″ × 16″ (16.5 × 40.5 cm) $5.00

Andrew Wyeth
Schooner Aground
Syracuse University
9736 17″ × 29″ (43 × 74 cm) $12.00
9272 8¼″ × 14″ (21 × 35.5 cm) $5.00

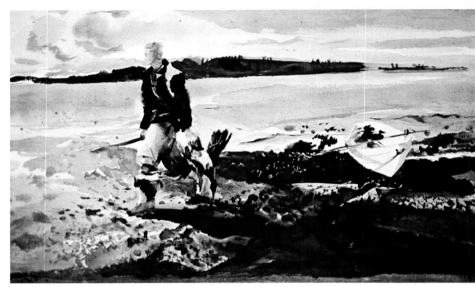

Andrew Wyeth
The Coot Hunter
9734 18″ × 29¾″ (46 × 75.5 cm) $12.00
9257 12″ × 20″ (30.5 × 51 cm) $6.00

Andrew Wyeth
Tolling Bell
Arizona State University, Arizona
9423 24″ × 17½″ (61 × 44.5 cm) $12.00
9264 14″ × 10″ (35.5 × 25 cm) $5.00

Andrew Wyeth
Chester County Farm
Illinois State Museum, Illinois
9732 21½″ × 29½″ (55 × 75 cm) $14.00
9273 10″ × 14″ (26 × 35.5 cm) $5.00

Andrew Wyeth
Mother Archie's Church
Addison Gallery of American Art, Massachusettes
9735 15½″ × 30″ (39 × 76 cm) $12.00

Andrew Wyeth
Split Ash Basket
9738 21½″ × 29½″ (55 × 75 cm) $14.00
9274 10″ × 14″ (25.5 × 35.5 cm) $5.00

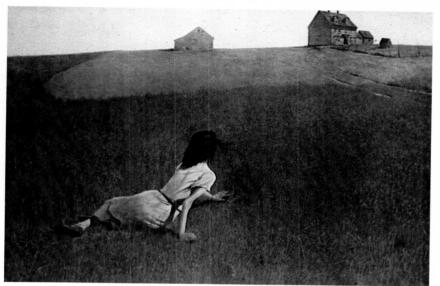

Andrew Wyeth
Christina's World, 1948
The Museum of Modern Art, New York
9733 17½″ × 26″ (44.5 × 66 cm) $7.50

Andrew Wyeth
The Olson Farm
Museum of Fine Arts, Houston
9740 21½″ × 29½″ (55 × 75 cm) $14.00
9263 10″ × 14″ (25 × 35.5 cm) $5.00

Andrew Wyeth
That Gentleman
Dallas Museum of Fine Arts, Texas
9739 14½″ × 30″ (37 × 76 cm) $14.00
9262 6¾″ × 14″ (17 × 35.5 cm) $5.00

Andrew Wyeth
Lobster Man
9259 16″ × 21½″ (40 × 55 cm) $10.00
9260 10½″ × 14″ (27 × 35.5 cm) $5.00

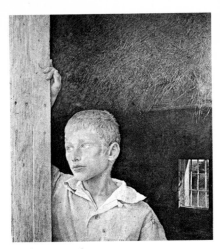

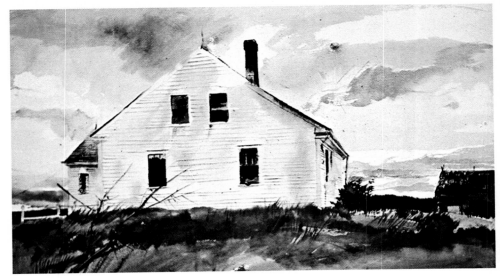

Andrew Wyeth
Albert's Son
National Gallery, Oslo
9422 24″ × 20″ (61 × 51 cm) $12.00
9255 14″ × 11½″ (35.5 × 29 cm) $5.00

Andrew Wyeth
Bradford House
9731 18″ × 30¾″ (46 × 78 cm) $12.00
9256 12″ × 20″ (30.5 × 51 cm) $6.00

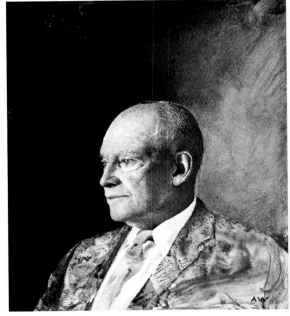

Andrew Wyeth
Young America
9265 13½″ × 19½″ (34 × 49.5 cm) $7.50

Andrew Wyeth
Portrait of Dwight D. Eisenhower
Los Angeles County Museum of Art
Gift of Dwight D. Eisenhower
4047 12″ × 10″ (30.5 × 25.5 cm) $4.00

NOTE: Many other Andrew Wyeth's available —
a list will be supplied upon request.

Norman Rockwell
Homecoming
9190 21¾″ × 17″ (55.5 × 43 cm) **$8.00**

Norman Rockwell
Marriage License
9191 18″ × 17″ (46 × 43 cm) **$8.00**

Norman Rockwell
No Swimming
9192 20″ × 17″ (51 × 43 cm) **$8.00**

Norman Rockwell
Shuffleton's Barber Shop
5238 21″ × 20″ (53.5 × 51 cm) **$10.00**

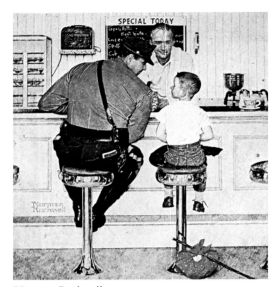

Norman Rockwell
The Runaway
5237 22″ × 20″ (56 × 51 cm) $10.00

Norman Rockwell
Only Skin Deep
9193 22¼″ × 17″ (56.5 × 43 cm) $8.00

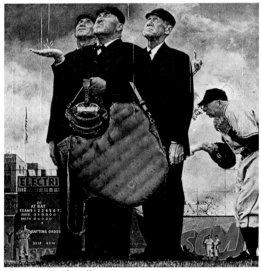

Norman Rockwell
The Umpires
5239 25¾″ × 20″ (65.5 × 51 cm) $10.00

Norman Rockwell
Tired but Happy
9197 21¼″ × 17″ (54 × 43 cm) $8.00

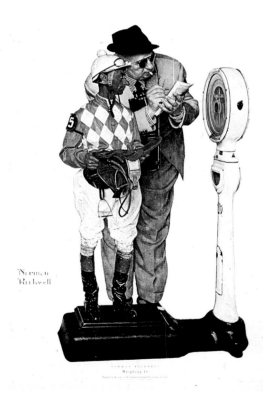

Norman Rockwell
Weighing In
5241 21½″ × 20″ (54.5 × 61 cm) $10.00

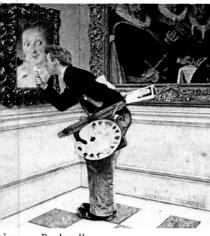

Norman Rockwell
The Art Critic
9187 18¼″ × 17″ (46.5 × 43 cm) $8.00

Norman Rockwell
Before and After
9188 18¼″ × 17″ (46.5 × 43 cm) $8.00

Norman Rockwell
Family Tree
9189 18½″ × 17″ (47 × 43 cm) $8.00

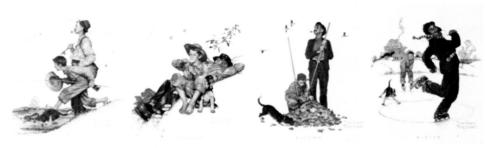

Norman Rockwell
The Four Seasons
9194 each 16″ × 12″ (41 × 30.5 cm) **$8.00** (set of four)

Norman Rockwell
Roadblock
236 21″ × 20″ (53.5 × 51 cm) $10.00

Norman Rockwell
The Truth About Santa
9199 18½″ × 17″ (47 × 43 cm) $8.00

Norman Rockwell
Walking to Church
5240 21″ × 20″ (53.5 × 51 cm) $10.00

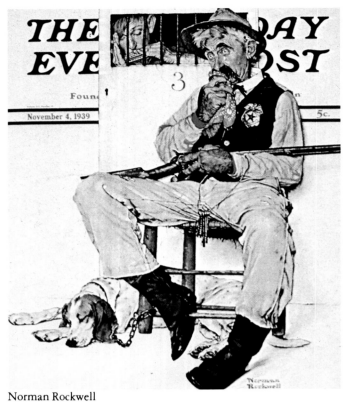

Norman Rockwell
Jailor
7072 24″ × 20″ (60 × 51 cm) $10.00

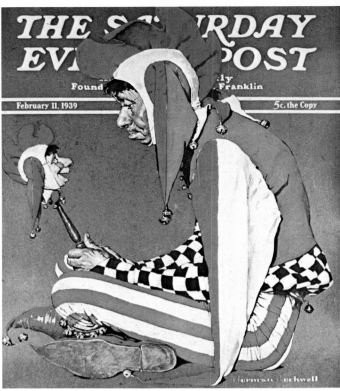

Norman Rockwell
Jester
7043 24″ × 20″ (60 × 51 cm) $10.00

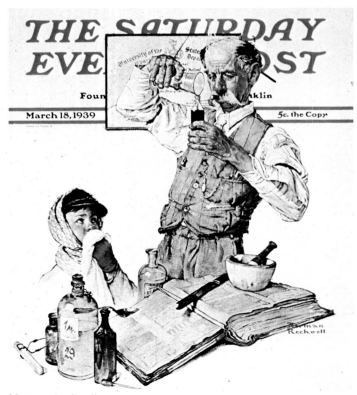

Norman Rockwell
Remedy
7044 24″ × 20″ (60 × 51 cm) $10.00

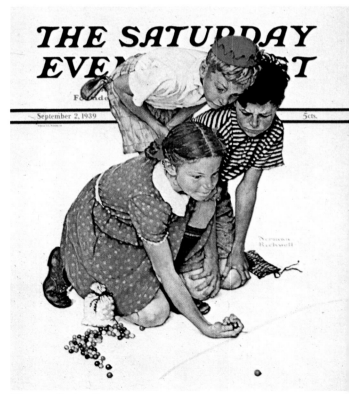

Norman Rockwell
Neighborhood Champ
7045 24″ × 20″ (60 × 51 cm) $10.00

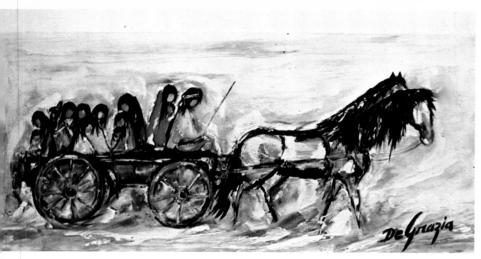

Ted De Grazia
Navajo Wagon
9589 15″ × 32″ (38 × 81 cm) $14.00

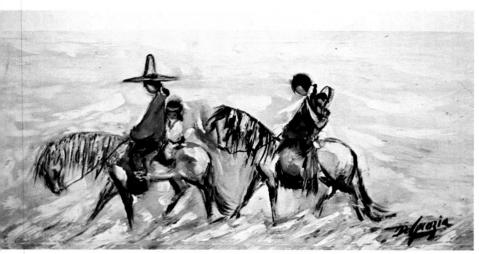

Ted De Grazia
Navajo Family
9587 15″ × 32″ (38 × 81 cm) $14.00

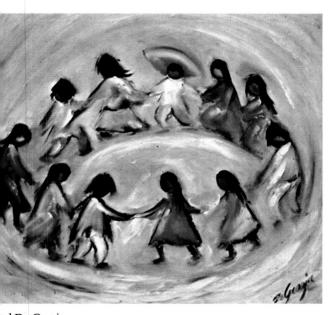

ed De Grazia
os Ninos
584 24″ × 26″ (61 × 66 cm) $14.00

Ted De Grazia
Navajo Bridegroom
9329 24″ × 9″
(61 × 23 cm) $7.50

Ted De Grazia
Navajo Bride
9328 24″ × 9″
(61 × 23 cm) $7.50

Ted De Grazia
Sunflower
9058 12″ × 9″
(30.5 × 23 cm)
$3.50

Ted De Grazia
Balloon
9059 12″ × 9″
(30.5 × 23 cm)
$3.50

Ted De Grazia
Boy with Rooster
9054 12″ × 9″
(30.5 × 23 cm)
$3.50

Ted De Grazia
Girl with Piggy Bank
9055 12″ × 9″
(30.5 × 23 cm)
$3.50

Ted De Grazia
Angel Music
9060 12″ × 9″
(30.5 × 23 cm)
$3.50

Ted De Grazia
Piccolo Pete
9061 12″ × 9″
(30.5 × 23 cm)
$3.50

Ted De Grazia
Flower Girl
9057 12″ × 9″
(30.5 × 23 cm)
$3.50

Ted De Grazia
Flower Boy
9056 12″ × 9″
(30.5 × 23 cm)
$3.50

Ted De Grazia
Mariachi in Blue
9326 24″ × 8″
(61 × 20.5 cm)
$6.00

Ted De Grazia
Mariachi in Red
9327 24″ × 8″
(61 × 20.5 cm) $6.00

Ted De Grazia
Navajo Mother
9588 24″ × 24″ (61 × 61 cm) $14.00

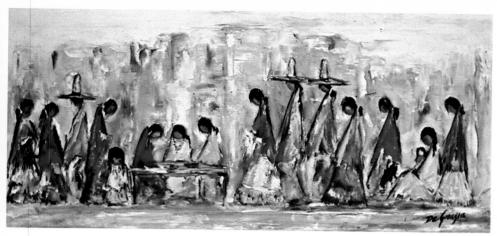

Ted De Grazia
Navajo Fair
9586 15″ × 32″ (38 × 81 cm) $14.00

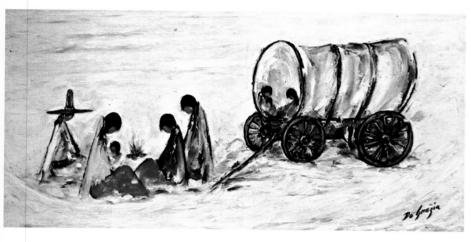

Ted De Grazia
Navajo Campfire
9585 23¾″ × 48″ (60 × 122 cm) $18.00

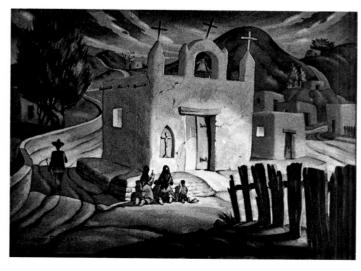

Hubert Rickert
Mexican Church
Private Collection
4122 12″ × 16⅜″ (30.5 × 41.5 cm) $5.00

Alice Asmar
Taos Corn Dancers
5161 15¼″ × 30½″ (39 × 77.5 cm) $14.00

Alice Asmar
Saguaro - Rendez-Vous
5168 24″ × 12″ (61 × 30.5 cm) $10.00

Alice Asmar
The Birthday Party
5184 15″ × 30″ (38 × 76 cm) $14.00

Alice Asmar
Quails and California Poppies
4195 16″ × 22″ (40.5 × 56 cm) $10.00

Alice Asmar
Joshua Tree
5167 24″ × 12″ (61 × 30.5 cm) $10.00

Alice Asmar
Tesuque Children Dancing
166 20″ × 24½″ (51 × 62 cm) $12.00
093 10¼″ × 12¼″ (26 × 31 cm) $3.50

Alice Asmar
Golden Prickly Pear and Magic
5170 20″ × 12¾″ (51 × 32.5 cm) $8.00

Alice Asmar
Rhode Island Red and Dutch Rabbit
169 24″ × 12″ (61 × 30.5 cm) $10.00

Alice Asmar
Only a Rose
5146 20″ × 19¾″ (51 × 50 cm) $12.00

Linda Avey
The Children
4130 14″ × 18″ (35.5 × 46 cm) $6.00

Linda Avey
The Wading Pool
4133 18″ × 14″ (46 × 35.5 cm) $6.00

Linda Avey
The Stream
4132 14″ × 18″ (35.5 × 46 cm) $6.00

Linda Avey
Fishing
4131 18″ × 14″ (46 × 35.5 cm) $6.00

Linda Avey
The Wagon
4134 14″ × 18″ (35.5 × 46 cm) $6.00

Charlotte Becker
Smiling Through
4183 18″ × 14″ (46 × 35.5 cm) $4.00

Charlotte Becker
I See You
4178 18″ × 14″ (46 × 35.5 cm) $4.00

Charlotte Becker
Little Miss Mischief
4179 18″ × 14″ (46 × 35.5 cm) $4.00

Charlotte Becker
In Slumberland
4177 14″ × 18″ (35.5 × 46 cm) $4.00

Charlotte Becker
Playmates
4182 14″ × 18″ (35.5 × 46 cm) $4.00

Charlotte Becker
Morning Sunshine
4180 14″ × 18″ (35.5 × 46 cm) $4.00

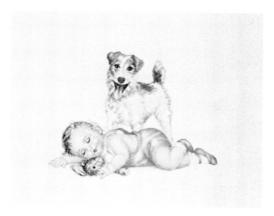

Charlotte Becker
On Guard
4181 14″ × 18″ (35.5 × 46 cm) $4.00

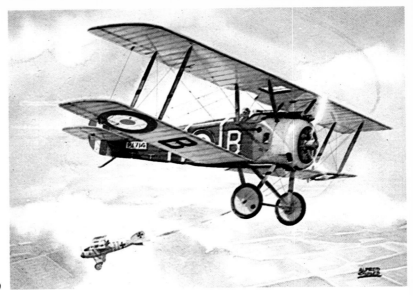

Alfred Owles
Sopwith Camel, 1917
4008 12″ × 16″ (30.5 × 40.5 cm) $5.00

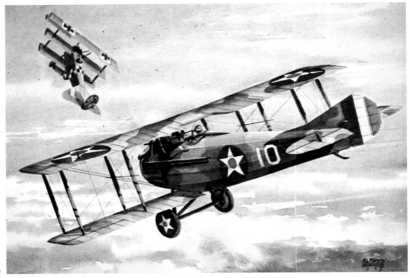

Alfred Owles
French Spad, 1916
4009 12″ × 16″ (30.5 × 40 cm) $5.00

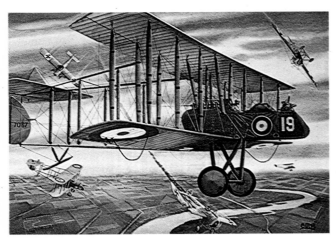

Alfred Owles
British F-E-2-Ds Give Boelcke a Bad Time
5008 18″ × 25″ (46 × 63.5 cm) $10.00

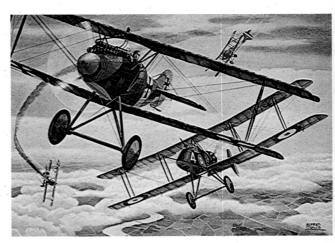

Alfred Owles
Last of the Vickers F-E-8 Gun Bus
1915-1917 Meet Up with German
Roland-1917
5005 18″ × 25¼″ (46 × 64 cm) $10.00

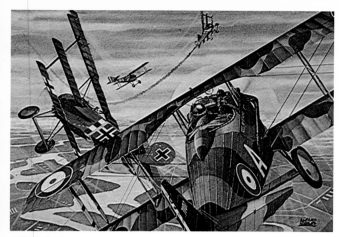

Alfred Owles
Spads Flight "A" Tackles Some
German DR-1
5001 18″ × 25″ (46 × 63.5 cm) $10.00

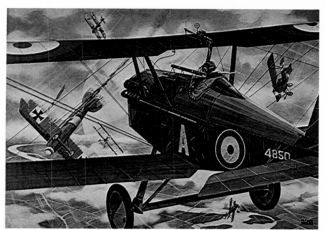

Alfred Owles
Captain Albert Ball R.A.F. and Comrades
Mix-It Up with the Luftwaffe
5006 18″ × 24½″ (46 × 62 cm) $10.00

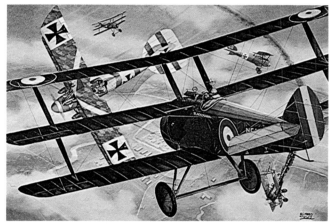

Alfred Owles
Raymond Collishaws Sopwith Triplane
Black Maria Adds Up Quite a Score
for Canada
5003 18″ × 25″ (46 × 63.5 cm) $10.00

Alfred Owles
German Albatross-Photographic Recon.
Bomber Caught in the Act
5004 18″ × 25″ (46 × 63.5 cm) $10.00

Alfred Owles
British R-E-8 and Vickers Gun
Busses Give the Luftwaffe a
Bad Time
5007 18″ × 24½″ (46 × 62 cm) $10.00

4000 4001 4002

4003 4004

4005 4006 4007

Albert Anker (1831-1910)
The Sunday School Walk
9000 12″ × 20″ (30.5 × 51 cm) $12.00

Betty N. Curry
Children's Prints:
4006 Duck
4005 Frog
4001 Duck
4000 Duck with Bow
4002 Owl
4004 Frog with Tooth
4007 Bear
4003 Racoon
Each: 14″ × 11″ (35.5 × 28 cm) $3.50

Paul Peel
After the Bath
5103 20½″ × 15″ (52 × 38 cm) $9.00

Bob Totten
Little Miss Muffin
5021 24″ × 18″ (61 × 46 cm) $10.00

Susan Newcomb
If I Had A Penny
5011 24″ × 20″ (61 × 51 cm) $10.00

Willard Fowler
Affection
4188 12″ × 10″ (30.5 × 25.5 cm) $4.00

Willard Fowler
Adoring Cupids
4187 12″ × 10″ (30.5 × 25.5 cm) $4.00

V. Toiettj
The Favorite
4223 5¾″ × 21″ (15 × 53.5 cm) $7.50

Rick Bennett
Kitty
2017 10″ × 8″ (25.5 × 20 cm) $2.50

Pia Roshardt
Mice and Frogs
9675 11″ × 40″ (28 × 100 cm) $6.00

Pia Roshardt
Butterflies and Bees
9674 11″ × 40″ (28 × 100 cm) $6.00

Rick Bennett
Kitten
2016 10″ × 8″ (25.5 × 20 cm) $2.50

Pia Roshardt
Birds and Bugs
9673 11″ × 40″ (28 × 100 cm) $6.00

James Ingwerson
Gary
9108 20″ × 16″ (51 × 40.5 cm) $3.00
9107 14″ × 11″ (36 × 28 cm) $1.50

James Ingwerson
Gretchen
9110 20″ × 16″ (51 × 40.5 cm) $3.00
9109 14″ × 11″ (36 × 28 cm) $1.50

Susan Anderson
The Frog Prince
(Grimm's Fairy Tales)
4274 22½″ × 16″ (57 × 40.5 cm) $6.00

Susan Anderson
Little Brother and Sister
(Grimm's Fairy Tales)
4277 20½″ × 16″ (52 × 40.5 cm) $6.00

Susan Anderson
Thumbelina and the Butterfly
(Hans Christian Anderson)
4276 22½″ × 16″ (57 × 40.5 cm) $6.00

Leslie Emery
This is My Love
9335 19″ × 24″ (48 × 61 cm) $7.50

Susan Anderson
Bunnies and Fairies
4275 20″ × 12¼″ (51 × 31 cm) $6.00

2023
A Bold Bluff

2024
Poker Sympathy

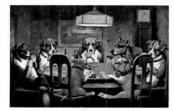

2025
A Friend in Need

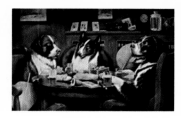

2026
Post Mortem

2027
His Station and Four Aces

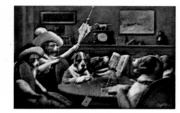

2028
Sitting Up with a Sick Friend

2029
Pinched with Four Aces

2030
Waterloo

C. M. Coolidge, **Poker Dogs,** Each 9½″ × 14″ (24 × 35.5 cm) $2.50

Mr. Stops
A Colon
Victoria and Albert Museum, London
2092 16″ × 10½″ (40 × 27 cm) $4.00
1030 8″ × 5½″ (20 × 13½ cm) $1.50

Mr. Stops, 1824
**Punctuation Personified —
Robert's Interview**
Victoria and Albert Museum, London
2091 16″ × 10½″ (41 × 26 cm) $4.00
1031 8″ × 5½″ (20 × 13 cm) $1.50

Songs
Divine and Moral
Victoria and Albert Museum, London
Colored by John Constable as a birthday present
for his daughter Emily
2090 16″ × 10½″ (41 × 26 cm) $4.00
1026 8″ × 5″ (20 × 13 cm) $1.50

Sydney Beh
Old Man of Capri
9002 17″ × 10″ (43 × 25.5 cm) $3.00
9002A 12″ × 7″ (30.5 × 18 cm) $2.00

Sydney Beh
Old Woman of Capri
9003 17″ × 10″ (43 × 25.5 cm) $3.00
9003A 12″ × 7″ (30.5 × 18 cm) $2.00

Paul Detlefson
Dream Country
9591 24″ × 36″ (61 × 91.5 cm) $12.00
9332 18″ × 24″ (46 × 61 cm) $10.00

Paul Detlefson
The Good Old Summertime
9592 24″ × 36″ (61 × 91.5 cm) $12.00

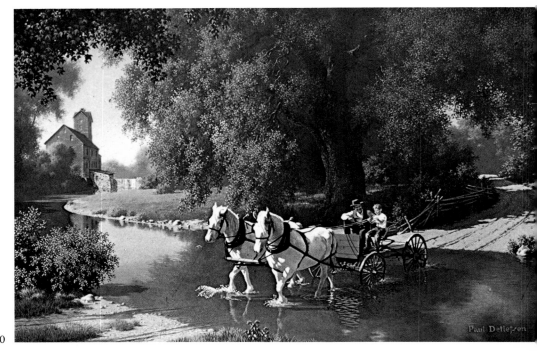

Paul Detlefson
The Big Moment
9590 24″ × 36″ (61 × 91.5 cm) $12.00

Paul Detlefson
Good Old Days
9333 19″ × 25″ (48 × 63.5 cm) $10.00

Paul Detlefson
Snow Capped Peaks
9594 24″ × 36″ (61 × 91.5 cm) $12.00

Paul Detlefson
Reflected Beauty
9593 24″ × 36″ (61 × 91.5 cm) $12.00

Alfred Owles
Pioneers
9650 24″ × 36″ (61 × 91.5 cm) $10.00

Alfred Owles
Down on the Farm
9649 20″ × 28″ (51 × 71 cm) $10.00

Alfred Owles
The Red Barn
9651 20″ × 28″ (51 × 71 cm) $10.00

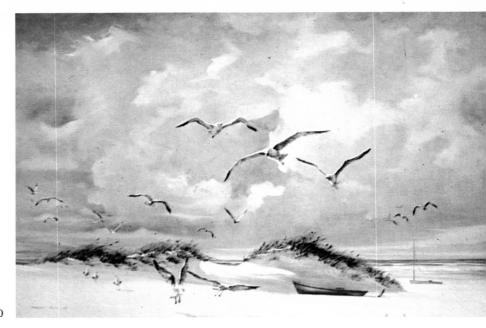

Carolyn Blish
Flying In
9557 24″ × 36″ (61 × 91.5 cm) $16.00

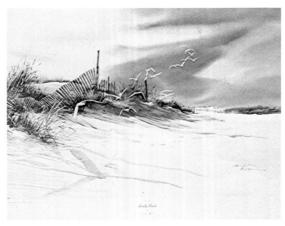

Carolyn Blish
Lonely Beach
9562 18″ × 26″ (46 × 66 cm) $12.00

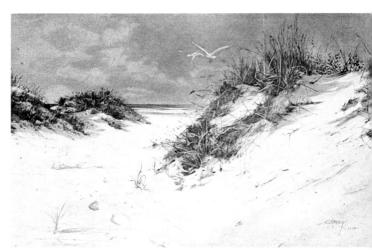

Carolyn Blish
The Sea Beyond
9567 24″ × 36″ (61 × 91 cm) $16.00

Carolyn Blish
Hillside Farm
9602 24″ × 36″ (61 × 91.5 cm) $12.00
9011 10½″ × 14″ (27 × 35.5 cm) $3.50

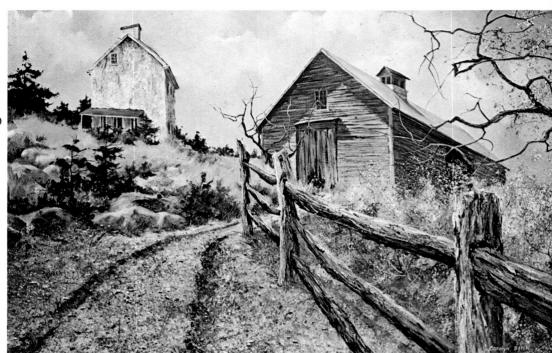

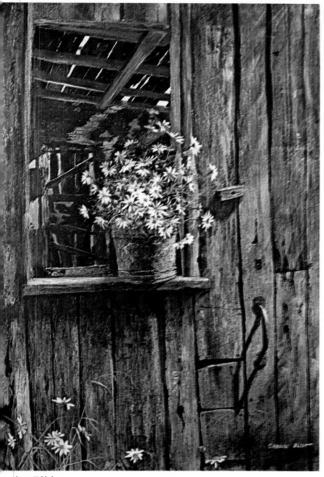

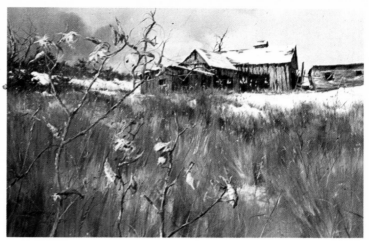

Carolyn Blish
Old Vermont
9563 24″ × 36″ (61 × 91 cm) $16.00

Carolyn Blish
il of Daisies
64 24″ × 36″ (61 × 91.5 cm) $12.00
14 10½″ × 14″ (27 × 35.5 cm) $3.50

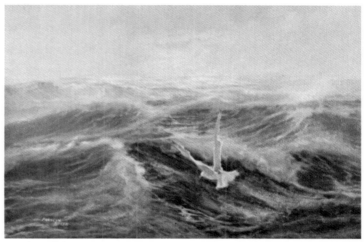

Carolyn Blish
Lone Flight
9560 22″ × 32″ (56 × 81 cm) $14.00

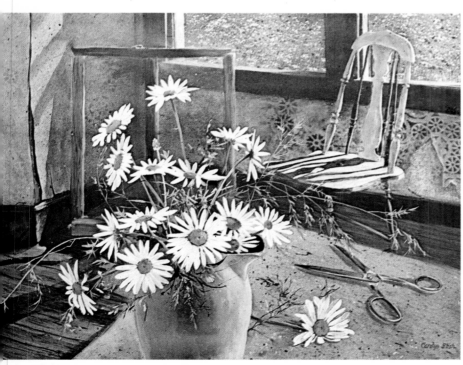

Carolyn Blish
At the Beach
9010 12″ × 18″ (30 × 45.5 cm) $6.00

Carolyn Blish
st Cut
59 24″ × 32″ (61 × 81 cm) $12.00
12 10½″ × 14″ (27 × 35.5 cm) $3.50

Carolyn Blish
Sea Shells
9015 12″ × 18″ (30 × 45 cm) $6.00

Carolyn Blish
A Sea of Daisies
9016 14″ × 20½″ (35 × 52 cm) $7.50

Carolyn Blish
April Daffodils (top left)
9004 12″ × 10″ (31 × 26 cm) $3.50

Carolyn Blish
January Snow (top right)
9005 12″ × 10″ (31 × 26 cm) $3.50

Carolyn Blish
July Daisies (centre left)
9006 12″ × 10″ (31 × 26 cm) $3.50

Carolyn Blish
October Leaves (centre right)
9007 12″ × 10″ (31 × 26 cm) $3.50

Carolyn Blish
Early Summer (bottom left)
9008 9″ × 12″ (23 × 31 cm) $3.50

Carolyn Blish
At the Pump (bottom right)
9009 9″ × 12″ (23 × 31 cm) $3.50

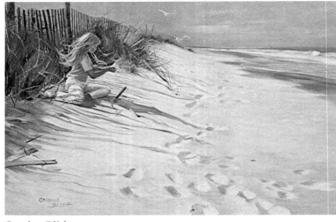

Carolyn Blish
Beach Child
9556 20″ × 30″ (51 × 76 cm) $12.00

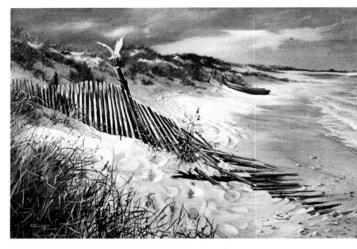

Carolyn Blish
Lone Gull
9561 24″ × 36″ (61 × 91 cm) $16.00

Carolyn Blish
The Lantern
9311 18″ × 24″ (46 × 61 cm) $12.00

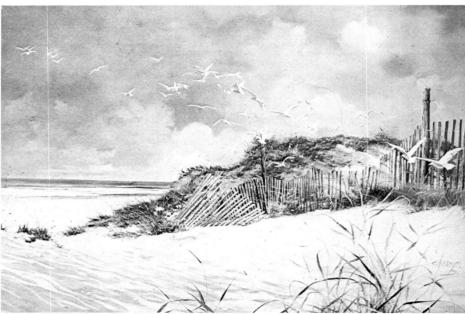

Carolyn Blish
Rendezvous
9566 24″ × 36″ (61 × 91 cm) $16.00

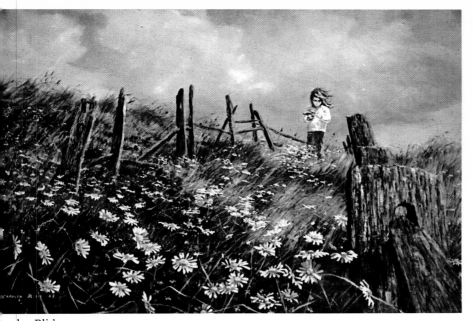

Carolyn Blish
Just Picked
9013 14″ × 20½″ (35 × 52 cm) $7.50

Carolyn Blish
...cking Daisies
...65 24″ × 36″ (61 × 91.5 cm) $16.00

Carolyn Blish
The Kerosene Lamp
9310 18″ × 24″ (46 × 61 cm) $12.00

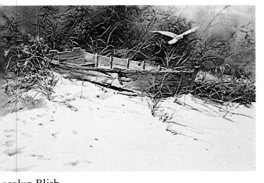

Carolyn Blish
...st Harbor
...12 16″ × 24″ (40.5 × 61 cm) $15.00

Carolyn Blish
Sunlight
9313 18″ × 24″ (46 × 61 cm) $12.00

Carolyn Blish
...he Helmet Crab
...58 20″ × 30″ (51 × 76 cm) $12.00

Carolyn Blish
Tulips and Daisies
9314 18″ × 24″ (46 × 61 cm) $12.00

83

Nappi
Basket of Black-Eyed Susans
9138 16″ × 20″ (41 × 51 cm) $4.00
9139 12″ × 16″ (30.5 × 40.5 cm) $2.50

Nappi
Water Pump
9380 18″ × 24″ (45.5 × 61 cm) $6.00
9145 12″ × 16″ (30.5 × 40.5 cm) $2.50

Nappi
Hay Wagon
9382 18″ × 24″ (45.5 × 61 cm) $6.00
9142 12″ × 16″ (30.5 × 40.5 cm) $2.50

Nappi
Bucket of Strawberries
9140 16″ × 20″ (41 × 51 cm) $4.00
9141 12″ × 16″ (30.5 × 40.5 cm) $2.50

Nappi
Milk Cans
9381 18″ × 24″ (45.5 × 61 cm) $6.00
9144 12″ × 16″ (30.5 × 40.5 cm) $2.50

Nappi
Hill Top Barn
9383 18″ × 24″ (45.5 × 61 cm) $6.00
9143 12″ × 16″ (30.5 × 40.5 cm) $2.50

Duane Armstrong
Picnic
9303 20″ × 20″ (51 × 51 cm) $4.00

Duane Armstrong
Springtime
9305 20″ × 20″ (51 × 51 cm) $4.00

Richard Heichberger N.W.S.
Last Night
196 13″ × 20″ (33 × 51 cm) **$8.00**

Richard Heichberger N.W.S.
The Old Rusty Bucket
215 18″ × 24″ (46 × 61 cm) **$10.00**

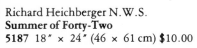

Richard Heichberger N.W.S.
The Wagon
5174 18″ × 24″ (46 × 61 cm) **$8.00**

Richard Heichberger N.W.S.
Summer of Forty-Two
5187 18″ × 24″ (46 × 61 cm) **$10.00**

85

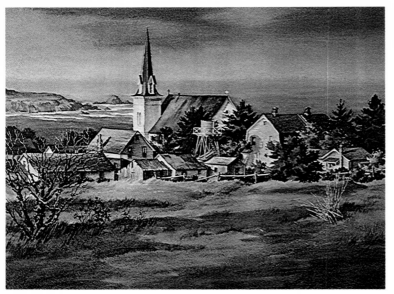

Dan Toigo
Mendocino
5013 20″ × 25¾″ (51 × 65.5 cm) $10.00

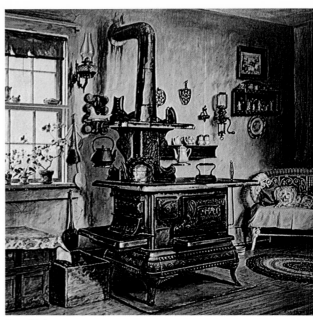

Dan Toigo
The Stove
5023 22″ × 22″ (56 × 56 cm) $10.00

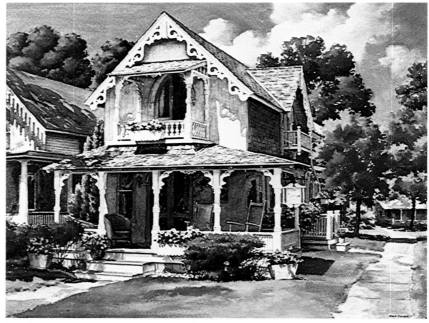

Dan Toigo
Cape Cod Cottage
5147 18″ × 24″ (46 × 61 cm) $10.00

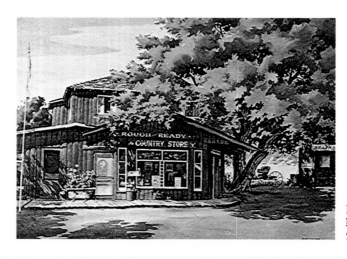

Dan Toigo
Rough and Ready
5015 18″ × 25″ (46 × 63.5 cm) $10.00

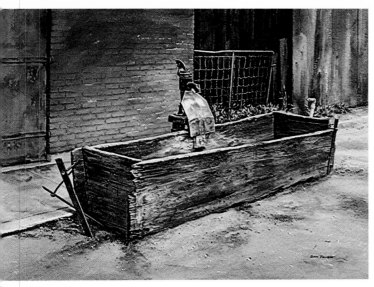

Dan Toigo
The Water Trough
5208 18½″ × 24″ (47 × 61 cm) $10.00

Dan Toigo
The Farm
5020 18″ × 25½″ (46 × 64 cm) $10.00
4192 12″ × 16¾″ (30.5 × 42.5 cm) $4.00

Dan Toigo
Fourges, France
5019 18″ × 25″ (46 × 63.5 cm) $12.00

Jon S. Legere
Mid August
7069 17¼″ × 29¼″ (44 × 74 cm) $12.00

Jon S. Legere (American, 1944-)
Late in the Day
5089 24″ × 20″ (61 × 51 cm) $12.00

R. Bradford Johnson
For Sale, 200 Acres
7026 15″ × 30″ (38 × 76 cm) $10.00

R. Bradford Johnson
Washday in the Valley
7027 15″ × 30″ (38 × 76 cm) $10.00

R. Bradford Johnson
Over Lookin' the Valley
2054 8″ × 10″ (20 × 26 cm) $2.50

R. Bradford Johnson
Spring in the Valley
2055 8″ × 10″ (20 × 26 cm) $2.50

R. Bradford Johnson
Dusk in the High Country
101 14″ × 18″ (36 × 46 cm) $6.00

Bradford Johnson
High and Dry
2083 6⅛″ × 10¼″ (15.5 × 26 cm) $2.50

R. Bradford Johnson
Dusk and Fond Memories
100 14″ × 18″ (36 × 46 cm) $6.00

Bradford Johnson
Moved to the City
2084 6¼″ × 10¼″ (16 × 26 cm) $2.50

Bradford Johnson
A Mythical Land called Oregon
2000 8″ × 14″ (20 × 35.5 cm) $4.00

Jerome Grimmer
Interstate Bypass
7059 20″ × 30″ (51 × 76 cm) $12.00

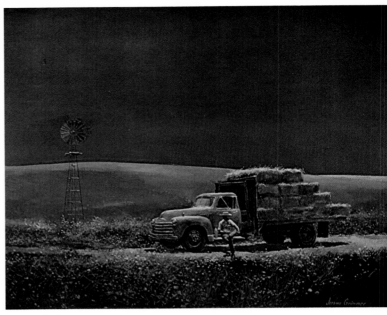

Jerome Grimmer
Daydreams
5134 19½″ × 24″ (49.5 × 61 cm) $10.00

Jerome Grimmer
Late Afternoon
7090 22″ × 28″ (56 × 71 cm) $12.00

Jerome Grimmer
Summer Rain
5189 20″ × 30″ (51 × 75 cm) $12.00

Jose' Olivet Legares
In the Foothills
7084 25″ × 35½″ (63.5 × 90 cm) $18.00

David Shepherd
Winter Plough
9700 20″ × 30″ (51 × 76 cm) $18.00

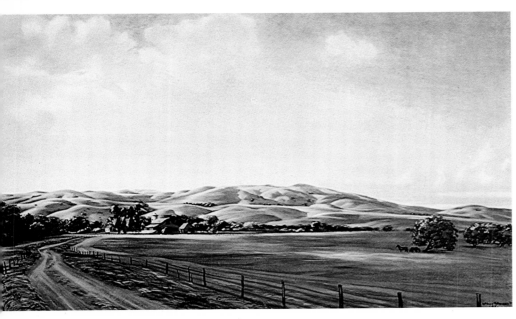

Arthur Stewart
The Big Sky
7119 24″ × 40″ (41 × 102 cm) $18.00

D. Michael McCarthy
"Mount Cowen"
(Absaroko Mountains, Montana)
7100 24" × 30" (61 × 76 cm) $12.00

Tony Cardella
Mountain Village
7010 26" × 21" (66 × 53 cm) $12.00

Tony Cardella
Hillside Homes
7009 26" × 21" (66 × 53 cm) $12.00

Vernon Kerr
The Orchard
7133 24″ × 30″ (61 × 76 cm) $12.00

Vernon Kerr
Ripples of Time
7134 30″ × 24″ (76 × 61 cm) $12.00

Vernon Kerr
Snow Bright
5014 18″ × 24″ (46 × 61 cm) $10.00

Vernon Kerr
Summer Mists
5160 24″ × 18″ (61 × 46 cm) $10.00

Vernon Kerr
Where Light Begins
5012 18″ × 24″ (46 × 61 cm) $10.00

Vernon Kerr
Happy Colors
7007 30″ × 24″ (76 × 61 cm) $12.00

Vernon Kerr
Apple Spring
7083 30″ × 24″ (76 × 61 cm) $12.00

Vernon Kerr
Autumn Pond
5155 18″ × 24″ (46 × 61 cm) $8.00

Vernon Kerr
Summer Days
5153 16″ × 20″ (40.5 × 51 cm) $7.50

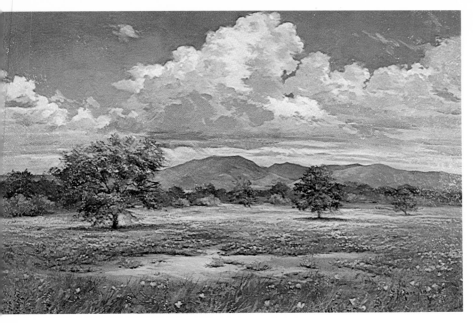

Vernon Kerr
California Splendor
7085 24″ × 36″ (61 × 91.5 cm) $12.00

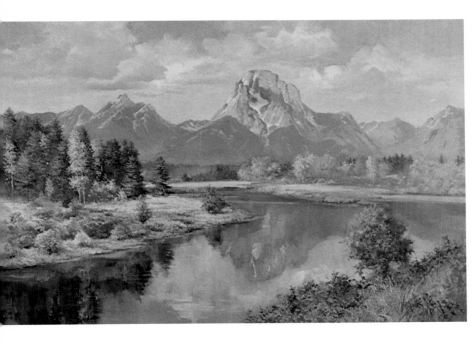

Vernon Kerr
Grand Tetons
7139 24″ × 36″ (61 × 91.5 cm) $12.00

Vernon Kerr
Fresh Snow
7082 24″ × 36″ (61 × 91.5 cm) $12.00

Vernon Kerr
The Last Song of Summer
7138 24″ × 36″ (61 × 91.5 cm) $12.00

Vernon Kerr
Autumn Reflections
7135 24″ × 36″ (61 × 91.5 cm) $12.00
4247 12″ × 18″ (30.5 × 46 cm) $4.00

Franc
Two Trees
7018 20″ × 30″ (51 × 76 cm) $12.00
4073 12″ × 18″ (30.5 × 46 cm) $4.00

Franc
The Orchard
7017 20″ × 30″ (51 × 76 cm) $12.00
4072 12″ × 18″ (30.5 × 46 cm) $4.00

John Markwood
Autumn Countryside
173 20″ × 24″ (51 × 61 cm) $10.00

John Markwood
Peaceful Place
117 24″ × 18″ (61 × 46 cm) $10.00

John Markwood
American Beauties
148 24″ × 18″ (61 × 46 cm) $6.00

John Markwood
Apple Blossoms and Dandelions
7031 18″ × 36″ (46 × 92 cm) $12.00
4104 12″ × 24″ (30.5 × 61 cm) $5.00

John Markwood
That Bucket
7003 24″ × 30″ (61 × 76 cm) $12.00

John Markwood
The Hidden Path
7032 24″ × 36″ (61 × 91 cm) $10.00

Claude Lorenz
Sylvan Solitude
9637 30″ × 24″ (76 × 61 cm) $6.00

Claude Lorenz
Sylvan Glade
9636 30″ × 24″ (76 × 61 cm) $6.00

Claude Lorenz
Cottage in the Woods
9635 24″ × 36″ (61 × 91.5 cm) $7.50

Claude Lorenz
By a Waterfall
9634 24″ × 36″ (61 × 91.5 cm) $7.50

Mark Wheeler
Country Station
4032 12½″ × 21½″ (32 × 52.5 cm) $6.00
1043 6″ × 10″ (15 × 25 cm) $1.50

Mark Wheeler
Country Scene
4031 12½″ × 21½″ (32 × 52.5 cm) $6.00
1042 6″ × 10″ (15 × 25 cm) $1.50

Davis Schwartz
Cypress Point
9218 16″ × 20″ (40.5 × 51 cm) $3.50

Bernard Wynne
Field of Lupine
7057 22″ × 28″ (56 × 71 cm) $12.00
4049 12″ × 16″ (30.5 × 40.5 cm) $3.00

Bernard Wynne
Santa Margarita Creek
7042 24″ × 30″ (61 × 76 cm) $15.00
4011 12″ × 16″ (30.5 × 40.5 cm) $3.00

Robert Wood
Path of Gold
9726 25″ × 30″ (63.6 × 76 cm) $10.00
9251 12″ × 16″ (30.5 × 40.5 cm) $2.50

Robert Wood
In the Tetons
9721 25″ × 30″ (63.5 × 76 cm) $10.00
9248 12″ × 16″ (30.5 × 40.5 cm) $2.50

Robert Wood
Fields of Blue
9247 12″ × 16″ (30.5 × 40.5 cm) $2.50

Robert Wood
Autumn Mood
9243 16″ × 20″ (40.5 × 51 cm) $3.50

Robert Wood
The Brook
9244 16″ × 20″ (40.5 × 51 cm) $3.50

Robert Wood
Winter's Arrival
9729 25″ × 30″ (63.5 × 76 cm) $10.00
9254 12″ × 16″ (30.5 × 40.5 cm) $2.50

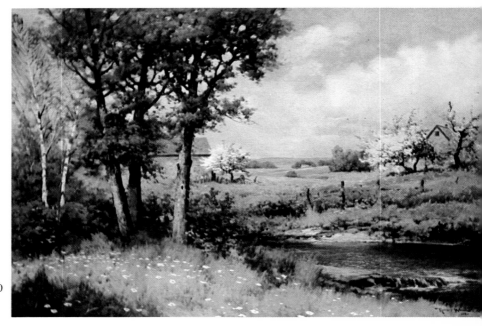

Robert Wood
Spring Time
9728 24″ × 36″ (61 × 91.5 cm) $12.00
9252 16″ × 22″ (40.5 × 56 cm) $3.50
9253 12″ × 16″ (30.5 × 40.5 cm) $2.50

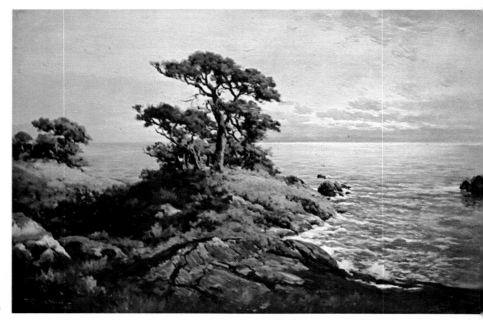

Robert Wood
Pacific Coast
9249 16″ × 20″ (40.5 × 51 cm) $3.50
9250 12″ × 16″ (30.5 × 40.5 cm) $2.50

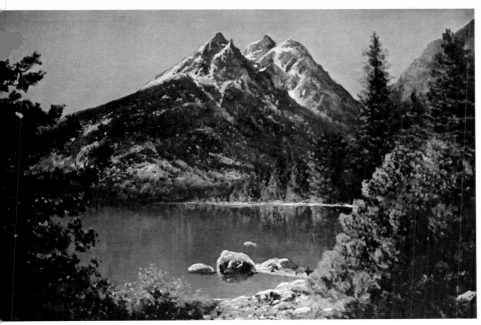

Robert Wood
Mountain Lake
9723 24″ × 36″ (61 × 91.5 cm) $12.00

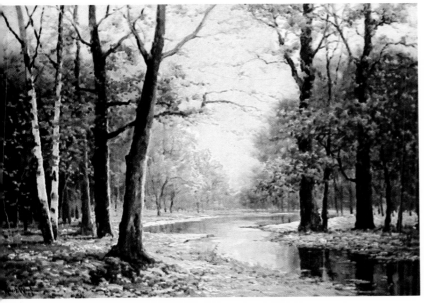

Robert Wood
Autumn Glade
9717 24″ × 36″ (61 × 91.5 cm) $12.00
9241 16″ × 22″ (40.5 × 56 cm) $3.50
9242 12″ × 16″ (30.5 × 40.5 cm) $2.50

Robert Wood
Montana Mountains
9722 24″ × 36″ (61 × 91.5 cm) $12.00

Robert Wood
Early Fall
9719 24″ × 36″ (61 × 91.5 cm) $12.00

Robert Wood
Evening in the Tetons
9720 24″ × 36″ (61 × 91.5 cm) $12.00
9246 12″ × 16″ (30.5 × 40.5 cm) $2.50

Robert Wood
Desert in Spring
9718 24″ × 36″ (61 × 91.5 cm) $12.00
9245 16″ × 22″ (40.5 × 56 cm) $3.50

Vernon Kerr
Desert Beauty
4167 16″ × 20″ (40.5 × 51 cm) $7.50

Bernard Wynne
Copper Mountains
074 20″ × 30″ (51 × 76 cm) $12.00
048 12″ × 18″ (30.5 × 46 cm) $3.00

Vernon Kerr
Desert Spring
7137 24″ × 36″ (61 × 91.5 cm) $12.00

Vernon Kerr
Desert Magic
2085 12″ × 16″ (30.5 × 40.5 cm) $4.00

Vernon Kerr
Smoke Tree
7136 24″ × 36″ (61 × 91.5 cm) $12.00

Loren D. Adams, Jr.
Afternoon Island Surf
7146 20″ × 30″ (51 × 76 cm) $12.00

Loren D. Adams, Jr.
Aureola
7145 20″ × 30″ (51 × 76 cm) $12.00

Loren D. Adams, Jr.
Transfiguration
7144 20″ × 30″ (51 × 76 cm) $12.00

Loren D. Adams, Jr.
Islands at Eventide
7005 24″ × 36″ (61 × 91.5 cm) $12.00
4020 12″ × 18″ (30.5 × 46 cm) $5.00
1006 6½″ × 10″ (16 × 25.5 cm) $1.50

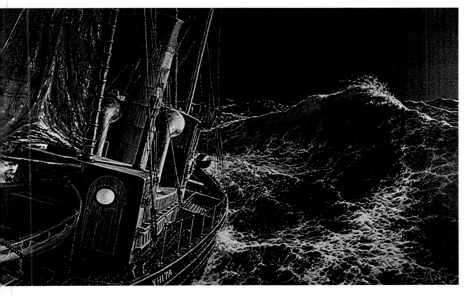

Loren D. Adams, Jr.
The End of the Storm
7006 22½″ × 36″ (57 × 91.5 cm) $16.00
4170 12″ × 19¼″ (30.5 × 49 cm) $5.00
1005 6¼″ × 10″ (16 × 25.5 cm) $1.50

Loren D. Adams, Jr.
A New Dawn
5227 24″ × 18″ (61 × 46 cm) $10.00

107

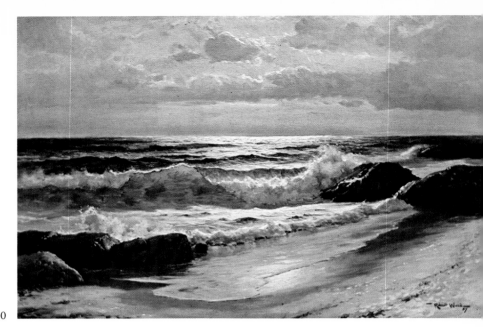

Robert Wood
Sea and Sand
9727 24″ × 36″ (61 × 91.5 cm) $12.00

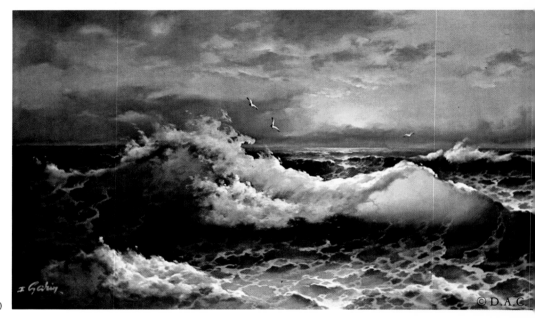

Eugene Garin
Cresting Waves
7049 24″ × 48″ (61 × 122.cm) $15.00

© D.A.C

Eugene Garin
Calm Weather Ahead
7022 20″ × 30″ (51 × 76 cm) $10.00
4124 12″ × 18″ (30.5 × 46 cm) $4.00

Eugene Garin
Restless Sea
9608 26″ × 40″ (66 × 102 cm) $16.00

Eugene Garin
Stormy Cove
9609 36″ × 26″ (91.5 × 66 cm) $16.00

Eugene Garin
Fury
9607 24″ × 36″ (61 × 91.5 cm) $16.00

109

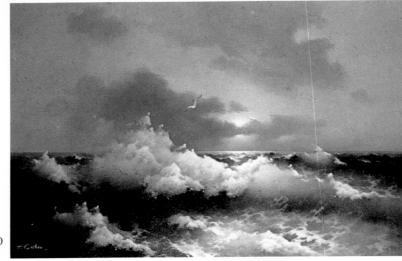

Eugene Garin
Days End
7068 24″ × 36″ (61 × 91.5 cm) $12.00
4125 12″ × 18″ (30.5 × 46 cm) $4.00

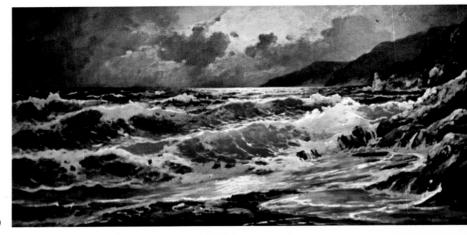

Alex Dzigurski
After the Storm
9600 24″ × 48″ (61 × 122 cm) $18.00

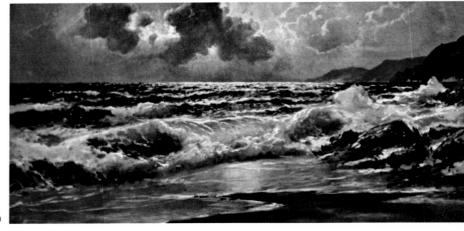

Alex Dzigurski
Rock Bound Coast
9601 24″ × 48″ (61 × 122 cm) $18.00

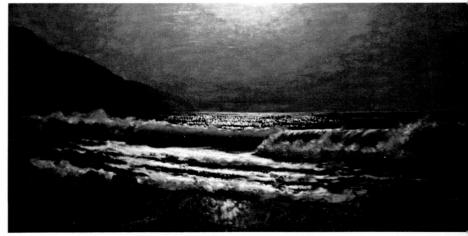

Henry Vander Velde
Island Surf
7052 18″ × 36″ (46 × 91 cm) $12.00
4026 12″ × 18″ (30.5 × 46 cm) $2.50

Vernon Kerr
Agate Cove
2006 9″ × 12″ (23 × 30.5 cm) $2.00

Vernon Kerr
Sculptured Jade
2007 9″ × 12″ (23 × 30.5 cm) $2.00

Vernon Kerr
Reflections
2005 9″ × 12″ (23 × 30.5 cm) $2.00

Vernon Kerr
Mendocino Waters
2004 9″ × 12″ (23 × 30.5 cm) $2.00

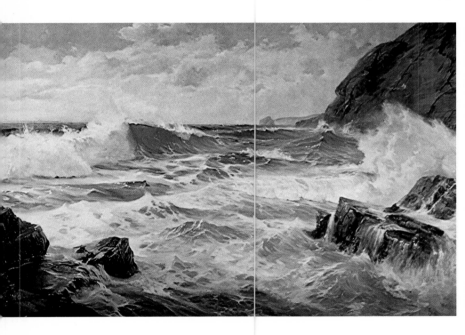

Vernon Kerr
Exhilaration
7002 24″ × 36″ (61 × 91.5 cm) $12.00

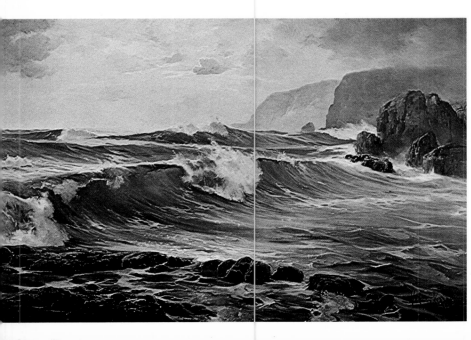

Vernon Kerr
Turning Point
7001 24″ × 36″ (61 × 91.5 cm) $12.00

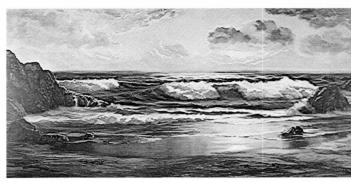

B. Carrick
Afternoon Tide
5228 12″ × 24″ (30.5 × 61 cm) $5.00

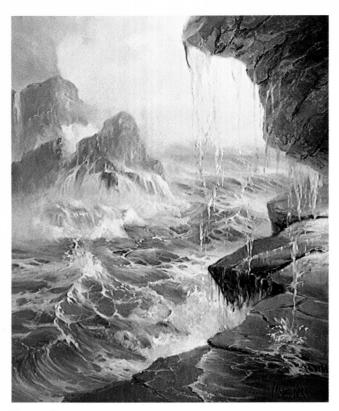

Vernon Kerr
Dance of the Seven Veils
7004 30″ × 24″ (76 × 61 cm) $12.00

Vernon Kerr
Light Fantastic
5171 12″ × 24″ (30.5 × 61 cm) $5.00

Vernon Kerr
Outreach
5172 12″ × 24″ (30.5 × 61 cm) $5.00

Vernon Kerr
Reflections
5157 18″ × 24″ (46 × 61 cm) $8.00
2005 9″ × 12″ (23 × 30.5 cm) $2.00

Vernon Kerr
Glowing Surf
9703 24″ × 48″ (61 × 122 cm) $15.00

B. Carrick
Afternoon Tide
7070 24″ × 48″ (61 × 122 cm) $18.00
7125 18″ × 36″ (46 × 91.5 cm) $12.00
5228 12″ × 24″ (30.5 × 61 cm) $5.00

ernon Kerr
oonlight Serenade
12 16″ × 20″ (40.5 × 51 cm) $7.50

Vernon Kerr
Sculptured Jade
5156 18″ × 24″ (46 × 61 cm) $8.00
2007 9″ × 12″ (23 × 30.5 cm) $2.00

Oswald W. Brierly
The ''America''
7122 image 14¼″ × 23″ (36 × 60 cm) $18.00
plate 18¾″ × 27″ (47 × 68.5 cm)

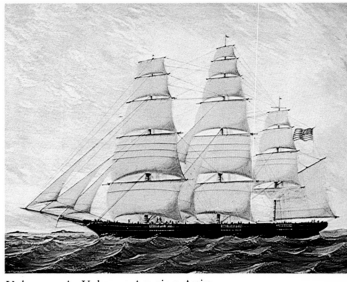

Unknown - An Unknown American Artist
The Ocean Herald, American Clipper
in the Mediterranean
5124 19¼″ × 24″ (49 × 61 cm) $12.00
1087 8″ × 10″ (20 × 25.5 cm) $1.50

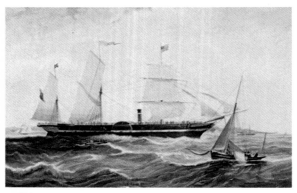

William A. Knell
Steamship President
7129 image 15½″ × 23¾″ (39.5 × 60.5 cm) $15.00
plate 19½″ × 26¼″ (49.5 × 67 cm)

G. S. Tregear
The British Queen
7126 image 16¼″ × 21¾″ (41 × 55 cm) **$15.00**
plate 19¾″ × 24½″ (50 × 62 cm)

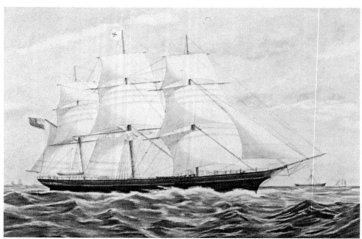

T. G. Dutton
The Clipper Ship ''Mirage''
7127 image 12″ × 18″ (30.5 × 45.5 cm) $12.00
plate 16″ × 20½″ (40.5 × 52 cm)

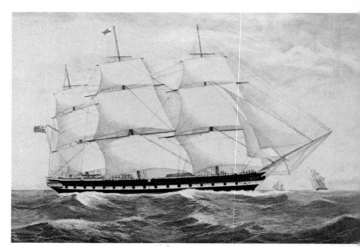

T. G. Dutton
Clipper Ship ''Shannon''
7128 image 12″ × 18″ (30.5 × 45.5 cm) $12.00
plate 16″ × 20½″ (40.5 × 52 cm)

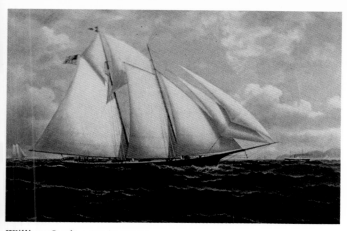

William Coulter (1849-1936)
The Casco, 1879
Coll. Oakland Museum, Gift of the
Women's Board of the Oakland Museum Association
5125 18″ × 27″ (46 × 69 cm) $15.00
4146 12″ × 18″ (30.5 × 46 cm) $6.00
1011 6⅝″ × 10″ (17 × 25.5 cm) $1.50

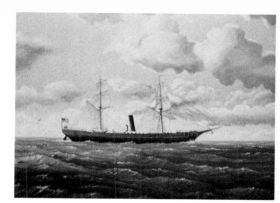

Raymond Bayless
Atlantic Crossing
4171 12″ × 16″ (30.5 × 40.5 cm) $5.00

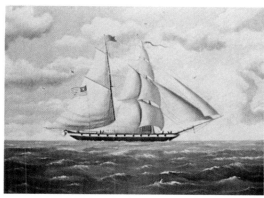

Raymond Bayless
Guarding the Coast
4172 12″ × 16″ (30.5 × 40.5 cm) $5.00

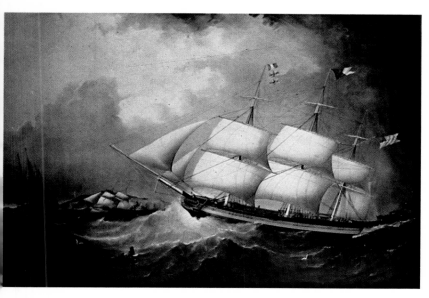

Samuel Walters
The Independence
9712 20″ × 29½″ (51 × 74.5 cm) $14.00
9239 9″ × 13¼″ (23 × 33.5 cm) $2.50

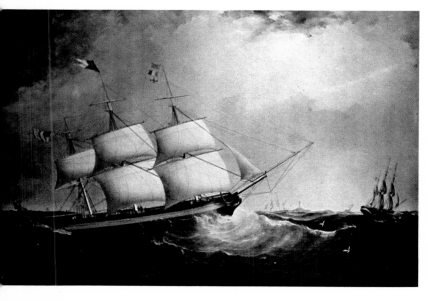

Samuel Walters
The ''Roscoe''
9713 20″ × 29¼″ (51 × 74.5 cm) $14.00
9240 9″ × 13¼″ (23 × 33.5 cm) $2.50

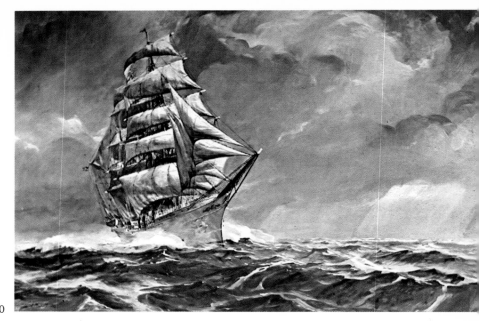

James A. Mitchell III
The Sea Eagle
9644 27″ × 40″ (68.5 × 101.5 cm) $18.00

**Sailing Ships Clippers and Whalers -
Sets only**
12 pieces (6 illustrated)
9215 Average size: 9″ × 14″ (23 × 35.5 cm)
plus ample margins Set $24.00

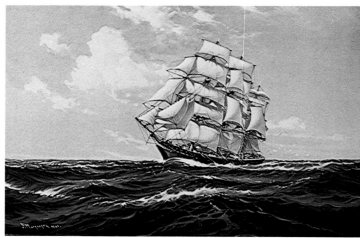

R. MacGregor
Outward Bound
9369 16″ × 24″ (40.5 × 61 cm) $7.50

R. MacGregor
Blue Waters
9366 16″ × 24″ (40.5 × 61 cm) $7.50

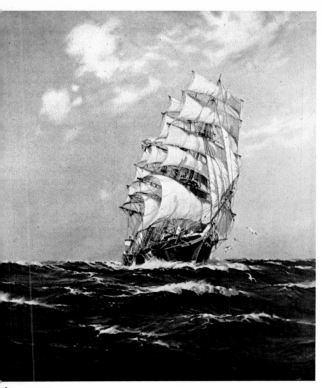

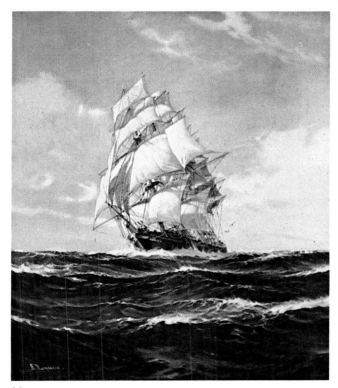

Macgregor
Cutty Sark
9367 24″ × 20″ (61 × 51 cm) $8.00
9116 12″ × 10″ (30.5 × 25.5 cm) $2.50

Macgregor
Red Jacket
9368 24″ × 20″ (61 × 51 cm) $8.00
9117 12″ × 10″ (30.5 × 25.5 cm) $2.50

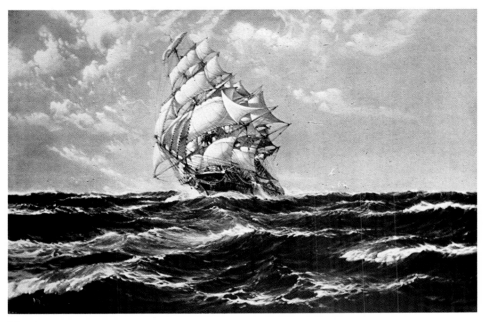

Macgregor
Flying Cloud
9638 20″ × 30″ (51 × 76 cm) 10.00

117

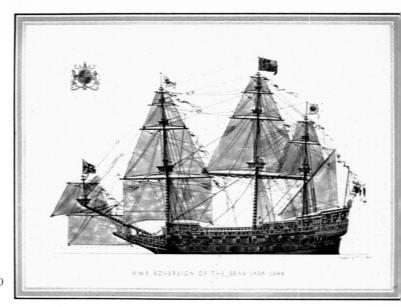

Muth
H.M.S. Sovereign of the Seas
9375 17¼″ × 22½″ (44 × 57.5 cm) $20.00
9133 9″ × 11¾″ (23 × 30 cm) $9.00

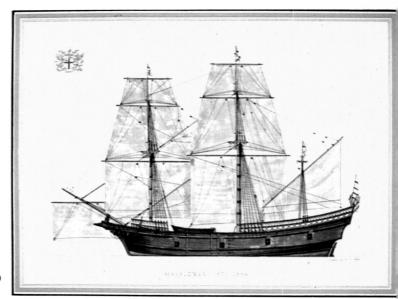

Muth
Mayflower
9377 17¼″ × 22½″ (44 × 57.5 cm) $20.00
9135 9″ × 11¾″ (23 × 30 cm) $9.00

Muth
H.M.S. Bounty
9374 17¼″ × 22½″ (44 × 57.5 cm) $20.00
9132 9″ × 11¾″ (23 × 30 cm) $9.00

Muth
S.M. Friedrich Wilhelm
9379 17¼″ × 22½″ (44 × 57.5 cm) $20.00
9137 9″ × 11¾″ (23 × 30 cm) $9.00

Muth
Santa Maria
9378 17¼″ × 22½″ (44 × 57.5 cm) $20.00
9136 9″ × 11¾″ (23 × 30 cm) $9.00

Muth
H.M.S. Victory
9376 17¼″ × 22½″ (44 × 57.5 cm) $20.00
9134 9″ × 11¾″ (23 × 30 cm) $9.00

Jerome Grimmer
5:30 A.M.
5186 18″ × 24″ (46 × 61 cm) $10.00

Jerome Grimmer
Seafarers
5185 18″ × 24″ (46 × 61 cm) $10.00

Jerome Grimmer
Heading Out
7000 24″ × 32″ (61 × 81 cm) $12.00

Jerome Grimmer
Silhouettes
5127 18″ × 24″ (46 × 61 cm) $10.00

Richard Heichberger N.W.S.
Heading Home
5192 18″ × 24″ (46 × 61 cm) $10.00

Dan Toigo
The Cove
5188 18¾″ × 24″ (48 × 61 cm) $10.00

Dan Toigo
The Mooring
5154 18″ × 24″ (46 × 61 cm) $7.50

Lavere Hutchings
Newport Marina
5190 18″ × 25″ (46 × 63.5 cm) $10.00

Alberto Munoz
Mallorca
7113 22¼″ × 30″ (57 × 76 cm) $12.00

Marcel Dyf
Low Tide
5067 18″ × 22″ (46 × 56 cm) $10.00
Not for sale in England

Marcel Dyf
Summer Day
5069 18″ × 22″ (46 × 56 cm) $10.00
Not for sale in England

Macgregor
Good Going
9639 20″ × 30″ (51 × 76 cm) $12.00

W. F. Burton
Eventide
9573 20″ × 30″ (51 × 76 cm) $22.00

W. F. Burton
Oyster Beds
9574 20″ × 30″ (51 × 76 cm) $22.00

Deryck Foster
The Big Class
9605 20″ × 30″ (51 × 76 cm) $22.00

Kenneth Harris
Low Tide
9355 14″ × 21¼″ (35.5 × 54 cm) $10.00

Kenneth Harris
Dawn in Virginia
9353 14½″ × 22″ (37 × 56 cm) $10.00

Kenneth Harris
Setting Out Decoys
9356 14½″ × 22″ (37 × 56 cm) $10.00

Kenneth Harris
Hunter's View
9354 14½″ × 22″ (37 × 56 cm) $10.00

Roy Mason
Piney Creek
9640 21½″ × 30″ (54.5 × 76 cm) $12.00

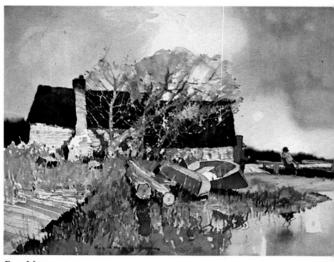

Roy Mason
Fisherman's Hangout
9118 14½″ × 20″ (37 × 51 cm) $7.50

Wolf & J. Smit
Ring-Necked Pheasant
9213 20″ × 26″ (51 × 66 cm) $7.50

Wolf & J. Smit
English Pheasant
9212 20″ × 26″ (51 × 66 cm) $7.50

Richard F. Bishop
From a Blind
9306 18″ × 24″ (45.5 × 61 cm) $15.00

Garden Birds — Set of 6 pieces
9080 Each: 9¾″ × 12″ (25 × 30.5 cm)
Set $16.00

Game Birds — Sets only — 10 plates
2 illustrated
9079 Each: 11½″ × 17½″ (29 × 44.5 cm)
Set $30.00

John Gould
Calothorax mulsanti (left)
4245 20½" × 14½" (52 × 37 cm) $7.50

Calliphlox Amethystina (center)
4246 20½" × 14½" (52 × 37 cm) $7.50

Eriocnemis Derbianus (right)
4244 20½" × 14½" (52 × 37 cm) $7.50

Ken Goldman
Cedar Waxwings
4189 12" × 10" (30.5 × 25.5 cm) $4.00

Ken Goldman
Ruby Crowned and Golden Crowned Kinglets
4190 12" × 10" (30.5 × 25.5 cm) $4.00

Ken Goldman
Stellar Jays
4193 21⅜" × 16" (54 × 40.5 cm) $7.50

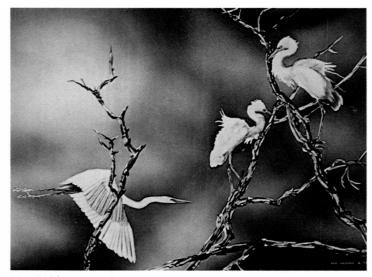

Ken Goldman
Egrets
5175 18" × 23¾" (46 × 60.5 cm) $10.00

Ken Goldman
Toucans
4194 21" × 16" (53.5 × 40.5 cm) $7.50

Mort Solberg A.W.S.
Redheads
4018 14″ × 18″ (35.5 × 46 cm) $8.00

Mort Solberg A.W.S.
Pintails
4019 14″ × 18″ (35.5 × 46 cm) $8.00

Mort Solberg A.W.S.
Wood Ducks
4017 14″ × 18″ (35.5 × 46 cm) $8.00

Mort Solberg A.W.S.
Ring Neck Pheasants
4217 20″ × 16″ (51 × 40.5 cm) $6.00
1213 10″ × 8″ (25.5 × 20 cm) $1.50

Mort Solberg A.W.S.
California Quail
4173 20″ × 16″ (51 × 40.5 cm) $6.00
1211 10″ × 8″ (25.5 × 20 cm) $1.50

Mort Solberg A.W.S.
Barred Owl
4215 20″ × 16″ (51 × 40.5 cm) $6.00
1209 10″ × 8″ (25.5 × 20 cm) $1.50

Mort Solberg A.W.S.
Great Horned Owl
4174 20″ × 16″ (51 × 40.5 cm) $6.00
1212 10″ × 8″ (25.5 × 20 cm) $1.50

Mort Solberg A.W.S.
Boreal Owl
4216 20″ × 16″ (51 × 40.5 cm) $6.00
1210 10″ × 8″ (25.5 × 20 cm) $1.50

Mort Solberg A.W.S.
Saw-Whet Owl
4218 20″ × 16″ (51 × 40.5 cm) $6.00
1214 10″ × 8″ (25.5 × 20 cm) $1.50

. Hinger
urrowing Owls
99 20″ × 16″
1 × 41 cm) $4.00
03 10″ × 8″
5 × 20 cm) $1.50

R. Hinger
Barn Owls
9100 20″ × 16″
(51 × 41 cm) $4.00
9104 10″ × 8″
(25 × 20 cm) $1.50

Hinger
reech Owls
01 20″ × 16″
1 × 41 cm) $4.00
05 10″ × 8″
5 × 20 cm) $1.50

R. Hinger
Snowy Owls
9102 20″ × 16″
(51 × 41 cm) $4.00
9106 10″ × 8″
(25 × 20 cm) $1.50

Tara
Animals - Cheetahs
9397 28″ × 22″ (71 × 56 cm) $10.00
9222 14″ × 11″ (35.5 × 28 cm) $4.00

Tara
Animals - Lions
9398 28″ × 22″ (71 × 56 cm) $10.00
9223 14″ × 11″ (35.5 × 28 cm) $4.00

erbert Dicksee
on
35 23¼″ × 18¾″ (59 × 47.5 cm) $18.00

Herbert Dicksee
Tiger
5136 23″ × 20″ (58 × 51 cm) $18.00

Kurt Meyer-Eberhardt
Fawn
9195 15¾″ × 13¼″ (40 × 34 cm) $9.00

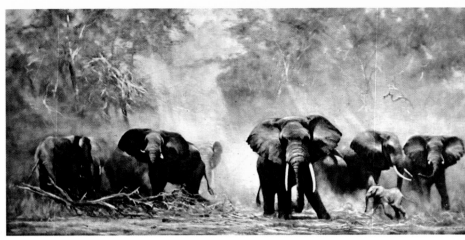

David Shepherd (British, 1931-)
Elephants at Amboseli
9698 20″ × 40″ (51 × 101.5 cm) $36.00

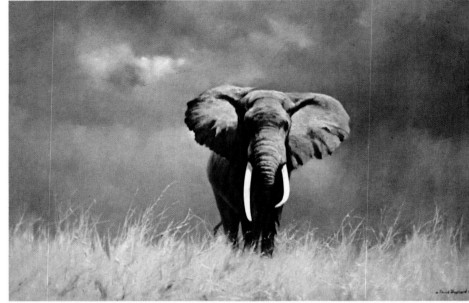

David Shepherd
Wise Old Elephant
9701 20″ × 30″ (51 × 76 cm) $20.00

Kurt Meyer Eberhardt
Mare and Foal
9125 17″ × 12½″ (43 × 32 cm) $9.00

David Shepherd
Storm over Amboseli
9699 20″ × 30″ (51 × 76 cm) $20.00

aud Earl
ur by Honours (1901)
47 15″ × 31″ (38 × 79 cm) $18.00

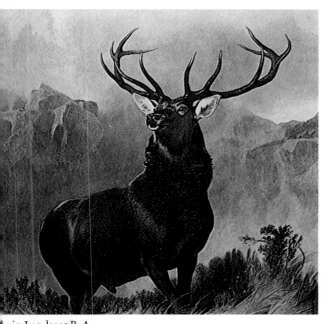

win Landseer R.A.
e Monarch of the Glen
81 image 20″ × 20½″ (51 × 52 cm) $15.00
 plate 28″ × 23″ (71 × 58.5 cm)

Currier & Ives
The First Bird of the Season
2009 10″ × 14¼″ (25.5 × 36 cm) $7.50

Currier & Ives
A Double-Barreled Breech-Loader
2008 10″ × 14¼″ (25.5 × 36 cm) $7.50

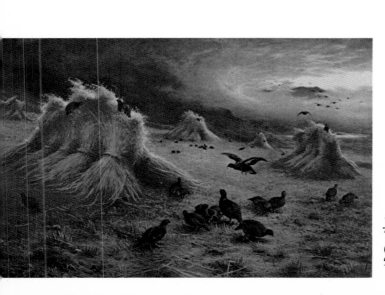

Joseph Farquharson A.R.A.
The Highland Raiders
(The Grouse at Home)
5150 image 15¾″ × 24″ (40 × 61 cm) $15.00
 plate 18″ × 28″ (46 × 71 cm)

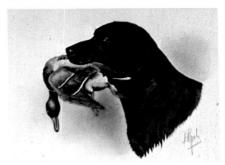

B. Riab
Labrador (hand colored, signed etching)
9184 10¾″ × 15½″ (27 × 39 cm) $36.00

B. Riab
Pointer (hand colored, signed etching)
9185 10¾″ × 15½″ (27 × 39 cm) $36.00

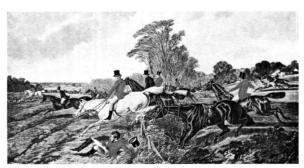

4081 Full Cry

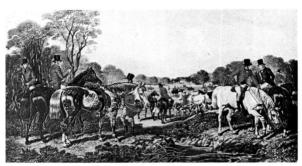

4082 The Meet

4079 Breaking Cover

4080 The Death

J. F. Herring, 1795-1865
Prints: 4079-4081 10″ × 18″ (25 × 46 cm) $4.50 each

Francis Grant
Sir Richard Sutton and The Quorn Hounds
7156 16½″ × 28″ Image (42 × 71 cm) $18.00
20½″ × 29¾″ Plate (52 × 75.5 cm)

C. Agar - J. Maiden
The Bury Hunt
7155 17½″ × 24″ Image (44.5 × 61 cm) $18.00
20½″ × 27″ Plate (52 × 69 cm)

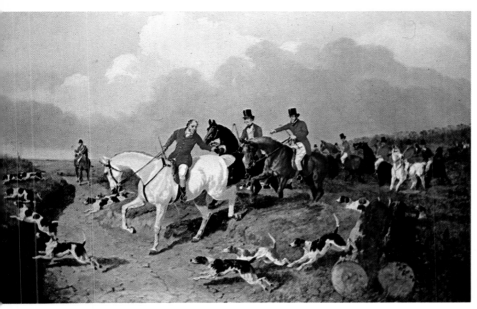

J. F. Herring
The Find
9617 20″ × 30″ (51 × 76 cm) $14.00

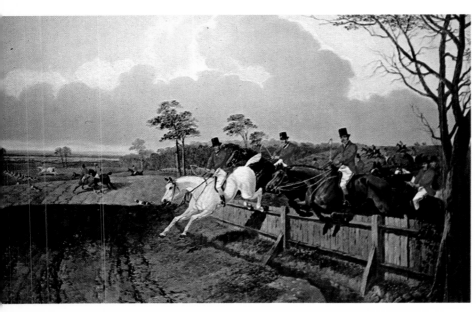

J. F. Herring
Full Cry
9618 20″ × 30″ (51 × 76 cm) $14.00

William Heath
The Epping Hunt, 1819
(Or HOBBIES IN AN UPROAR)
2089 8″ × 12½″ (20 × 32 cm) $8.00

Francis Grant
The Melton Breakfast
7021 image 17½″ × 28″ (44.5 × 71 cm) $18.00
plate 20¾″ × 29½″ (53 × 75 cm)

T.N.H. Walsh
The Last Change In, 1883
7131 14″ × 28″ (35.5 × 71 cm) $18.00

T.N.H. Walsh
We Shall Do It Easily, 1881
7132 14″ × 28″ (35.5 × 71 cm) $18.00

C. C. Henderson
Fore's Coaching Incidents-Flooded
158 image 12¾ " × 23 " (32.5 × 58.5 cm)
plate 15½ " × 25½ " (39 × 65 cm) $18.00

M. Dovaston
Auld Lang Syne
9598 22 " × 30 " (56 × 76 cm) $15.00

M. Dovaston
And So The Story Goes
9597 22 " × 30 " (56 × 76 cm) $15.00

A. B. Frost
Woodcock-Shooting in October
4163 13″ × 19″ (33 × 48.5 cm) $10.00

A. B. Frost
American Forest Shooting
4248 18″ × 12″ (46 × 30.5 cm) $7.50

A. B. Frost
Ruffed-Grouse Shooting
4162 13″ × 20″ (33 × 51 cm) $10.00

Jane Carlson
Deep in the Woods (left)
9575 28″ × 17″ (71 × 43 cm) $12.00
The Last Run (right)
9577 28″ × 17″ (71 × 43 cm) $12.00

Jane Carlson
High Country
9576 20½″ × 27″ (52 × 69 cm) $12.00

. F. Abbott
Henry Callender
262 17½″ × 12½″
(44.5 × 32 cm) $12.00

L. F. Abbott
The Blackheath Golfer
4263 17½″ × 12½″
(44 × 32 cm) $12.00

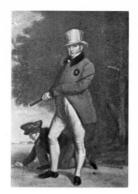

Sir Henry Raeburn
John Taylor
4264 17½″ × 12½″
(44 × 32 cm) $12.00

Rules of Golf
9098 (set of 20 subjects)
(I subject illustrated) approx. 9″ × 8½″
(23 × 21.5 cm) $36.00

A. B. Frost (American, 1851-1928)
Approximately 13″ × 10″ (33 × 25.5 cm) $9.00
each
NOTE: Six more A. B. Frost golfing prints not
illustrated: **A Good Brassy Lie — Fore —
Twosome — Leg Wrappings — Good Form —
Good Shot**

9065 Temper

9068 Stymied

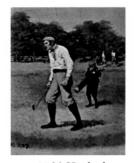

9064 Hooked

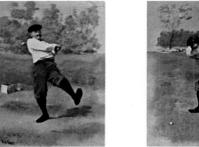

9066 By Sheer Strength

9067 The Duffer

9069 Bunkered

137

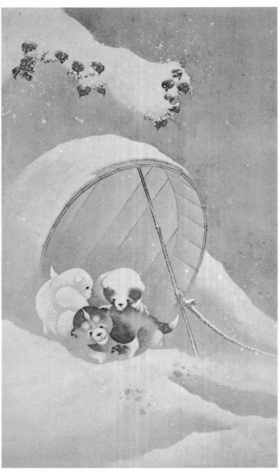

Katsushika Hokusai 1760-1849
Puppies in the Snow (detail)
Freer Gallery of Art
Smithsonian Institution, Washington, D.C.
7058 image 22½″ × 16″ (57 × 40.5 cm) $18.00
scroll 26″ × 19½″ (66 × 49.5 cm)

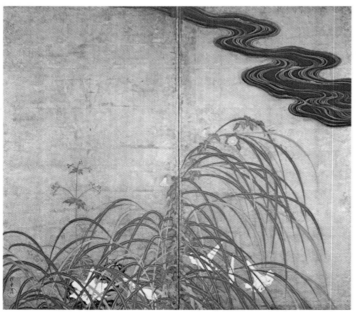

Sakai Hoitsu
Flowering Plants of Summer
Tokyo National Museum
7102 left 30″ × 16½″ (76 × 42 cm) each panel $16.00
7103 right 30″ × 16½″ (76 × 42 cm) each panel $16.00
1092 8¾″ × 8″ (22 × 20 cm) both panels $1.50

Japanese, Matabei Style, Tosa School, 16th Century
The Brooklyn Museum, N.Y.
Gift of Mrs. Louis Natanson
5159 20″ × 14½″ (51 × 37 cm) plus Gold Borders $

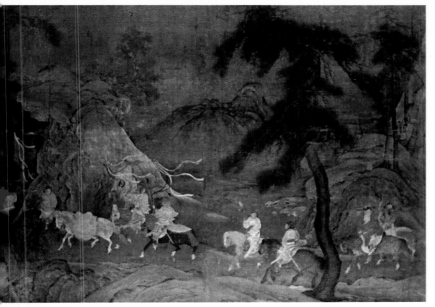

Chinese, Sung Dynasty
The Tribute Horse
Metropolitan Museum of Art, New York
0580 29¼" × 40¼" (74 × 102 cm) $36.00

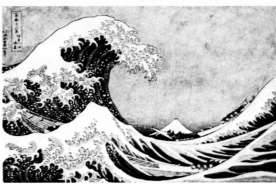

Hokusai (1760-1849)
The Great Wave off Kanazawa
Victoria and Albert Museum
4083 10" × 15" (25 × 38 cm) $6.00

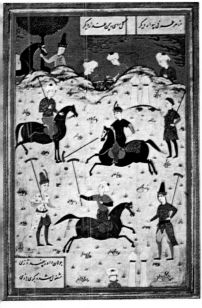

Persian Illumination
A Game of Polo
Victoria and Albert Museum
4115 13" × 8¼" (33 × 21 cm) $6.00

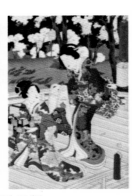

Utagawa Ukiyoe Kunisada (Japanese, 1786-1865)
Prince Geinji (Tryptch)
Private Collection
7154 14" × 30½" Tryptch (35.5 × 77.5 cm) $16.00
(14" × 9¾" each plate)

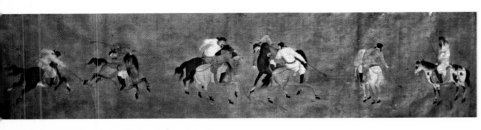

Li Ling (Chinese, Ming Dynasty 1368-1644)
Polo Players
Victoria and Albert Museum
5058 6¾" × 29" (17 × 73.5 cm) $12.00

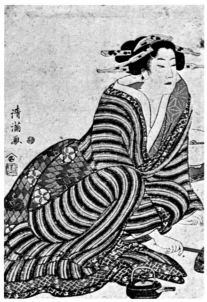

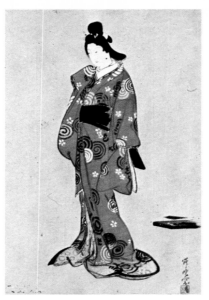

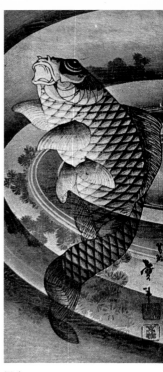

Torii Kiyomitzu
Singing Girl
Victoria and Albert Museum
4102 15″ × 10″ (38 × 25 cm) $6.00

Kyosai (1831-1889)
Lady in Red
Victoria and Albert Museum
5088 22″ × 12¾″ (56 × 32.5 cm) $10.00

Katsushika Taito
A Carp Leaping in a Pool
Victoria and Albert Museum
5043 25¼″ × 11¾″ (64 × 30 cm) $12.00
4024 14″ × 6½″ (36 × 16.5 cm) $5.00

Hiroshige
View of Yedo
2098 8½″ × 13½″ (22 × 34 cm) $5.00

Hiroshige
Kameya - Tea House
2097 8½″ × 13½″ (22 × 34 cm) $5.00

Hiroshige II
Cherry Blossoms
2112 8½″ × 13½″ (22 × 34 cm) $5.00

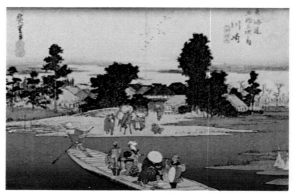

Hiroshige
Tokaido No. 3 Ferry On The River
2095 9″ × 14″ (23 × 35.5 cm) $5.00

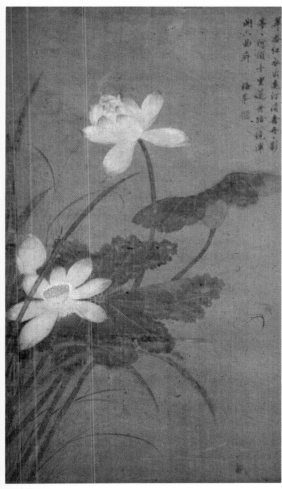

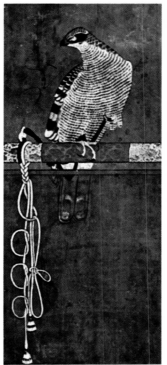

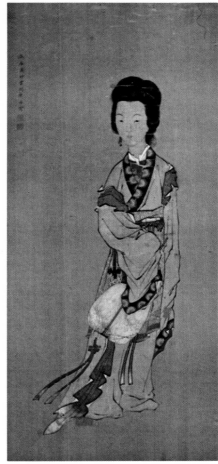

Japanese
Falcon
Sammlung Preetorius, Munich
5086 23″ × 10½″ (58.5 × 27 cm) $10.00
4098 13¼″ × 6″ (33.5 × 15 cm) $5.00
1071 10″ × 4½″ (25 × 11.5 cm) $1.50

Mei Feng
Lotus Flowers
Sammlung Preetorius, Munich
7034 29″ × 16½″ (73.5 × 42 cm) $18.00
1097 10″ × 5¾″ (25 × 15 cm) $1.50

Ch'en Yang
Portrait of a Lady
Sammlung Preetorius, Munich
7011 26½″ × 12″ (67 × 30.5 cm) $16.00
1067 10″ × 4½″ (25 × 11.5 cm) $1.50

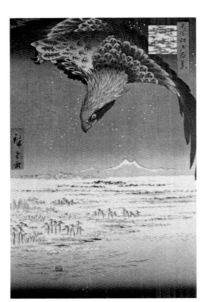

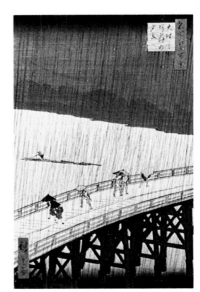

Ichiryusai Hiroshige 1797-1858
Fireworks, Riogoku, 1858
(From the Hundred Views of Edo)
The Brooklyn Museum, N. Y.
2081 13″ × 8⅝″ (33 × 22 cm) $5.00

Ichiryusai Hiroshige
**Eagle Flying Over the Fukagama District
of Edo, 1857**
(From the One-Hundred Views of Edo)
The Brooklyn Museum, N. Y.
2080 13″ × 8⅝″ (33 × 22 cm) $5.00

Utagawa Hiroshige
Ohashi Bridge in the Rain, 1857
Philadelphia Museum of Art
The Louis E. Stern Collection
2082 13¼″ × 8⅝″ (34 × 22 cm) $5.00

Y. S. Lim
Little Bird
5195 14½″ × 23″ (37 × 58.5 cm) $8.00

Y. S. Lim
Spring Bird-Yellow
2087 9″ × 12″ (23 × 30.5 cm) $4.50

Y. S. Lim
Two Birds
5196 30″ × 12″ (76 × 30.5 cm) $10.00

Y. S. Lim
Spring Bird-Mauve
2088 9″ × 12″ (23 × 30.5 cm) $4.50

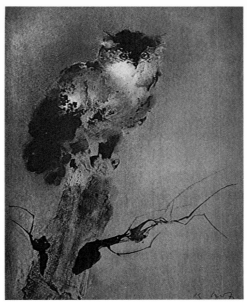

Kaiko Moti
Owl
9373 22½″ × 18″ (55 × 46 cm) $15.00

Kaiko Moti
The Eagle
9372 24″ × 18″ (61 × 46 cm) $15.00

Leonor Fini
The Secret Feast
9339 23″ × 14″ (58.5 × 35.5 cm) $25.00

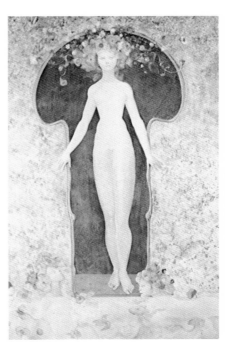

Leonor Fini
The Guardian of the Wells
9336 23″ × 17½″ (58.5 × 44.5 cm) $25.00

Leonor Fini
Night Express
9338 22¾″ × 15¾″ (58 × 40 cm) $25.00

Leonor Fini
The Lock
9337 22½″ × 14″ (56 × 35.5 cm) $25.00

143

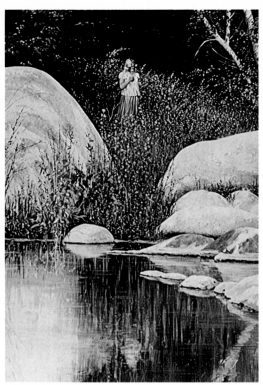

Mort Solberg A.W.S.
Linda
7008 30″ × 20″ (76 × 51 cm) $14.00

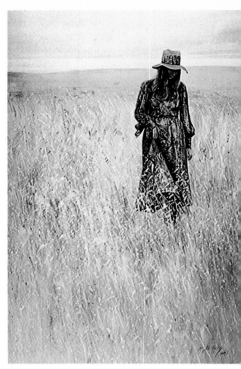

Mort Solberg A.W.S.
Suzanne
7080 30″ × 20″ (76 × 51 cm) $14.00

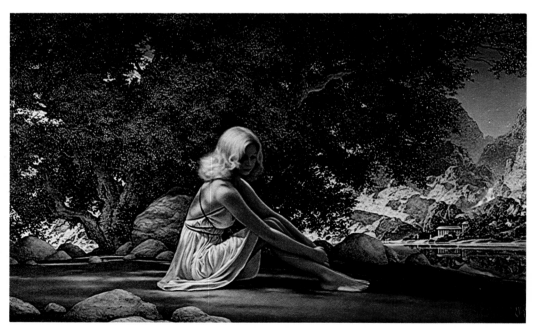

Clifford Vernon Vincent
Rita
7095 21½″ × 36″ (55 × 91.5 cm) $16.00

Graciela Rodo Boulanger
Holiday on Wheels
9570 23½″ × 23½″ (60 × 60 cm) $20.00

Graciela Rodo Boulanger
Tour De France
9572 23½″ × 23½″ (60 × 60 cm) $20.00

Graciela Rodo Boulanger
Les Musiciens
9571 31″ × 15½″ (79 × 39.5 cm) $20.00

Graciela Rodo Boulanger
Fanfare
9569 31″ × 15½″ (79 × 39.5 cm) $20.00

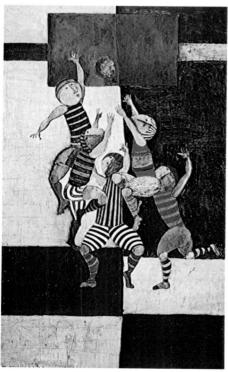

Graciela Rodo Boulanger
Basketball
9568 31″ × 18¾″ (79 × 48 cm) $20.00

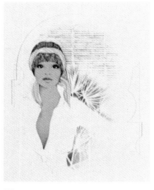
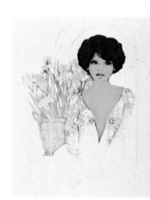

Tara
9403 (top left) 28″ × 22″ (71 × 56 cm) $10.00
9228 14″ × 11″ (35.5 × 28 cm) $4.00
9405 (bottom left) 28″ × 22″ (71 × 56 cm) $10.00
9230 14″ × 11″ (35.5 × 28 cm) $4.00
9404 (top right) 28″ × 22″ (71 × 56 cm) $10.00
9229 14″ × 11″ (35.5 × 28 cm) $4.00
9406 (bottom right) 28″ × 22″ (71 × 56 cm) $10.00
9231 14″ × 11″ (35.5 × 28 cm) $4.00

Tara
9407 (top left) 28″ × 22″ (71 × 56 cm) $10.00
9232 14″ × 11″ (35.5 × 28 cm) $4.00
9409 (bottom left) 28″ × 22″ (71 × 56 cm) $10.00
9234 14″ × 11″ (35.5 × 28 cm) $4.00
9408 (top right) 28″ × 22″ (71 × 56 cm) $10.00
9233 14″ × 11″ (35.5 × 28 cm) $4.00
9410 (bottom right) 28″ × 22″ (71 × 56 cm) $10.00
9235 14″ × 11″ (35.5 × 28 cm) $4.00

Tara
Clowns
9399 (left) 28″ × 22″ (71 × 56 cm) $10.00
9224 14″ × 11″ (35.5 × 28 cm) $4.00

9400 (right) 28″ × 22″ (71 × 56 cm) $10.00
9225 14″ × 11″ (35.5 × 28 cm) $4.00

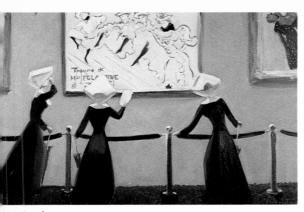

Jean Appleton
A Visit to the Louvre
4257 12″ × 18″ (30.5 × 46 cm) $4.00

Jean Appleton
A Day at the Beach
4258 12″ × 18″ (30.5 × 46 cm) $4.00

Hazel Wyllie
Who
4054 13¾″ × 28″ (35 × 71 cm) $12.00

Marcel Dyf
Charme
5066 21¾″ × 18″ (55 × 46 cm) $12.00

Marcel Dyf
The Sonnet
5068 21½″ × 18″ (55 × 46 cm) $12.00

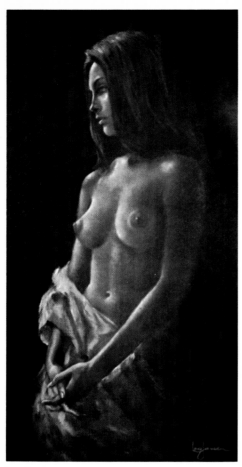

Leo Jansen
Nude Study #4
9702 36″ × 18″ (91.5 × 46 cm) **$10.00**

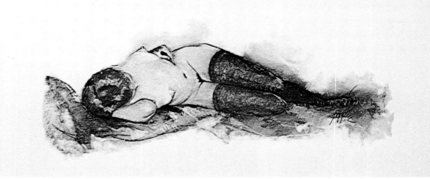

Poppee
Model Study #2
5018 18″ × 24″ (46 × 61 cm) **$10.00**

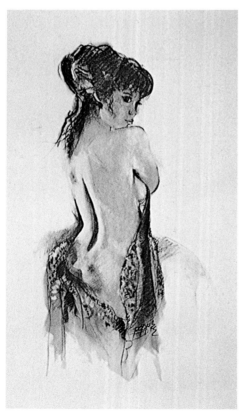

Poppee
Seated Nude
5022 24″ × 18″ (61 × 46 cm) **$10.00**

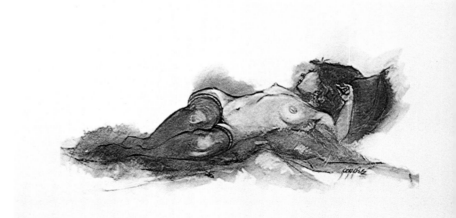

Poppee
Model Study #1
5017 18″ × 24″ (46 × 61 cm) **$10.00**

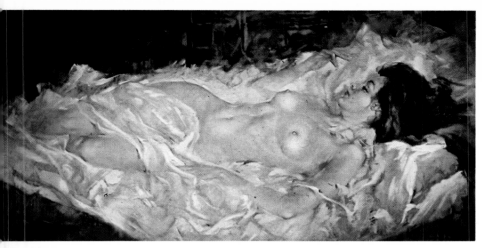

Julian Ritter
American Venus
0672 18" × 36" (46 × 91.5 cm) $12.00

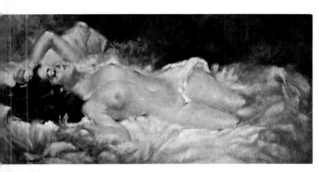

Julian Ritter
Model Study #1
0390 12" × 24" (30.5 × 61 cm) $7.50

Julian Ritter
Model Study #2
0391 12" × 24" (30.5 × 61 cm) $7.50

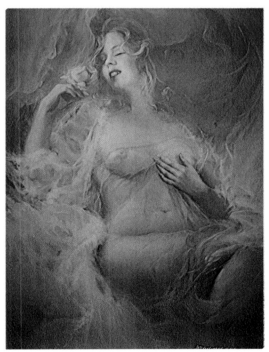

Harry Bissinger
Daphne
5149 24" × 18" (61 × 46 cm) $10.00

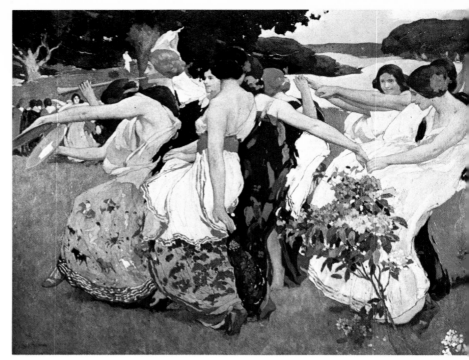

Arthur Mathews
Youth (1917)
The Oakland Museum, California
7033 23″ × 30″ (58.5 × 76 cm) $16.00
4105 12″ × 15¾″ (30.5 × 40 cm) $4.00

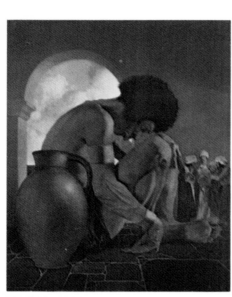

Maxfield Parrish
Sinbad Plots Against the Giant, 1907
Philadelphia Museum of Art
Gift of Mrs. Francis P. Garvan
4204 20″ × 16″ (51 × 40.5 cm) $7.50
1163 10″ × 8″ (25.5 × 20 cm) $1.50

Axatard
The Happy Village
2010 8″ × 10″ (20 × 26 cm)
$2.50

Axatard
The Village Bear
2011 8″ × 10″ (20 × 26 cm)
$2.50

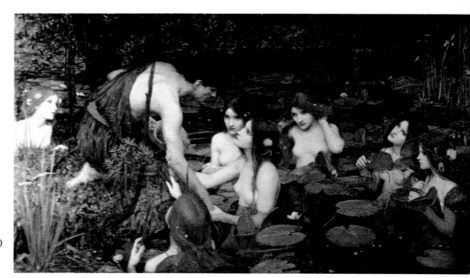

J. W. Waterhouse
Hylas and the Nymphs
City of Manchester Art Galleries
7055 18¼″ × 30″ (46 × 76 cm) $12.00
4030 10″ × 16½″ (25.5 × 42 cm) $6.00
1041 6¼″ × 10″ (16 × 25.5 cm) $1.50

Karl Spitzweg
The Cactus Friend
9203 20″ × 10½″ (51 × 27 cm) **$10.00**
9204 14¼″ × 7½″ (36 × 19 cm) **$3.00**

Karl Spitzweg
The Pensionist
9205 14″ × 8″ (36 × 20 cm) **$3.00**

Karl Sptizweg
The Bookworm
9206 20″ × 11″ (51 × 28 cm) 10.00
9207 14″ × 8″ (20 × 10 cm) **$3.00**

Pech - Black and White Etchings:
Illustrated from left to right: **Schubert, Bach, Beethoven**
Average plate size of each:
8¼″ × 6¼″ (21 × 16 cm) **$14.00** (large)
6″ × 4¾″ (15 × 12 cm) **$10.00** (small)
Also available:

	lg.	small
Bach	9149	9150
Beethoven	9151	9152
Brahms	9153	9154
Haydn	9155	9156
Liszt	9157	9158
Mozart	9159	9160
Schubert	9161	9162
Schumann	9163	9164
Wagner	9165	9166
Weber	9167	9168

Willy Von Beckerath
Brahms at the Piano
5009 22″ × 18″ (56 × 46 cm) **$7.50**
4191 14″ × 11¾″ (36 × 30 cm) **$4.00**

Authors

2099 Elizabeth Barrett Browning
2100 Robert Browning
2101 Robert Burns
2102 Lord Byron
2103 Geoffrey Chaucer
2104 Ralph Waldo Emerson
2105 Oliver Wendell Holmes
2106 John Keats
2107 Henry W. Longfellow
2108 John Milton
2109 Edgar Allen Poe
2110 Lord Alfred Tennyson
2111 William Wordsworth
Approx. Plate Size 10″ × 8″ (25.5 × 20 cm) $7.50 each

Illustrated Elizabeth Barrett Browning

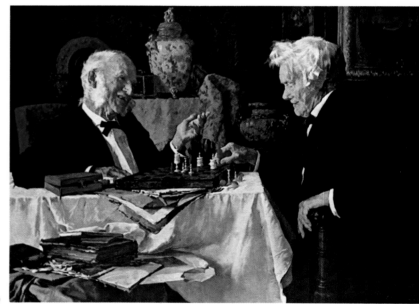

Louis C. Moeller
Cronies
9370 18″ × 24″ (46 × 61 cm) $10.00

Louis C. Moeller
Legal Adversaries
9371 18″ × 24″ (46 × 61 cm) $10.00

W. Dendy Sadler
The Right of Way
5251 14¼″ × 19″ (36 × 48 cm) $16.00

W. Dendy Sadler
The Plaintiff and the Defendant
5250 14¼″ × 19″ (36 × 48 cm) $16.00

W. Dendy Sadler
Parent and Guardian
5206 13¾″ × 19¼″ (35 × 49 cm) $16.00

W. Dendy Sadler
Christmas Time
5207 14″ × 18½″ (35.5 × 47 cm) $16.00

John Landis
(From the top, left to right)
2059 The Miller
2056 Abraham
2058 Market Thieves
2057 Ezra
2060 The Old Prophet
2062 The Vision
2061 The Oracle
 Above are 10″ × 8″ (25.5 × 20.5 cm)
 sheet size $1.00
2061 is 12″ × 16″ (30.5 × 40.5 cm) sheet size $2.00

Heinrich Hofmann (German, 1822-1911)
Christ at Twelve
5137 24″ × 18″ (61 × 46 cm) $4.00

Enstrom
Grace
9062 16″ × 21″ (40.5 × 53.5 cm) $4.00

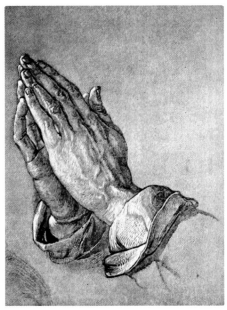

Albrecht Durer
Praying Hands, 1508-09
Graphische Sammlung Albertina, Wien
2034 11″ × 7½″ (28 × 19 cm) $3.00

Toby Rosenthal
The Cardinal's Portrait
9301 19″ × 24″ (48 × 61 cm) $7.50

Father Michael D. Buckley
21 California Mission Saints and
Father Junipero Serra
9315 17″ × 22″ (43 × 56 cm) $6.00

Unknown
Sacred Heart of Jesus
5141 24″ × 18″ (61 × 46 cm) $4.00

Warner Sallman
Christ at Heart's Door
9217 21½″ × 16″ (54.5 × 40.5 cm) $2.25

R. Stang
The Last Supper (after Da Vinci)
9704 20″ × 40″ (51 × 101.5 cm) $12.00
9705 16″ × 30″ (40.5 × 76 cm) $7.50
9219 9″ × 17″ (23 × 43 cm) $2.50

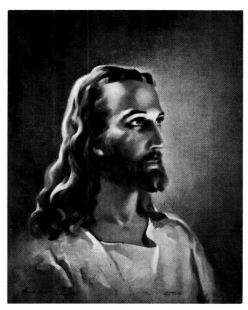

Warner Sallman
Head of Christ
9216 20″ × 16″ (51 × 41 cm) $2.25

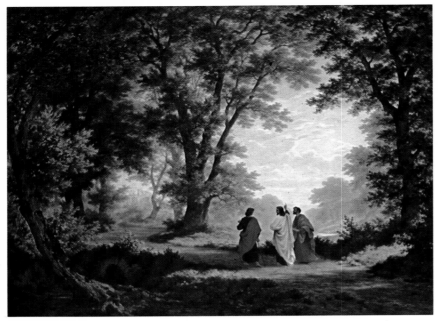

Robert Zund
The Way to Emmaus
9742 24¾″ × 32¾″ (63 × 83 cm) $24.00
9424 18¾″ × 24¾″ (47.5 × 63 cm) $18.00

Antique Cars — Sold in sets of 18 pieces only (6 subjects illustrated)
9206 — Each 12″ × 16″ (30.5 × 40.5 cm) sheet size. $35.00
Subjects are: Alfa-Romeo 1930 — Berna 1902 — Bugatti 1910 — Cadillac 1931 — Delage 1933 — Dusenberg 1929 — Fiat 1906 — Ford (Model T) 1911 — Hispano Suiza 1926 — Lancia 1909 — Maybach 1936 — Mercedes 1900 — Mercedes-Benz 1928 — Mercer 1913 — Opel 1909 — Renault 1910 — Rolls-Royce (Silver Ghost) 1907 — Spyker 1906.

Robert F. McDonnell

Car Portraits (illustrated in this order): Top Left: **9119 Bugatti (1931) Royal Type 41**; Middle Left: **9120 Bugatti (1921) Brescia**; Lower Left: **9121 Chitty-Chitty-Bang-Bang (1921)**; Top Right: **9122 Cord (1936) Westchester Sedan**; Middle Right: **9124 Squire (1935)**; Lower Right: **9123 Mercedes-Benz (1955) 300SR**. The 6 prints are each: 18″ × 24″ (46 × 61 cm) $4.00 each or $20.00 set.

Balloons – 12 pieces (6 subjects illustrated) Sold in sets only
9208 Sheet Size: 16″ × 12″ (40.5 × 30.5 cm) Plate size: 10¼″ × 7¼″ (26 × 18.5 cm) $25.00 set

O'Klein (signed, hand-colored etchings)
From the top:
9147 Chacun Son Tour — 9148 Comme Nos Maitres — 9146 A La Queue
Each: 5 ½″ × 17 ¼″ (14 × 44 cm) $26.00

Redon
La Poule Mange Les Escargots
(signed, hand-colored etching)
9178 9 ½″ × 13 ¼″
(24.5 × 33.5 cm) $26.00

Redon
Le Canard Mange Les Limaces
(signed, hand-colored etching)
9179 9 ¼″ × 13 ¼″
(23.5 × 33.5 cm) $26.00

Redon (top)
How Practical
(signed, hand-colored etching)
9176 9 ¾″ × 13 ¾″
(25 × 34 cm) $26.00

Redon (bottom)
Business is Business
(signed, hand-colored etching)
9177 8 ¼″ × 11 ¾″
(21 × 29 cm) $26.00

Redon
Emotion
(signed, hand-colored etching)
9175 13 ¾″ × 9 ¾″
(25 × 34 cm) $26.00

Redon
Never Drink the Water
(signed, hand-colored etching)
9174 13 ¾″ × 9 ¾″
(34 × 25 cm) $26.00

Recipe
Cafe Granita
9170 14″ × 11″ (35.5 × 28 cm) $1.50

Recipe
Vinaigrette
9171 14″ × 11″ (35.5 × 28 cm) $1.50

Recipe
Tiny Swedish Pancakes
9172 14″ × 11″ (35.5 × 28 cm) $1.50

Recipe
The Family Sauce
9173 14″ × 11″ (35.5 × 28 cm) $1.50

Charles Wysocki
Young Gentlewoman
9271 20″ × 16″ (51 × 41 cm) $4.00

Charles Wysocki
Young Gentleman
9270 20″ × 16″ (51 × 41 cm) $4.00

Charles Wysocki
Still Life with Corn (top)
9266 16″ × 20″ (41 × 51 cm) $4.00

Charles Wysocki
Still Life with Duck (bottom)
9267 16″ × 20″ (41 × 51 cm) $4.00

Charles Wysocki
Still Life with Pumpkin (top)
9268 16″ × 20″ (41 × 51 cm) $4.00

Charles Wysocki
Still Life with Watermelon (bottom)
9269 16″ × 20″ (41 × 51 cm) $4.00

Gerald Stinski
67 Tangerine (top)
54 Limes (bottom)
Each: 4″ × 7½″ (10 × 19 cm) $2.50

R. Chailloux
Still Life Series 1330
From the top, left to right
9028 — 9029 — 9030 — 9031 — 9032 — 9033
Each: 10″ × 12″ (25.5 × 30.5 cm) $4.50

Gerald Stinski
Three Apples
5132 15″ × 30″ (38 × 76 cm) $12.00

Gerald Stinski
2066 Still Life — Eggs and Red Glass (left)
2065 Still Life — Apple and Knife (right)
Each: 8″ × 6″ (20 × 15 cm) $2.50

161

Franz Werner Tamm (German, 1658-1724)
Still Life
Kunsthalle, Hamburg
5044 24″ × 19½″ (61 × 49.5 cm) $12.00
1032 9¾″ × 8″ (25 × 20 cm) $1.50

Jan Davidsz De Heem (Dutch, 1606-1683)
Vase of Flowers, 1645
The National Gallery of Art, Washington, D.C.
Andrew W. Mellon Fund
5140 22½″ × 18″ (57 × 46 cm) $10.00
1074 10″ × 8″ (25.5 × 20 cm) $1.50

Joseph Nigg
Grandmother's Bouquet #1
Kunsthistorisches Museum, Wien
4250 22″ × 16″ (56 × 41 cm) $10.00

Joseph Nigg
Grandmother's Bouquet #2
Kunsthistorisches Museum, Wien
4251 22″ × 16″ (56 × 41 cm) $10.00

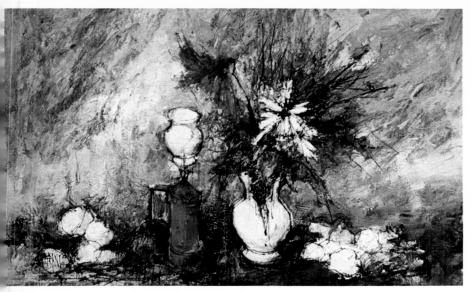

Franc
The White Vase
7019 20″ × 30″ (51 × 76 cm) $12.00
4074 12″ × 18″ (30.5 × 46 cm) $4.00

Tara
Florals
9401 (left) 28″ × 22″ (71 × 56 cm) $10.00
9426 (left) 14″ × 11″ (35.5 × 28 cm) $4.00
9402 (right) 28″ × 22″ (71 × 56 cm) $10.00
9227 (right) 14″ × 11″ (35.5 × 28 cm) $4.00

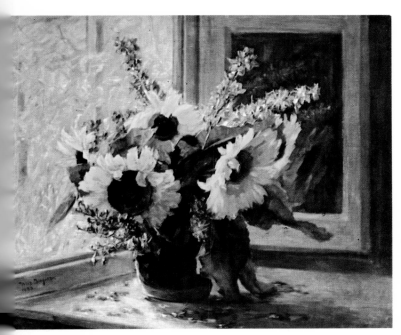

Wilhelm Birgels
Sunflowers in Window
555 28″ × 33½″ (71 × 85 cm) $30.00

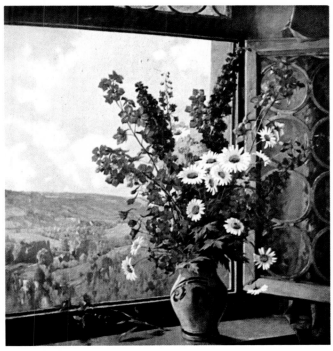

Hans Prentzel
View From My Window
9658 30″ × 26″ (76 × 67 cm) $30.00
9202 18¾″ × 16¾″ (47.5 × 42.5 cm) $12.00

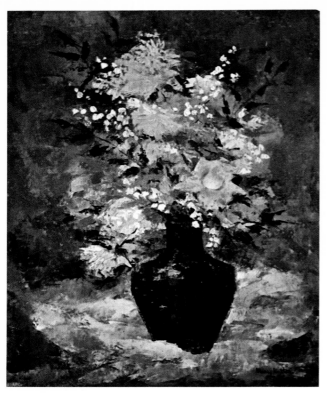

Mary Miller
Rose Bouquet
9128 20″ × 16″ (51 × 40.5 cm) $5.00
9129 12″ × 9″ (30.5 × 23 cm) $1.50

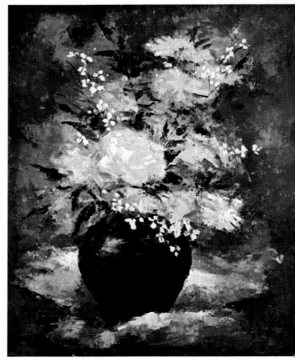

Mary Miller
Peace Rose
9126 20″ × 16″ (51 × 40.5 cm) $5.00
9127 12″ × 9″ (30.5 × 23 cm) $1.50

Redoute
Roses (sets only — 6 illustrated)
Large size — 16 pieces:
9180 Each: 16″ × 12″ (40.5 × 30.5 cm) $24.00 set
Medium size — 12 pieces:
9181 Each 9½″ × 7½″ (24 × 19 cm) $12.00 set

Chrysanthemums
Sets of 6 — 2 illustrated
9034 9¾″ × 12″ (25 × 30.5 cm) $14.00

Rick Bennett
Butterfly
2015 8″ × 10″ (20 × 25.5 cm) $3.00

Rick Bennett
Butterfly
2014 8″ × 10″ (20 × 25.5 cm) $3.00

Rick Bennett
Butterfly
2013 10″ × 8″ (25.5 × 20 cm) $3.00

Carlos Von Riefel
Antique Fruit — set of 8 (3 illustrated)
9186 16″ × 12″ (40.5 × 30.5 cm) $24.00

Arthur G. Brookshaw
Plate LXXXI Pears
4136 16″ × 12″ (40.5 × 30.5 cm) $6.00

Arthur G. Brookshaw
Plate XII Cherries
4135 16″ × 12″ (40.5 × 30.5 cm) $6.00

Arthur G. Brookshaw
Plate XXII Plums
4137 16″ × 12″ (40.5 × 30.5 cm) $6.00

G. Danset
Roses
9325 18″ × 25″ (45.5 × 63.5 cm) $26.00

G. Danset
Series 1318 — illustrated
From top, left to right:
9040 — 9041 — 9042 — 9043 — 9044 — 9045
Each: 10″ × 8″ (26 × 20.5 cm) $3.50

Carolyn Blish
Mixed Daisies
9309 24″ × 12″
(61 × 31 cm) $7.50

Carolyn Blish
Black-Eyed Susans
9308 24″ × 12″
(61 × 31 cm) $7.50

De Camp
Florals
From the top, left to right:
9048 — 9049 — 9050
9051 — 9052 — 9053
Each: 14″ × 11″ (35.5 × 28 cm) $4.00

G. Danset
Bouquet with Anemones
9324 18″ × 25″ (45.5 × 63.5 cm) $26.00

Nel Cary
Hanging Fuchsias and Ferns
9578 24″ × 30″ (61 × 76 cm) $10.00

Nel Cary
Poppies, Daisies and Ferns
9579 24″ × 30″ (61 × 76 cm) $10.00

Nel Cary
Fuchsias (top)
9022 16″ × 20″ (40.5 × 51 cm) $6.00
9026 11″ × 14″ (28 × 35.5 cm) $3.50
Ivy (bottom)
9023 16″ × 20″ (40.5 × 51 cm) $6.00
9027 11″ × 14″ (28 × 35.5 cm) $3.50

Nel Cary
Zinnias (left)
9020 20″ × 16″ (51 × 40.5 cm) $6.00
9024 14″ × 11″ (35.5 × 28 cm) $3.50
Marigolds (right)
9021 20″ × 16″ (51 × 40.5 cm) $6.00
9025 14″ × 11″ (35.5 × 28 cm) $3.50

Marion Godlewski
Blue Asters
5224 24″ × 19¼″ (61 × 49 cm) $12.00
4254 16″ × 12¾″ (40.5 × 32.5 cm) $5.00

Marion Godlewski
Spring Bloom
5223 24″ × 19¼″ (61 × 49 cm) $12.00
4255 16″ × 12¾″ (40.5 × 32.5 cm) $5.00

Marion Godlewski
Asters and Pink Blossoms
5222 24″ × 19¼″ (61 × 49 cm) $12.00
4256 16″ × 12¾″ (40.5 × 32.5 cm) $5.00

Marion Godlewski
Chrysanthemums
5225 24″ × 18″ (61 × 46 cm) $12.00
4253 16″ × 12″ (40.5 × 30 cm) $5.00

Marion Godlewski
Moonlight Floral
7143 30″ × 20″ (76 × 51 cm) $15.00
4252 18″ × 12″ (46 × 30.5 cm) $5.00

Marcel Dyf
The Blue Vase
4069 18″ × 14¼″ (46 × 36 cm) $7.50
1001 10″ × 7¼″ (25.5 × 19 cm) $1.50

Not for sale in England

Marcel Dyf
Summer Bouquet
4070 18″ × 14¼″ (46 × 36 cm) $7.50
1000 10″ × 7¼″ (25.5 × 19 cm) $1.50

Not for sale in England

Vernon Kerr
Tender Promise
4200 20″ × 16″ (51 × 40.5 cm) $7.50
1158 10″ × 8″ (25.5 × 20 cm) $1.50

Vernon Kerr
My Happiness
4198 20″ × 16″ (51 × 40.5 cm) $7.50
1156 10″ × 8″ (35.5 × 20 cm) $1.50

Vernon Kerr
Especially Yours
4197 20″ × 16″ (51 × 40.5 cm) $7.50
1155 10″ × 8″ (25.5 × 20 cm) $1.50

Vernon Kerr
Sweet Memories
4199 20″ × 16″ (51 × 40.5 cm) $7.50
1157 10″ × 8″ (25.5 × 20 cm) $1.50

Joanne Oliver
May
4013 18″ × 14″ (46 × 35.5 cm) $6.00

Joanne Oliver
June
4016 20″ × 16″ (51 × 41 cm) $6.00

Joanne Oliver
April
4015 18″ × 14″ (46 × 35.5 cm) $6.00

Ann Dart
Mixed Bouquet
4151 16″ × 12″ (40.5 × 30.5 cm) $5.00

Ann Dart
Iris
4150 16″ × 12″ (40.5 × 30.5 cm) $5.00

Ann Dart
White Bouquet
4153 16″ × 12″ (40.5 × 30.5 cm) $5.00

Ann Dart
Geranium Basket
4149 16″ × 12″ (40.5 × 30.5 cm) $5.00

Ann Dart
Pansies
4152 16″ × 12″ (40.5 × 30.5 cm) $5.00

Rouviere
Blue and White
5030 22½ ″ × 18″ (56 × 46 cm) $9.00
1142 9¾ ″ × 8″ (25 × 20 cm) $1.50

Rouviere
Yellow Bouquet
5032 22″ × 18″ (56 × 46 cm) $9.00
1144 9¾ ″ × 8″ (25 × 20 cm) $1.50

Rouviere
White Bouquet
5031 22½ ″ × 18″ (56 × 46 cm) $9.00
1143 9¾ ″ × 8″ (25 × 20 cm) $1.50

Pierre Barat
Bouquet #1
5052 22″ × 18″ (56 × 46 cm) $9.00
1050 10″ × 8″ (25 × 20.5 cm) $1.50

Alice Asmar
Happy Magnolia
7096 30" × 22" (76 × 56 cm) $16.00

Alice Asmar
Memories
5162 18" × 19" (46 × 48.5 cm) $10.00

Alice Asmar
Columbus Queen & Antique Cloth
5164 18" × 18" (46 × 46 cm) $10.00

Pierre Barat
Bouquet #2
5053 22" × 18" (56 × 46 cm) $9.00
1051 10" × 8" (25 × 20.5 cm) $1.50

Alice Asmar
White Knight and Old Lace
5163 19¼ " × 18" (49 × 46 cm) $10.00

Elisee Maclet
The Red Mill
7030 20¼″ × 28″ (51.5 × 71 cm) $12.00

Bernard Buffet
Sailboat
9316 20″ × 25¾″ (51 × 65.5 cm) $16.00

Antoine Blanchard
Place du Luxembourg
4129 12″ × 18″ (30.5 × 46 cm) $4.50

Antoine Blanchard
Cafe de la Paix
4127 12″ × 18″ (30.5 × 46 cm) $4.50

Antoine Blanchard
Boulevard de la Madeleine
4126 12″ × 18″ (30.5 × 46 cm) $4.50

Antoine Blanchard
Champs Elysees
4128 12″ × 18″ (30.5 × 46 cm) $4.50

Edward Penfield (1866-1925)-*The Brooklyn Museum, N.Y.*
September, Harper's Poster, 1894-98
7109 30″ × 20″ (76 × 51 cm) $12.00
1189 10″ × 6⅝″ (25.5 × 17 cm) $1.50

Edward Penfield-*The Brooklyn Museum, N.Y.*
January, Harper's Poster, 1895
7108 30″ × 21¼″ (76 × 54 cm) $12.00
1188 10″ × 7⅛″ (25.5 × 18 cm) $1.50

Maxfield Parrish (1870-1966)-*The Brooklyn Museum, N.Y.*
Christmas Poster, Harper's Weekly, December 1895
7107 30″ × 20½″ (76 × 52 cm) $12.00
1162 10″ × 6⅝″ (25.5 × 17 cm) $1.50

Maxfield Parrish-*The Brooklyn Museum, N.Y.*
The Century Poster, Midsummer Holiday, August 1897
7106 30″ × 20″ (76 × 51 cm) $12.00
1161 10″ × 6⅝″ (25.5 × 17 cm) $1.50

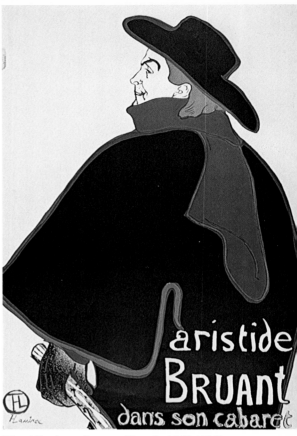

Henri Toulouse-Lautrec (French, 1864-1901)
Aristide Bruant Dans Son Cabaret
7028 27½ ″ × 18½ ″ (70 × 47 cm) $10.00
1252 10″ × 6⅝″ (25.5 × 17 cm) $1.50

Jules Cheret (1836-1933)
Lidia, Poster
7101 30″ × 21¼ ″ (76 × 54 cm) $15.00
1153 10″ × 7″ (25.5 × 18 cm) $1.50

Henri Toulouse-Lautrec
At the Nouveau Cirque:
The Dancer and the Five Stiff Shirts, 1891
Philadelphia Museum of Art
Purchased: The John D. McIlhenny Fund
7024 30″ × 21¾ ″ (76 × 55.5 cm) **$18.00**
1215 10″ × 7³/₈″ (25.5 × 19 cm) $1.50

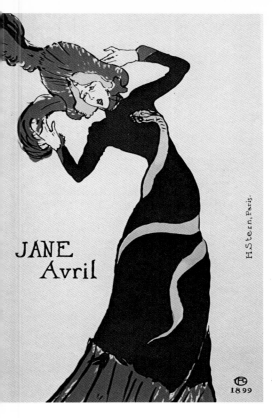

Henri Toulouse-Lautrec (1864-1901)
Jane Avril - Poster
7098 30'' × 20'' (76 × 50.5 cm) $12.00
1262 10'' × 6¾'' (25 × 17 cm) $1.50

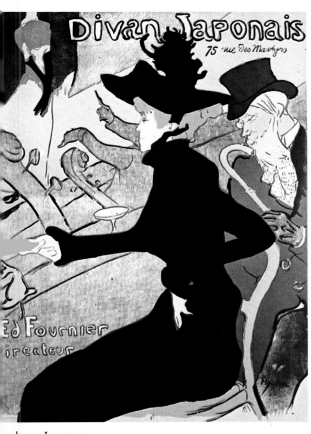

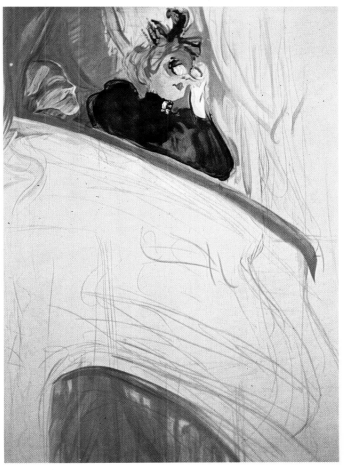

oulouse-Lautrec
ivan Japonais
tedelijk Museum, Holland
117 30″ × 23″ (76 × 58.5 cm) $10.00
239 10″ × 7⅝″ (25.5 × 19 cm) $1.50

Henri Toulouse-Lautrec
La Loge
Stedelijk Museum, Holland
7121 30″ × 21¾″ (76 × 55 cm) $10.00
1241 10″ × 7¼″ (25.5 × 18.5 cm) $1.50

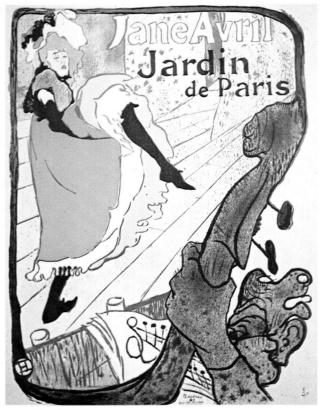

Henri Toulouse-Lautrec
Jardin De Paris
Stedelijk Museum, Holland
7118 30″ × 22″ (76 × 56 cm) $10.00
1240 10″ × 7⅜″ (25.5 × 19 cm) $1.50

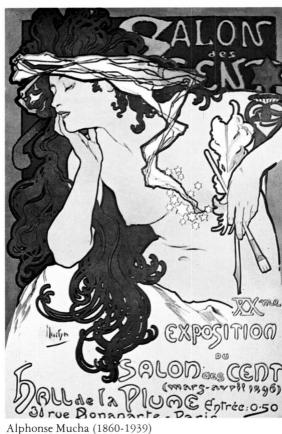

Alphonse Mucha (1860-1939)
Salon des Cent
Kunsthalle, Bremen
7071 30″ × 20″ (76 × 51 cm) $10.00
1120 10″ × 6½″ (25 × 17 cm) $1.50

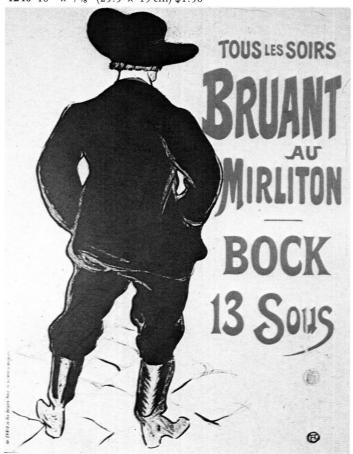

Henri Toulouse-Lautrec
Bruant Au Mirliton
Stedelijk Museum-Holland
7116 31¼″ × 23″ (79.5 × 58.5 cm) $10.00
1238 10″ × 7¾″ (25.5 × 19 cm) $1.50

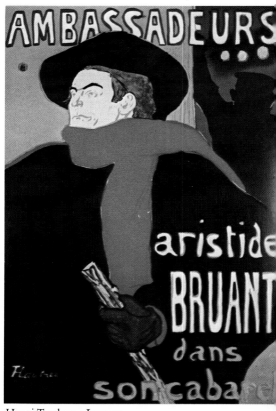

Henri Toulouse-Lautrec
Ambassadeurs
Stedelijk Museum, Holland
7115 33½″ × 23″ (85 × 58.5 cm) $10.00
1237 10″ × 6⅞″ (25.5 × 17.5 cm) $1.50

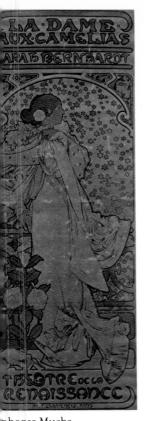
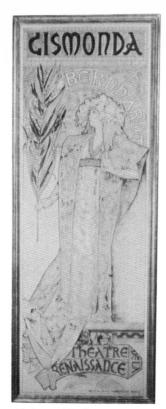

Alphonse Mucha
Sarah Bernhardt
36 27½″ × 10″ (70 × 25.5 cm) $8.00
21 10″ × 3½″ (25.5 × 9 cm) $1.50

Alphonse Mucha
Gismonda
Wichita Art Museum, Kansas
7105 27½″ × 9⅛″ (70 × 23 cm) $8.00
1185 10″ × 3⅜″ (25.5 × 8.5 cm) $1.50

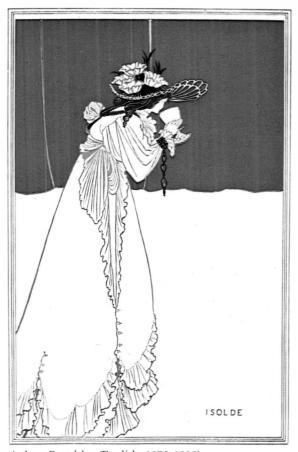

Aubrey Beardsley (English, 1872-1898)
Isolde
7060 27¼″ × 17¼″ (69 × 44 cm) $8.00
1053 10″ × 6¼″ (25 × 16 cm) $1.50

Georges De Feure
Lithographies Originales *Kunstindustrimuseet, Copenhagen*
15 30″ × 21¾″ (76 × 55 cm) $10.00
81 10″ × 7¼″ (25 × 18.5 cm) $1.50

Paul Berthon
Le Livre De Magda
Poesies Par Armand Silvestre
4267 22⅜″ × 15″ (57 × 38 cm) $10.00
1261 10″ × 6⅝″ (25.5 × 17 cm) $1.50

Gustav Klimt
Expectation #2
9625 Poster: 33½″ × 20¼″ (85 × 51 cm) $12.00

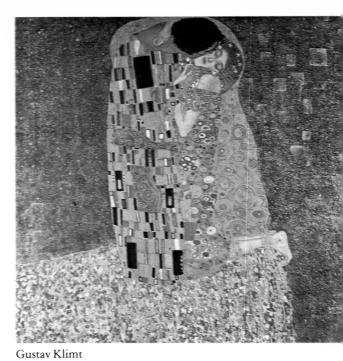

Gustav Klimt
The Kiss
9629 Poster: 27½″ × 27½″ (70 × 70 cm) $12.00
9113 Print: 11″ × 11″ (28 × 28 cm) $20.00

Gustav Klimt
Fulfillment
9626 Poster: 33½″ × 20¼″ (85 × 51 cm) $12.00

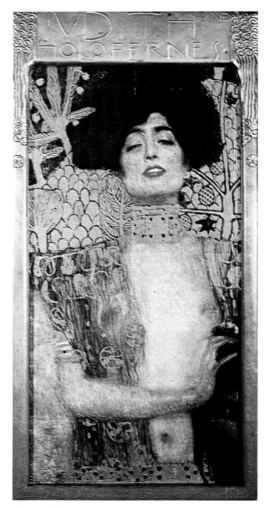

Gustav Klimt
Judith
9628 Poster: 37½″ × 18¼″ (95 × 46.5 cm) $12.00

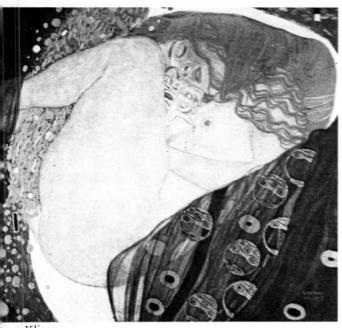

Gustav Klimt
Danae
5127 Poster: 29½″ × 29½″ (75 × 75 cm) $12.00
4512 10¼″ × 11″ (26 × 28 cm) $20.00

R. C. Gorman
Poster
5193 25″ × 29″ (63.5 × 74 cm) $20.00

Weyman Lew
''Swoon''
8097 36″ × 24″ (91 × 61 cm) $20.00

National Gallery of Art
Washington DC
12 November 1970 to
3 January 1971

**British painting
and sculpture
1960-1970**

British (Painting)
Poster
National Gallery of Art, Washington, D.C.
7016 36″ × 24″ (91.5 × 60 cm) $10.00

181

Arthur Secunda
Volcano Poster
7099 38″ × 19″ (96.5 × 48.5 cm) $20.00

Arthur Secunda
One Fine Dawn (Poster)
7086 35″ × 23″ (89 × 58.5 cm) sheet size $12.00

Arthur Secunda
Voyage - Poster
7123 34½″ × 22½″ (88 × 57 cm) $12.00

Andy Warhol
100 Cans (1962)
Albright-Knox Art Gallery, Buffalo, N.Y.
Gift of Seymour H. Knox
7094 30″ × 21¾″ (76 × 55 cm) $15.00
1177 10″ × 7¼″ (25.5 × 18 cm) $1.50

Friedensreich Hundertwasser (Austrian 1928-)
Regentag (Poster)
7075 33″ × 23½″ (84 × 60 cm) $18.00

Richard Hamilton
Poster
The Tate Gallery, London
9420 30″ × 20″ (76 × 51 cm) $10.00

Andy Warhol
Marilyn Monroe, 1964
The Tate Gallery, London
9421 30″ × 20″ (76 × 51 cm) $10.00

Fine art posters for gallery exhibits are a special publication service of Haddad's Fine Arts Inc.

Julian Dupre
Gathering the Hay
7062 18½″ × 25″ (47 × 63 cm) $12.00

Jean-Baptiste Corot (French, 1796-1875)
Ville D'Avray c. 1867-70
The National Gallery of Art, Washington D.C.
Gift of Count Cecil Pecci-Blunt
5123 18″ × 24″ (46 × 61 cm) $12.00
1180 7½″ × 10″ (19 × 25.5 cm) $1.50

Jean-Baptiste Corot
Souvenir De Mortefontaine
The Louvre Museum, Paris
5042 18″ × 24″ (46 × 61 cm) $12.00
1154 7½″ × 10″ (19 × 25.5 cm) $1.50

Jean Francois Millet, *The Louvre Museum, Paris*
The Gleaners
5094 18″ × 24″ (46 × 61 cm) $7.50
4107 11″ × 14½″ (28 × 37 cm) $3.00
1099 7¼″ × 9½″ (18.5 × 24 cm) $1.50

Jean Francois Millet *The Louvre Museum, Paris*
The Angelus, 1859
5093 19¾″ × 24″ (50 × 61 cm) $7.50
4106 11¾″ × 14″ (30 × 35.5 cm) $3.00
1098 8″ × 9½″ (20 × 24 cm) $1.50

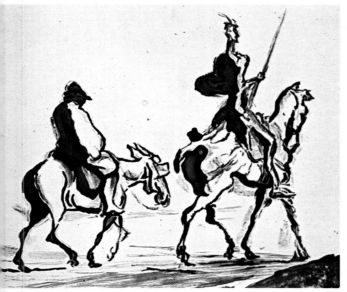

Henri Fantin-Latour
Flowers, 1865
The Louvre Museum, Paris
4160 18″ × 15¾″ (46 × 40 cm) $8.00
1080 9″ × 8″ (23 × 20 cm) $1.50

Henri Fantin-Latour (1836-1904)
Chrysanthemums 1879
Glasgow Art Gallery
5231 22½″ × 18″ (57 × 46 cm) $10.00
1258 10″ × 8″ (25.5 × 20 cm) $1.50

Henri Fantin-Latour
Daffodils and Tulips
The Louvre Museum, Paris
4161 18″ × 14½″ (46 × 37 cm) $8.00
1083 10″ × 8″ (25.5 × 20 cm) $1.50

Honore Daumier
Don Quixote
5061 16″ × 18½″ (40.5 × 47 cm) $7.50

Honore Daumier (French, 1808-1879)
Legal Studies
12 subjects sold by set only
9047 Black and white: $18.00 per set
9046 Hand colored: $36.00 per set
10″ × 7″ (25.5 × 18 cm)

Odilon Redon
Bouquet of Flowers
The Louvre Museum, Paris
5201 22½″ × 16″ (57 × 40.5 cm) $10.00
1193 10″ × 7⅛″ (25.5 × 18 cm) $1.50

185

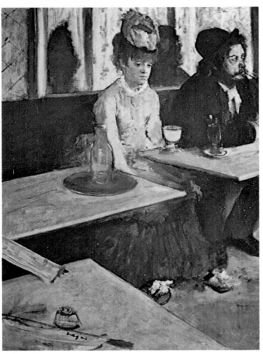

Edgar Degas
Absinth
The Louvre Museum, Paris
5062 24″ × 18″ (61 × 46 cm) $14.00
1072 10″ × 7½″ (25.5 × 18 cm) $1.50

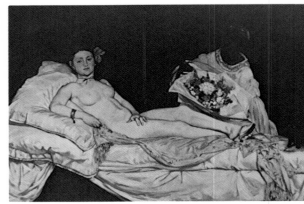

Edouard Manet
Olympia, 1863
The Louvre Museum, Paris
4168 12″ × 18″ (30.5 × 46 cm) $7.50
1160 6¾″ × 10″ (17 × 25.5 cm) $1.50

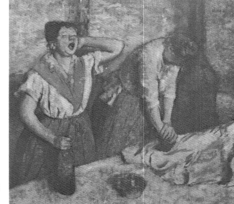

Edgar Degas (French, 1834-1917)
The Ironers c. 1884
The Louvre Museum, Paris
2086 14″ × 15¼″ (35.5 × 39 cm) $7.50
1017 8″ × 8¾″ (20 × 22 cm) $1.50

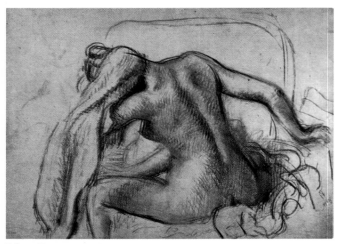

Edgar Degas
Woman Drying Her Neck
The Louvre Museum, Paris
4067 14½″ × 20″ (36.5 × 51 cm) $7.50
1075 7″ × 10″ (18 × 25.5 cm) $1.50

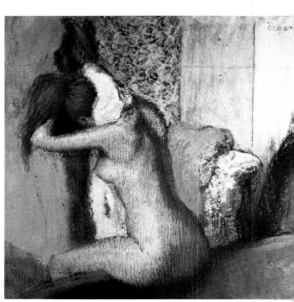

Edgar Degas
After the Bath
The Louvre Museum, Paris
5063 20¼″ × 21″ (51.5 × 53.5 cm) $12.00
1073 8″ × 8¼″ (20 × 21 cm) $1.50

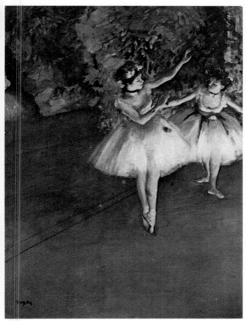

Edgar Degas
Two Dancers, 1877
Courtauld Institute Galleries, London
5138 24″ × 17¾″ (61 × 45.5 cm) $12.00
1055 10″ × 7¾″ (25.5 × 19 cm) $1.50

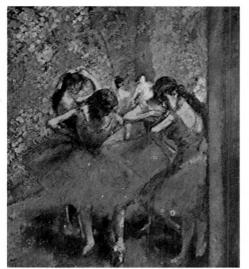

Edgar Degas
The Dancers in Blue
The Louvre Museum, Paris
5064 21″ × 18″ (53 × 46 cm) $10.00

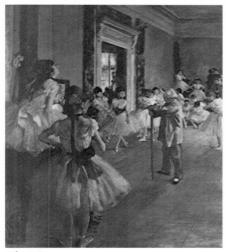

Edgar Degas
The Dancing Class
The Louvre Museum, Paris
4158 20½″ × 18″ (52 × 46 cm) $10.00
1016 9⅛″ × 8″ (23 × 20 cm) $1.50

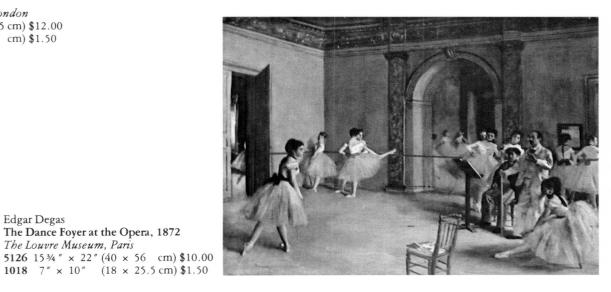

Edgar Degas
The Dance Foyer at the Opera, 1872
The Louvre Museum, Paris
5126 15¾″ × 22″ (40 × 56 cm) $10.00
1018 7″ × 10″ (18 × 25.5 cm) $1.50

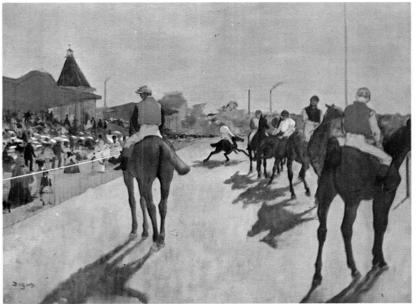

Edgar Degas
Ballerina and Lady with Fan
Philadelphia Museum of Art
The John G. Johnson Collection
4155 21¼″ × 16″ (54 × 40.5 cm) $10.00
1013 10″ × 7½″ (25.5 × 19 cm) $1.50

Edgar Degas
At The Race Course
The Louvre Museum, Paris
4154 16″ × 20¾″ (40.5 × 53 cm) $10.00
1012 7¾″ × 10″ (20 × 25.5 cm) $1.50

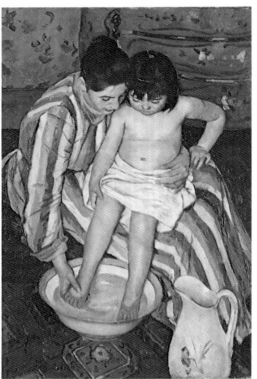

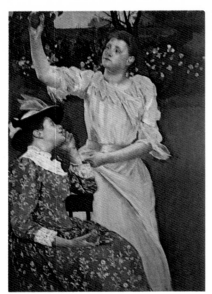

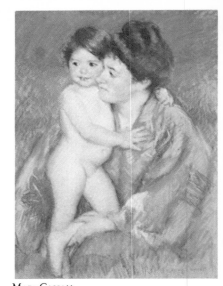

Mary Cassatt
Young Women Picking Fruit
Museum of Art, Carnegie Institute, Pittsburgh
Patrons Art Fund
5234 22½″ × 15¾″ (57 × 40 cm) $12.00
1259 10″ × 6⅞″ (25.5 × 17.5 cm) $1.50

Mary Cassatt
Woman with Baby
Sterling & Francine Clark Art Institute
Gift of the Executors of Governor
Lehman's Estate and the Edith &
Herbert Lehman Foundation
4169 21¼″ × 16″ (54 × 40.5 cm) $10.0
1036 10″ × 7½″ (25.5 × 19 cm) $1.5

Mary Stevenson Cassatt (American, 1845-1926)
The Bath, 1891
Art Institute of Chicago
Robert A. Waller Fund
4138 21″ × 14″ (53.3 × 35.5 cm) $10.00
1009 10″ × 6⅝″ (25.5 × 17 cm) $1.50

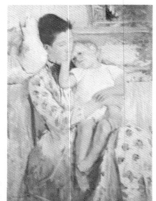

Mary Cassatt
Mother & Child, 1890
Wichita Art Museum, Kansas
The Roland P. Murdock Collection
4147 20″ × 14″ (51 × 35.5 cm) $8.00
1019 10″ × 7″ (25.5 × 18 cm) $1.50

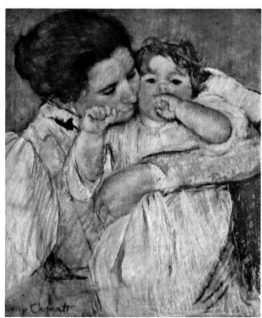

Mary Cassatt
Mother and Child, 1905
The Louvre Museum, Paris
4156 18″ × 14½″ (46 × 37 cm) $8.00
1014 9¾″ × 8″ (25 × 20 cm) $1.50

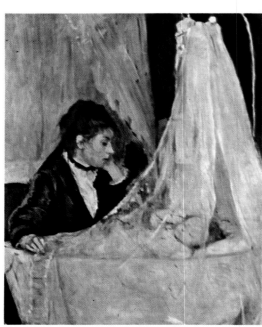

Berthe Morisot (French, 1841-1895)
The Cradle, 1873
The Louvre Museum, Paris
4184 18″ × 14¾″ (46 × 37.5 cm) $8.00
1184 9¾″ × 8″ (25 × 20 cm) $1.50

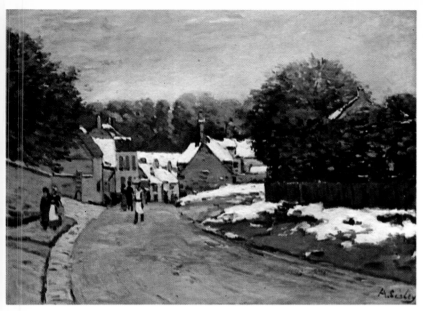

Alfred Sisley (French, 1839-1899)
Early Snow at Louveciennes
Museum of Fine Arts, Boston
9395 17¼″ × 23½″ (44 × 59.5 cm) $8.00

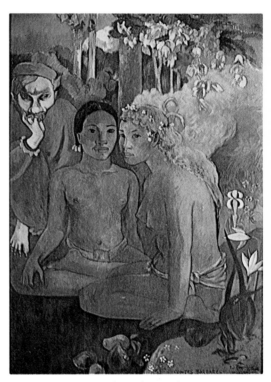

Paul Gauguin (French, 1848-1903)
Contes Barbares
4266 18″ × 12⅜″ (46 × 31.5 cm) $8.00

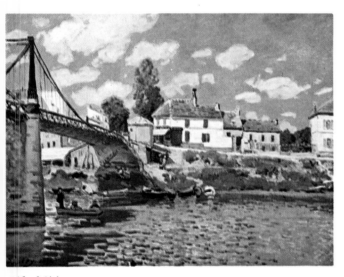

Alfred Sisley
The Bridge at Villeneuve
9394 17½″ × 22″ (44.5 × 56 cm) $10.00

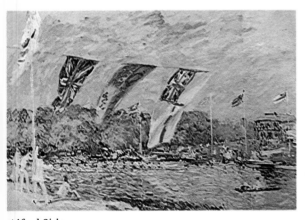

Alfred Sisley
The Regatta, 1874
The Louvre Museum, Paris
4123 14¼″ × 20″ (36 × 51 cm) $7.50
1025 7″ × 10″ (18 × 25.5 cm) $1.50

Camille Pissarro (French, 1831-1903)
Entrance to the Village of Voisins
The Louvre Museum, Paris
4205 14¾″ × 18″ (37.5 × 46 cm) $8.00
1191 8″ × 9¾″ (20 × 25 cm) $1.50

Camille Pissarro
The River Oise Near Pontoise, 1873
*Sterling and Francine Clark Art
Institute, Mass.*
4206 14¾″ × 18″ (37.5 × 46 cm) $8.00
1192 8″ × 9¾″ (20 × 25 cm) $1.50

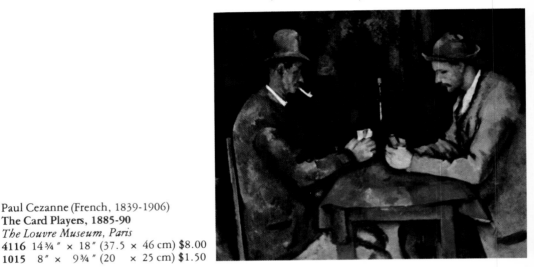

Paul Cezanne (French, 1839-1906)
The Card Players, 1885-90
The Louvre Museum, Paris
4116 14¾″ × 18″ (37.5 × 46 cm) $8.00
1015 8″ × 9¾″ (20 × 25 cm) $1.50

Paul Cezanne
**Landscape Near Aix, The River Plain
Of The Arc River**
*Museum of Art, Carnegie Institute,
Pittsburgh - Acquired through the generosity
of the Sarah M. Scaife Family*
5235 22½″ × 18″ (57 × 46 cm) $12.00
1260 10″ × 8″ (25 × 20 cm) $1.50

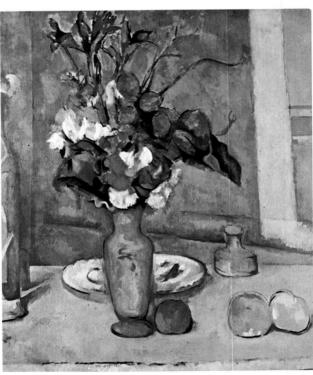

Paul Cezanne
Mount St. Victoire (Sans Viaduct)
The Hermitage, Leningrad
9317 18¾″ × 23¾″ (47 × 60 cm) $10.00

Paul Cezanne
The Blue Vase, 1885-87
The Louvre Museum, Paris
4139 20″ × 16¼″ (51 × 41 cm) $10.00
1010 10″ × 8″ (25.5 × 20 cm) $1.50

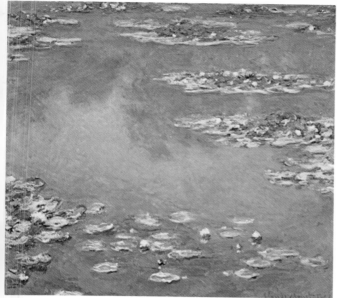

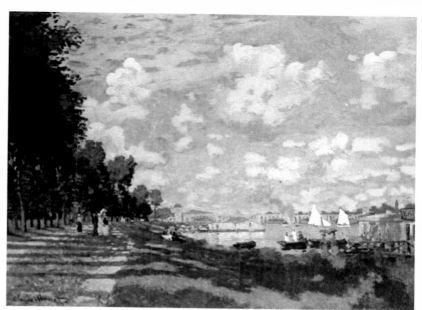

Claude Monet
Waterlilies, 1906
Art Institute of Chicago
Mr. & Mrs. Martin A. Ryerson Collection
7104 22″ × 23″ (56 × 58.5 cm) $16.00
1183 8″ × 8⅜″ (20 × 21 cm) $1.50

Claude Monet (French, 1840-1926)
The Bassin at Argenteuil, 1874
The Louvre Museum, Paris
4202 14″ × 18½″ (36 × 47 cm) $8.00

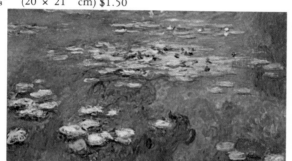

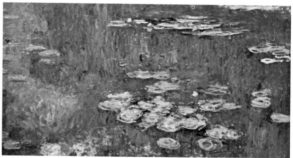

Claude Monet
Nympheas
Museum of Art, Carnegie Institute,
Pittsburgh - Acquired through the
generosity of Mrs. Alan M. Scaife
7152 Left Panel 17½″ × 30″ (44.5 × 76 cm) $16.00
7153 Right Panel 17½″ × 30″ (44.5 × 76 cm) $16.00
 (When joined the print is 17½″ × 53″)

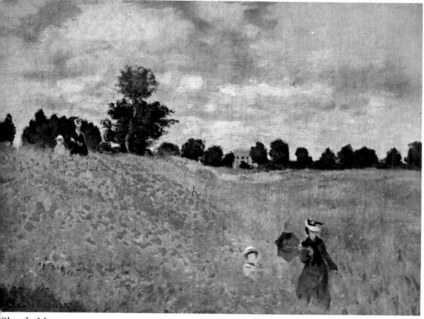

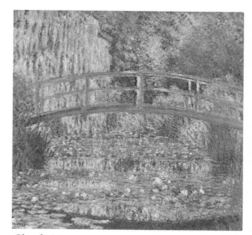

Claude Monet
Corn Poppies
The Louvre Museum, Paris
6096 18½″ × 24″ (47 × 61 cm) $12.00
4108 14″ × 18¼″ (35.5 × 46.5 cm) $6.00
4102 7½″ × 10″ (19 × 25.5 cm) $1.50

Claude Monet
Bassin Aux Nymphea's
The Louvre Museum, Paris
4203 14½″ × 15″ (37 × 38 cm) $8.00
1182 8″ × 8⅜″ (20 × 21 cm) $1.50

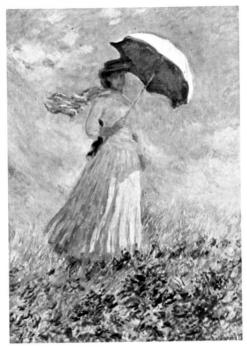

Claude Monet
Woman with an Umbrella, 1886
The Louvre Museum, Paris
5097 20″ × 13½″ (51 × 35 cm) $7.50
1103 10″ × 6¾″ (25.5 × 17 cm) $1.50

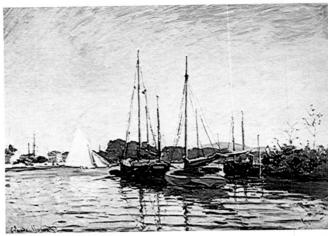

Claude Monet
The Pleasure Boats, c.1873
The Louvre Museum, Paris
5098 18″ × 25″ (46 × 63 cm) $12.00
4109 13″ × 18″ (33 × 46 cm) $6.00
1104 7¼″ × 10″ (18.5 × 25.5 cm) $1.50

Claude Monet
Waterlilies at Giverny, 1908
9131 14″ × 13¾″ (36 × 35 cm) $12.00

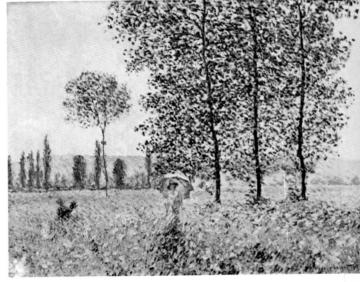

Claude Monet
Fields in Spring, 1887
Staatsgalerie, Stuttgart
5200 19½″ × 24″ (49.5 × 61 cm) $14.00
1181 8″ × 9⅞″ (20 × 25 cm) $1.50

Claude Monet
Pool, with Waterlilies, 1904
The Louvre Museum, Paris
9130 13¼″ × 13¾″ (34 × 35 cm) $12.00

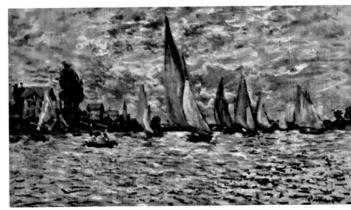

Claude Monet
The Boats, Regatta at Argenteuil, 1874
The Louvre Museum, Paris
4260 11″ × 18½″ (28 × 47 cm) $8.00

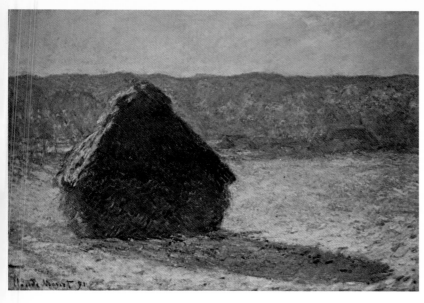

Claude Monet, (1840-1926)
Haystacks In Winter, 1891
Museum of Fine Arts, Boston
J. C. Edwards Collection
5221 17¾" × 24" (45 × 61 cm) $10.00

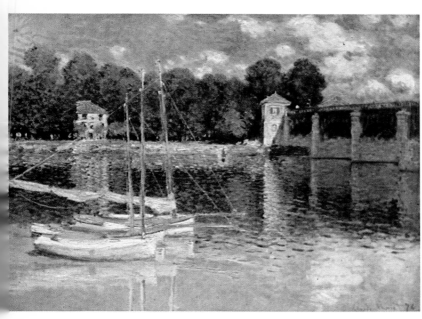

Claude Monet
Bridge at Argenteuil, 1874
The Louvre Museum, Paris
5099 16½" × 22" (42 × 56 cm) $10.00
1105 7½" × 10" (19 × 25.5 cm) $1.50

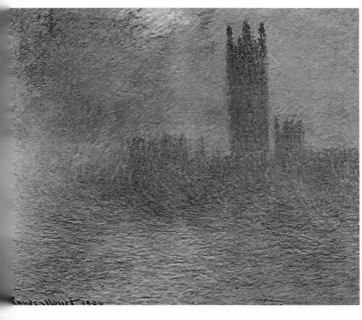

Claude Monet
London Houses of Parliament
The Louvre Museum, Paris
5100 21" × 24" (53 × 61 cm) $14.00
1106 8" × 9" (20 × 22 cm) $1.50

Pierre Auguste Renoir (French, 1841-1919)
A Girl with a Watering Can, 1876
National Gallery of Art Washington, D.C.
Chester Dale Collection
5204 24″ × 18″ (61 × 46 cm) $12.00
1199 10″ × 7½″ (25.5 × 19 cm) $1.50

Pierre Auguste Renoir
Two Seated Young Girls
Philadelphia Museum of Art
Mr. & Mrs. Carroll Tyson Collection
4212 20″ × 16″ (51 × 41 cm) $10.00
1204 10″ × 8″ (25.5 × 20 cm) $1.50

Pierre Auguste Renoir
Two Girls at the Piano, 1892
The Louvre Museum, Paris
4211 21″ × 16″ (53 × 41 cm) $10.00
1203 10″ × 7⅝″ (25.5 × 19 cm) $1.50

Pierre Auguste Renoir
Little Girl with a Hat
886 20¾″ × 15¾″ (52.5 × 40 cm) $16.00

Pierre Auguste Renoir
The Bathers, 1887
Philadelphia Museum of Art
Mr. & Mrs. Carroll S. Tyson Collection
4207 14″ × 21¼″ (35.5 × 54 cm) $10.00
1198 6⅝″ × 10″ (17 × 25.5 cm) $1.50

Pierre Auguste Renoir
Gabrielle and Jean
The Louvre Museum, Paris
024 22″ × 18″ (56 × 46 cm) $10.00

Pierre Auguste Renoir
In the Meadow, 1895
9670 28″ × 22″ (71 × 56cm) $18.00

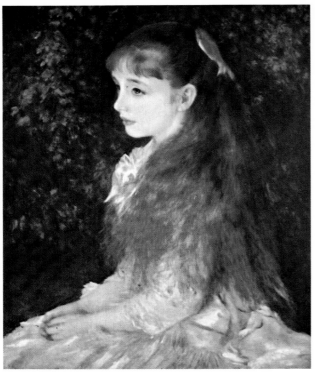

Pierre Auguste Renoir
Mademoiselle Irene
Collection Buhrle, Zurich
4209 20″ × 16″ (51 × 40.5 cm) $12.00
1251 10″ × 8″ (25.5 × 20 cm) $1.50

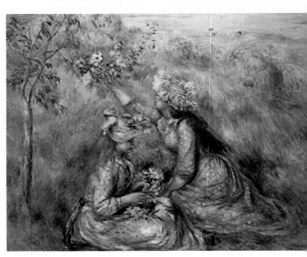

Pierre Auguste Renoir
Girls Picking Flowers
Museum of Fine Arts, Boston, Mass.
4242 16″ × 20″ (41 × 51.5 cm) $10.00
1219 8″ × 10″ (20 × 25.5 cm) $1.50

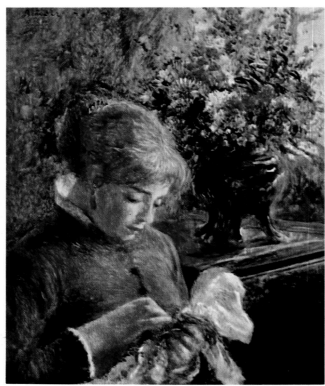

Pierre Auguste Renoir
Lady Sewing, 1879
Art Institute of Chicago
Mr. & Mrs. Lewis L. Coburn - Memorial Collection
4208 20″ × 16½″ (51 × 42 cm) $10.00
1200 9¾″ × 8″ (27 × 24.5cm) $1.50

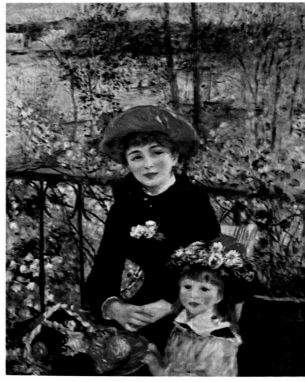

Pierre Auguste Renoir
On The Terrace, 1881
Art Institute of Chicago
Mr. & Mrs. Lewis L. Coburn Memorial Collection
5205 22½″ × 18″ (57 × 46 cm) $10.00
1202 10″ × 8″ (25.5 × 20 cm) $1.50

Pierre Auguste Renoir
Women in a Field
The Louvre Museum, Paris
7041 20″ × 25″ (51 × 63.5 cm) $15.00
4120 14½″ × 18″ (37 × 46 cm) $6.00
1136 8″ × 10″ (20 × 25.5 cm) $1.50

Pierre Auguste Renoir
Luncheon of the Boating Party, 1881
The Phillips Collection, Washington
9671 26½″ × 36″ (67.5 × 91.5 cm) $20.00

Pierre Auguste Renoir
Blonde Bather
Kunsthistorisches Museum, Wien
5025 24″ × 19¼″ (61 × 49 cm) $12.00
4121 15″ × 12″ (38 × 31 cm) $4.00
1137 10″ × 8″ (25 × 20 cm) $1.50

Pierre Auguste Renoir
Dance at Bougival, 1883
9385 24″ × 12½″ (60.5 × 32 cm) $8.00

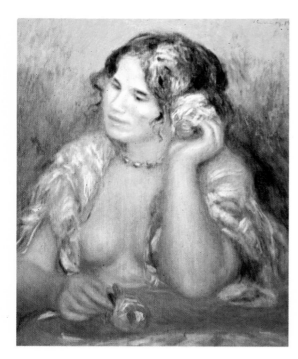

Pierre Auguste Renoir
Gabrielle with a Rose, 1911
The Louvre Museum, Paris
5026 20″ × 16½″ (51 × 42 cm) $12.00
1138 9¾″ × 8″ (27 × 24.5cm) $1.50

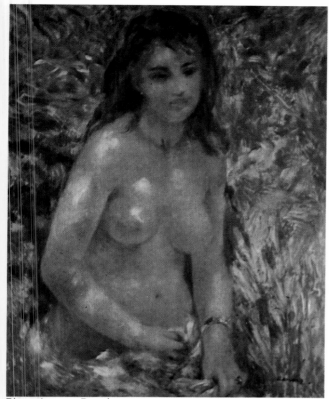

Pierre Auguste Renoir
Nude in the Sun
The Louvre Museum, Paris
4210 18″ × 14¼″ (46 × 37 cm) $8.00
1201 10″ × 7¾″ (25.5 × 19.5 cm) $1.50

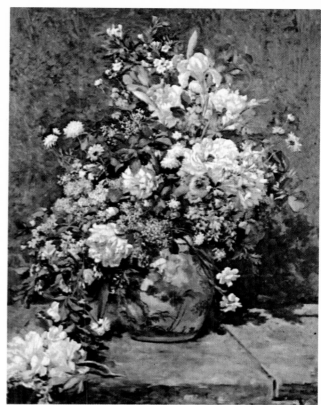

Pierre Auguste Renoir
Large Vase of Flowers - 1866
Fogg Museum of Art-Cambridge, Mass.
5214 24″ × 18″ (61 × 46 cm) $10.00
1242 10″ × 7½″ (25.5 × 19 cm) $1.50

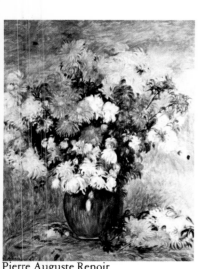

Pierre Auguste Renoir
Vase of Chrysanthemums
Rouen Museum, France
5027 24″ × 18″ (61 × 46 cm) $10.00
1139 10″ × 7½″ (25 × 19 cm) $1.50

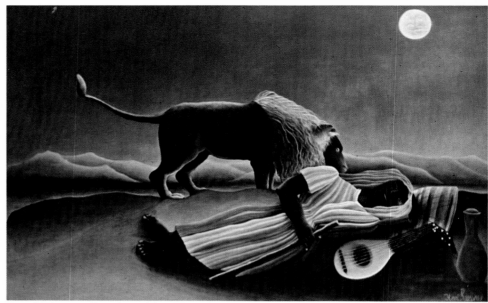

Henri Rousseau (French, 1844-1910)
The Sleeping Gypsy, 1897
Museum of Modern Art, New York
9676 17¼″ × 26¾″ (44 × 68 cm) $10.00

Henri Rousseau
The Snake Charmer, 1907
The Louvre Museum, Paris
5029 19½″ × 22″ (50 × 56 cm) $10.00
1141 8″ × 9″ (20 × 23 cm) $1.50

Henri Rousseau
Jungle Sunset, 1909
Kunstmuseum, Basel
5028 17¾″ × 25½″ (45 × 64 cm) $10.00
1140 7″ × 10″ (18 × 25 cm) $1.50

Vincent Van Gogh
Peasant Reaping, 1885
Stedelijk Museum, Holland
9092 15″ × 18¾″ (38 × 48 cm) $8.00

Vincent Van Gogh (Dutch, 1853-1890)
Peasant Digging, 1885
Stedelijk Museum, Holland
9091 20″ × 15¾″ (51 × 40 cm) $8.00

Vincent Van Gogh
Woman Gleaning, 1885
9097 19½″ × 16″ (49 × 40.5 cm) $8.00

Vincent Van Gogh
Peasant Reaping Corn, 1885
9093 19½″ × 13½″ (49.5 × 34 cm) $8.00

Vincent Van Gogh
Peasant Woman Digging, 1885
Stedelijk Museum, Holland
9094 20½″ × 15″ (52 × 38 cm) $8.00

Vincent Van Gogh
Grinding Coffee, 1881
Rijksmuseum Kroller-Muller, Otterlo
9084 19½″ × 13¾″ (49.5 × 35 cm) $8.00

Vincent Van Gogh
Boy with Sickle, 1881
9081 15½″ × 20″ (39.5 × 51 cm) $8.00

Vincent Van Gogh
The Fountain in the Hospital Garden
Stedelijk Museum, Holland
9342 19″ × 17½″ (48 × 44.5 cm) $8.00

Vincent Van Gogh
The Road with Poplars, 1885
Stedelijk Museum, Holland
9096 19¾″ × 14¼″ (50 × 36 cm) $8.00

Vincent Van Gogh
Pollard Birches and Shepherd, 1885
Stedelijk Museum, Holland
9095 15″ × 20¼″ (38 × 51.5 cm) $8.00

Vincent Van Gogh
Old Shoes
Stedelijk Museum, Holland
9086 10¼″ × 12¼″ (26 × 31 cm) $5.00

Vincent Van Gogh
La Meridienne (D'Apres Millet)
The Louvre Museum, Paris
4233 14½″ × 18″ (37 × 46 cm) $8.00
1228 8″ × 10″ (20 × 25.5 cm) $1.50

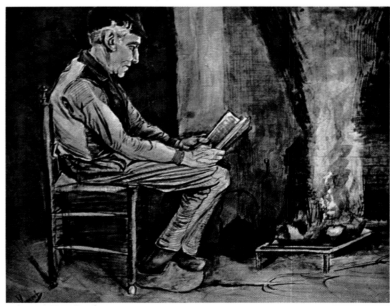

Vincent Van Gogh
Orchard in Provence, 1888
9090 14¼″ × 19½″ (36 × 49.5 cm) $8.00

Vincent Van Gogh
Bedroom at Arles
The Louvre Museum, Paris
4227 16″ × 20¼″ (40.5 × 51.5 cm) $10.00
1222 8″ × 10″ (20 × 25.5 cm) $1.50

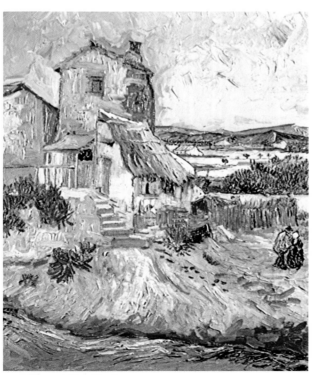

Vincent Van Gogh
The Old Mill, 1888
Albright-Knox Art Gallery, Buffalo, N.Y.
Bequest of A. Conger Goodyear
5182 24″ × 20″ (61 × 51 cm) $15.00
1175 9⅝″ × 8″ (25 × 20 cm) $1.50

Vincent Van Gogh
Man Reading, 1881
9085 16″ × 19¾″ (40.5 × 50 cm) $8.00

Vincent Van Gogh
Potato Eaters, 1885
Stedelijk Museum, Holland
9349 17¾″ × 24¾″ (45 × 63 cm) $12.00

Vincent Van Gogh
Field of Flowers
9611 19¼″ × 26¾″ (48.5 × 68 cm) $16.00

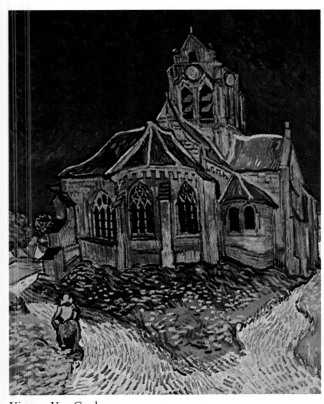

Vincent Van Gogh
Church at Auvers, 1890
The L'Impressionnisme Museum, Paris
4229 21¼″ × 17″ (54 × 43 cm) $10.00
1224 10″ × 7¾″ (25.5 × 20 cm) $1.50

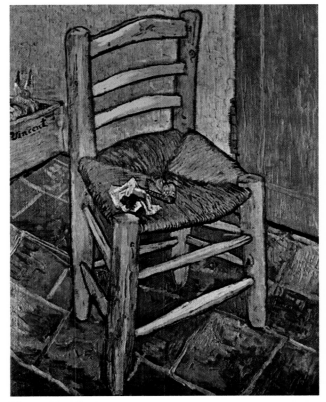

Vincent Van Gogh
The Chair and the Pipe, 1888-89
9082 15″ × 11¾″ (38 × 29 cm) $6.00

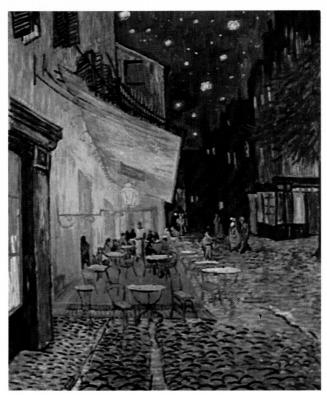

Vincent Van Gogh
Open Air Cafe
Rijkmuseum Kroller-Muller, Otterlo
9088 20″ × 16″ (51 × 40.5 cm) $10.00
9089 12½″ × 10″ (32 × 25.5 cm) $4.50

Vincent Van Gogh
The Restaurant de la Sirene
The L'Impressionnisme Museum, Paris
5075 15″ × 18″ (39 × 46 cm) $7.50
1084 8″ × 9½″ (20 × 24 cm) $1.50

Vincent Van Gogh
The Fields of Auvers
Neuve Staats Gallerie, Munich
4230 16″ × 20¼″ (41 × 51.5 cm) $10.00
1225 7¾″ × 10″ (20 × 25.5 cm) $1.50

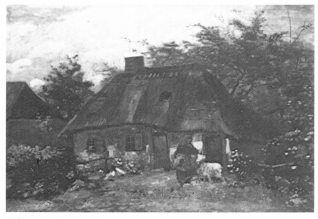

Vincent Van Gogh
Thatched Cottage
Stadelsches Kunstinstitue, Frankfort
4236 14½″ × 21½″ (37 × 55 cm) $10.00
1232 6¾″ × 10″ (17 × 25.5 cm) $1.50

Vincent Van Gogh
Thatched Cottages at Cordeville
The L'Impressionnisme Museum, Paris
5074 16″ × 20¼″ (40.5 × 51 cm) $10.00
1085 8″ × 10″ (20 × 25.5 cm) $1.50

Vincent Van Gogh
Gypsy Camp, 1888
The Louvre Museum, Paris
4232 16″ × 18″ (40.5 × 46 cm) $8.00
1227 8″ × 9″ (20 × 23 cm) $1.50

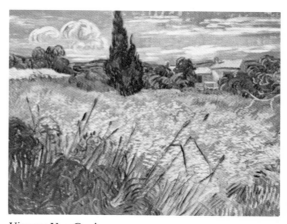

Vincent Van Gogh
Cypress with a Star
9341 21¼″ × 16¾″ (54 × 42.5 cm) $12.00
9083 13″ × 10″ (33 × 25 cm) $4.00

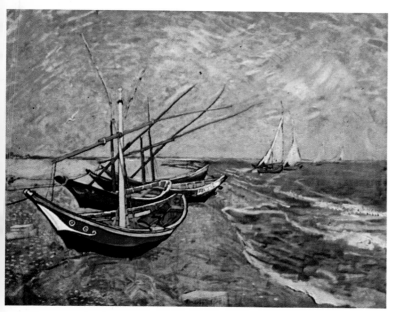

Vincent Van Gogh
Boats at Saintes-Maries, 1888
Stedelijk Museum, Holland
9340 17″ × 22″ (44 × 55 cm) $10.00

Vincent Van Gogh
The Green Corn
Narodni Galerie, Prague
4231 20¼″ × 16″ (51.5 × 40.5 cm) $10.00
1226 10″ × 7¾″ (25.5 × 20 cm) $1.50

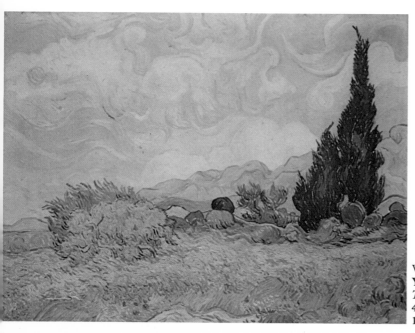

Vincent Van Gogh
Yellow Corn & Cypress, 1889
The National Gallery, London
4238 16″ × 20¾″ (40.5 × 53 cm) $10.00
1234 7⅝″ × 10″ (19 × 25.5 cm) $1.50

Vincent Van Gogh
The Vegetable Garden, 1888
Stedelijk Museum, Holland
9350 17″ × 21½″ (43 × 54.5 cm) $10.00

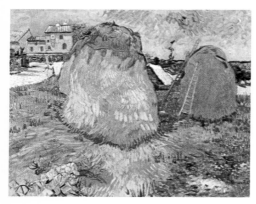

Vincent Van Gogh
Haystacks in Provence
Kroller Muller, Holland
9343 19″ × 23¾″ (48 × 60 cm) $12.00

Vincent Van Gogh
The Orchard, 1889
Courtauld Institute Galleries, London
7114 19¾″ × 24″ (50 × 61 cm) $12.00
1229 8″ × 9¾″ (20 × 25 cm) $1.50

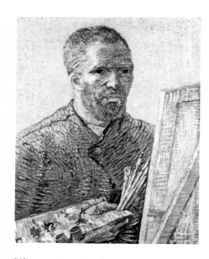

Vincent Van Gogh
Self-Portrait at his Easel, 1888
Stedelijk Museum, Amsterdam
9348 23½″ × 18″ (60 × 46 cm) $12.00

Vincent Van Gogh
The Poppy Field
Kunsthalle, Bremen
5073 18″ × 23¼″ (46 × 59 cm) $10.00

Vincent Van Gogh
Peach Tree in Bloom, 1888
Stedelijk Museum, Holland
345 24″ × 18″ (61 × 46 cm) $12.00

Vincent Van Gogh
View of Arles
Neuve Staatsgallerie, Munich
4237 16″ × 20½″ (40.5 × 52 cm) $10.00
1233 7¾″ × 10″ (20 × 25.5 cm) $1.50

Vincent Van Gogh
Pink Orchard, 1888
Stedelijk Museum, Holland
347 17½″ × 22″ (44 × 56 cm) $12.00

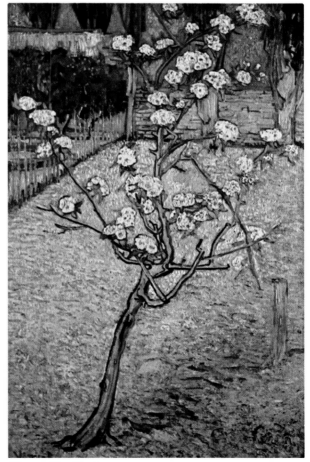

Vincent Van Gogh
Pear Tree in Bloom, 1888
Stedelijk Museum, Holland
9346 25½″ × 16″ (65 × 41 cm) $12.00
9077 14″ × 8¾″ (35.5 × 22.5 cm) $4.50

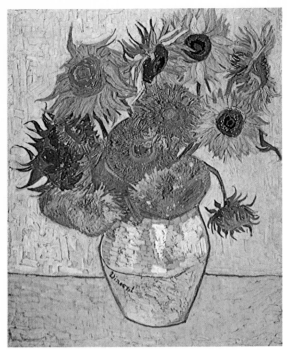

Vincent Van Gogh
Sunflowers (Green Background, 1888)
Staatsgallerie Moderne Kunst-Munich
5211 24″ × 19″ (61 × 48 cm) $12.00
1230 10″ × 8″ (25.5 × 20 cm) $1.50

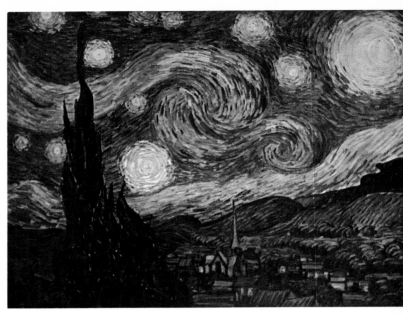

Vincent Van Gogh
Starry Night, 1889
Museum of Modern Art, New York
9612 21″ × 26″ (53.5 × 66 cm) $10.00

Vincent Van Gogh
Sunflowers, 1888
Philadelphia Museum of Art
The Mr. & Mrs. Carroll S. Tyson Collection
4235 20¼″ × 16″ (51.5 × 40.5 cm) $10.00

Vincent Van Gogh
Bell Lilies in a Copper Vase, 1886
The Louvre Museum, Paris
4228 18″ × 14¼″ (46 × 36 cm) $8.00
1223 8″ × 7⅞″ (20 × 20 cm) $1.50

Vincent Van Gogh
Crows Over Cornfields, 1890
9610 16″ × 33¼″ (41 × 85 cm) $12.00

Vincent Van Gogh
The Olive Grove, 1889
Kroller Muller, Otterlo, Holland
9087 16″ × 20″ (40.5 × 51 cm) $12.00

Vincent Van Gogh
Irises, 1890
Stedelijk Museum, Holland
9344 22½″ × 18″ (57 × 46 cm) $12.00

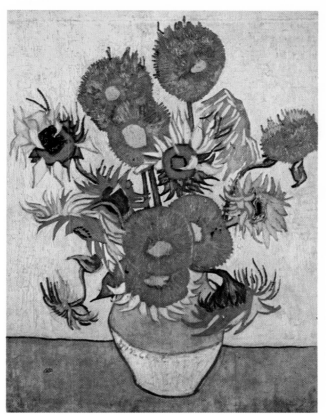

Vincent Van Gogh
Sunflowers (Yellow Background), 1888
Stedelijk Museum, Holland
9330 24″ × 18″ (60 × 46 cm) $10.00
9078 15″ × 12″ (38 × 30 cm) $4.50

Vincent Van Gogh
Sunflowers, 1887
The Metropolitan Museum of Art, N.Y.
Rogers Fund, 1949
4234 12¾″ × 18″ (32.5 × 46 cm) $6.00
1231 7⅛″ × 10″ (18 × 25.5 cm) $1.50

Vincent Van Gogh
Sunflowers, 1887
Rijksmuseum Kroller-Muller, Otterlo
9613 15¾″ × 26¼″ (40 × 66 cm) $12.00

Henri de Toulouse-Lautrec (1864-1901)
Jane Avril
Sterling and Francine Clark
Art Institute, Mass.
4225 18″ × 12″ (46 × 30.5 cm) $8.00
1217 10″ × 6⅝″ (25.5 × 17 cm) $1.50

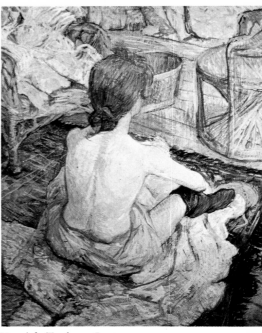

Henri de Toulouse-Lautrec
La Toilette
5045 20″ × 16½″ (50 × 42 cm) $10.00
1033 9½″ × 8″ (24.5 × 20 cm) $1.50

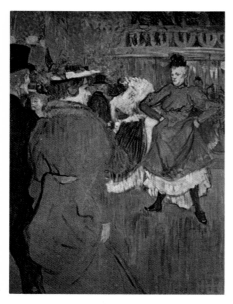

Henri de Toulouse-Lautrec
Quadrille at the Moulin Rouge, 1892
National Gallery of Art - Washington, D.C.
Chester Dale Collection
4226 18¾″ × 14″ (48 × 35.5 cm) $8.00
1218 10″ × 7½″ (25.5 × 19 cm) $1.50

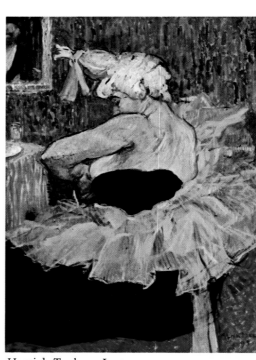

Henri de Toulouse-Lautrec
The Clownesse Cha-U-Kao, 1895
The Louvre Museum, Paris
4224 19″ × 14¼″ (48 × 36 cm) $8.00
1216 10″ × 7¼″ (25.5 × 18.5 cm) $1.50

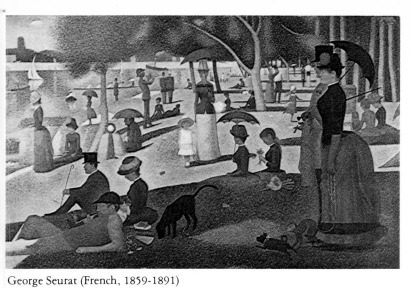

George Seurat (French, 1859-1891)
**A Sunday Afternoon on the Island
of La Grand Jatte 1884-86**
Art Institute of Chicago
Helen Birch Bartlett Memorial Collection
7079 18″ × 26¾″ (46 × 68 cm) $12.00
1208 6¾″ × 10″ (17 × 25.5 cm) $1.50

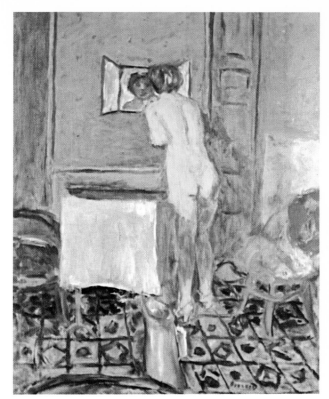

Pierre Bonnard (French, 1867-1947)
Nude Before the Fireplace, 1917
Kunstmuseum, Basel
5055 24″ × 18¾″ (61 × 48 cm) $12.00
1057 10″ × 7¾″ (25 × 19.5 cm) $1.50

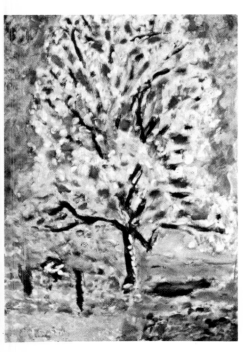

Pierre Bonnard
The Almond Tree in Bloom
National Museum of Modern Art, Paris
5054 21″ × 14¼″ (53.5 × 36 cm) $10.00
1056 10″ × 7″ (25.5 × 17.5 cm) $1.50

Paul Klee (Swiss, 1879-1940)
They're Biting, 1920
The Tate Gallery, London
9111 12½" × 9½" (32 × 24 cm) $4.00

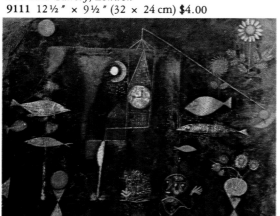

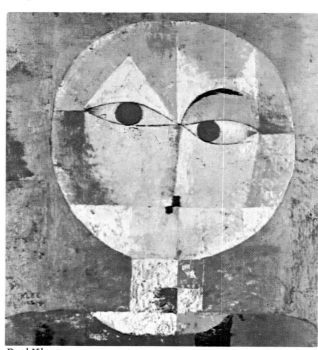

Paul Klee
Castle and Sun, 1928
The Tate Gallery, London
9364 18" × 21¾" (46 × 55 cm) $8.00

Paul Klee
Fish Magic, 1925
Philadelphia Museum of Art
The Louise and Walter Arensburg Collection
5194 18½" × 24" (47 × 61 cm) $10.00
1159 7⅝" × 10" (19 × 25.5 cm) $1.50

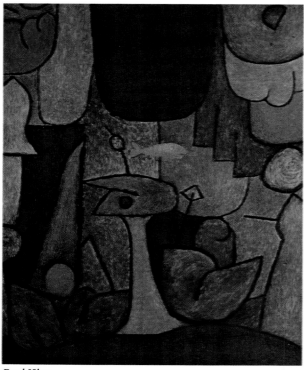

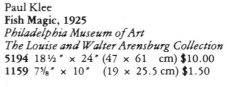

Paul Klee
Underwater Garden, (Sub-marine Garden,) 1939
Private Collection, Bern
9365 21¾" × 17¾" (56 × 45 cm) $8.00

Paul Klee
Senecio
Kunstmuseum, Basel
5087 17" × 16" (43.5 × 41 cm) $10.00
1078 8½" × 8" (21.5 × 20 cm) $1.50

Lyonel Feininger
Church of the Minorites II
Walker Art Center, Minneapolis
9063 19½″ × 16½″ (49 × 42 cm) $5.00

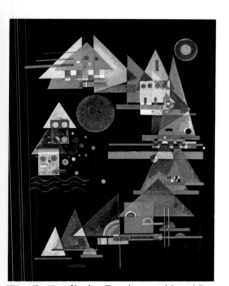

Wassily Kandinsky (Russian, 1866-1944)
Points in a Bow, 1927
9363 22½″ × 17″ (57 × 43.5 cm) $8.00

Paul Klee
Sinbad the Sailor, 1923
4010 13″ × 19″ (33 × 48 cm) $8.00

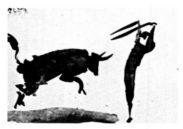

Pablo Picasso
Bullfight Set
Sold by set only
5105 16½″ × 11½″ (42 × 29.5 cm) $14.00 set

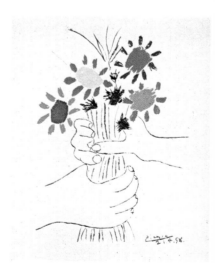

Pablo Picasso
Don Quixote, 1955
5122 Sheet size: 24″ × 18″ (61 × 46 cm) $7.50

Special Note (Not Illustrated)
Picasso
European BOOKPLATES FROM THE TOROS
(BULLFIGHT) SERIES. Plates Have one
or more reproductions per sheet -
no duplications. Random assortments.
Sheet size 10½″ × 14½″ (27 × 37 cm)
Packaged 30 sheets assorted $20.00
 12 sheets assorted $12.00
Quantity is limited to stock on hand
Subject to prior sale

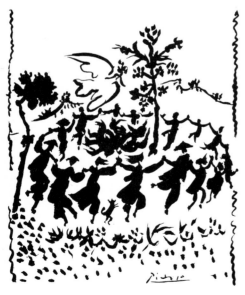

Pablo Picasso
Vive la Paix
5110 24″ × 18″ (61 × 46 cm) $7.50
1052 10″ × 7½″ (25 × 19 cm) $1.50

Pablo Picasso
Summer Bouquet
5109 24″ × 20″ (61 × 51 cm) $7.50

Pablo Picasso
Bouquet with Hands
5104 24″ × 20″ (61 × 51 cm) $7.50

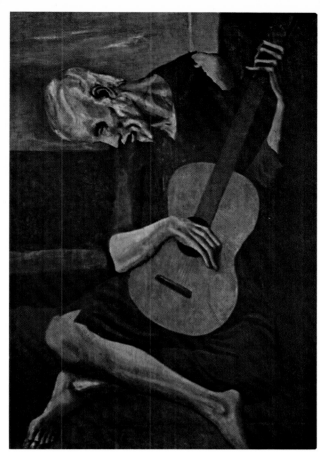

Pablo Picasso
The Old Guitarist, 1903
Art Institute of Chicago
Helen Birch Bartlett Memorial Collection
7110 26¾" × 18" (68 × 46 cm) $12.00
1190 10" × 6¾" (25.5 × 17 cm) $1.50

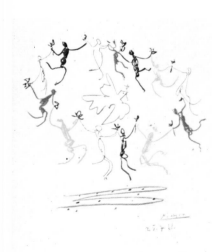

Pablo Picasso
La Ronde
5108 24" × 20" (61 × 51 cm) $7.50

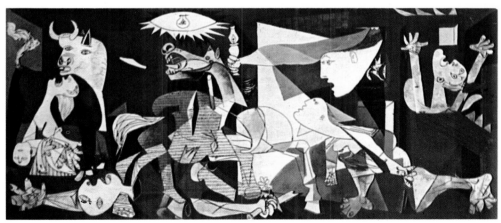

Pablo Picasso
Guernica, 1937
Museum of Modern Art, New York
9657 22" × 48½" (56 × 123 cm) $15.00

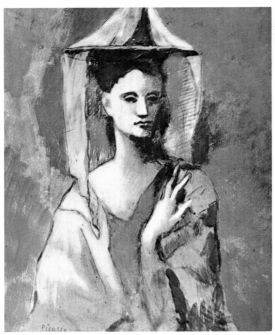

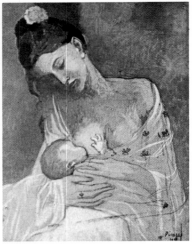

Pablo Picasso
Maternity
9169 19¼″ × 14¾″ (49 × 37.5 cm) $16.00

Pablo Picasso
The Girl of Majorca
Hermitage Museum, Leningrad
5107 22½″ × 18″ (57 × 46 cm) $10.00
1049 10″ × 7½″ (25 × 19.5 cm) $1.50

Marc Chagall
Blue Donkey
Kunstmuseum, Basel
2022 6½″ × 9¾″ (16 × 25 cm) $4.00

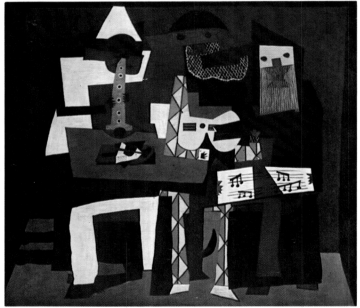

Pablo Picasso
The Three Musicians, 1921
Museum of Modern Art, New York
9384 21″ × 23½″ (53.5 × 60 cm) $10.00

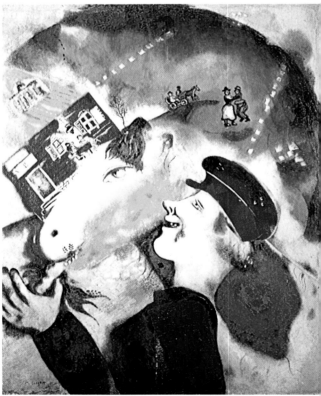

Marc Chagall (French, 1887-)
Peasant Village (1925)
Albright-Knox Art Gallery, Buffalo, N.Y.
Room of Contemporary Art Fund
7089 25″ × 20″ (63.5 × 51 cm) $15.00
1173 10″ × 8″ (25.5 × 20 cm) $1.50

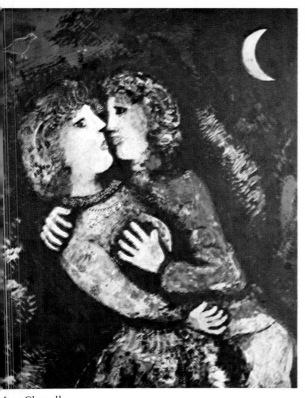

Marc Chagall
Two Lovers
Stedelijk Museum, Holland
9318 24″ × 18¼″ (61 × 46.5 cm) $10.00

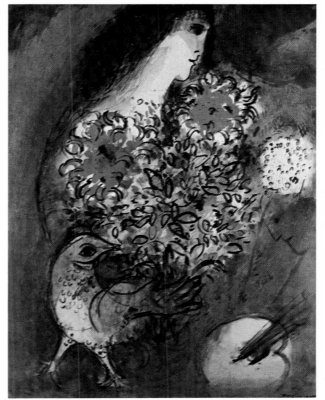

Marc Chagall
Woman, Flowers and Bird
Stedelijk Museum, Holland
9319 23½″ × 18″ (60 × 46 cm) $10.00

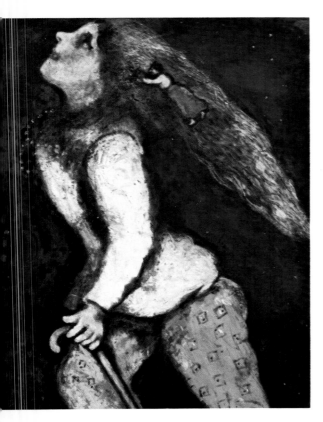

Marc Chagall
Dreams of a Youth, 1927-8
Santa Barbara Museum of Art,
Gift of Mme. Ganna Walska
5056 24″ × 18½″ (61 × 47 cm) $12.00
1065 10″ × 7½″ (25 × 19 cm) $1.50

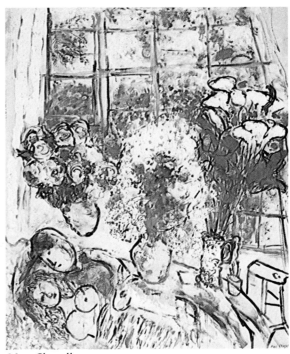

Marc Chagall
The White Window
Kunstmuseum, Basel
5057 24″ × 19¼″ (61 × 49 cm) $14.00
1066 10″ × 8″ (25 × 20 cm) $1.50

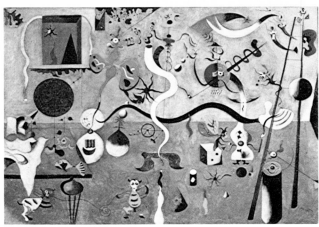

Joan Miro
Carnival of Harlequin (1924-5)
Albright-Knox Art Gallery, Buffalo, N.Y.
Room of Contemporary Art Fund
5177 17¾″ × 25″ (45 × 63.5 cm) $15.00
1166 7⅛″ × 10″ (18 × 25.5 cm) $1.50

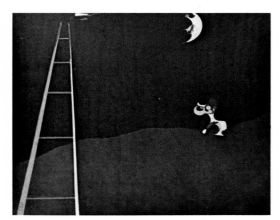

Joan Miro
Dog Barking at the Moon
Philadelphia Museum of Art
The A. E. Gallatin Collection
5198 17″ × 21¼″ (43 × 54 cm) $10.00
1179 8″ × 10″ (20 × 25.5 cm) $1.50

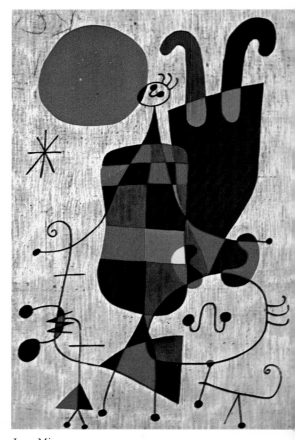

Joan Miro
Inverted Personages, 1949
Emanuel Hoffman Stiftung
Kunstmuseum, Basel
5092 24″ × 16″ (61 × 41 cm) $10.00
1100 10″ × 6¾″ (25 × 17 cm) $1.50

Mark Rothko
Red, White and Brown, 1957
The Kunstmuseum, Basel
7078 30″ × 24½″ (76 × 62 cm) $16.00
1205 9¾″ × 8″ (25 × 20 cm) $1.50

Piet Mondrian
Composition, 1921
Emanuel Hoffman Stiftung
Kunstmuseum, Basel
5095 20″ × 16¾″ (51 × 42.5 cm) $12.00
1101 9½″ × 8″ (24 × 20 cm) $1.50

Rufino Tamayo (Mexican, 1899-)
The Lovers
San Francisco Museum of Art
5010 18½″ × 24″ (47 × 61 cm) $10.00
1003 7¾″ × 10″ (19.5 × 25 cm) $1.50

221

Jean-Pierre Yvaral
Polychromatic Diffraction
Albright-Knox Art Gallery, Buffalo, N.Y.
Gift of Seymour Knox
5183 22½″ × 22½″ (57 × 57 cm) $15.00
1172 8″ × 8″ (20 × 20 cm) $1.50

Julio Le Parc
Series 14 No. 2
Albright-Knox Art Gallery, Buffalo, N.Y.
Gift of Seymour Knox
5180 22½″ × 22½″ (57 × 57 cm) $15.00
1174 8″ × 8″ (20 × 20 cm) $1.50

Jack Bush
Coloured Funnel (1965)
Albright-Knox Art Gallery, Buffalo, N.Y.
Charlotte A. Watson Fund
5178 22½″ × 22½″ (57 × 57 cm) $15.00
1164 8″ × 8″ (20 × 20 cm) $1.50

Auguste Herbin
Vie No. 1 (1950)
Albright-Knox Art Gallery, Buffalo, N.Y.
Gift of the Seymour H. Knox Foundation, Inc.
7087 30″ × 20″ (76 × 51 cm) $15.00
1167 10″ × 6⅝″ (25.5 × 17 cm) $1.50

222

Richard Diebenkorn
Cityscape I, 1963
San Francisco Museum of Art
7013 27¾″ × 23¼″ (70.5 × 59 cm) $16.00
1076 9½″ × 8″ (24 × 20 cm) $1.50

Josef Albers (American, 1888-)
Homage to the Square, Terra Caliente (1963)
Albright-Knox Art Gallery, Buffalo, N.Y.
Gift of the Seymour H. Knox Foundation, Inc.
and Evelyn Rumsey Cary Fund
5181 22½″ × 22½″ (57 × 57 cm) $15.00
1176 8″ × 8″ (20 × 20 cm) $1.50

Josef Albers
Departing in Yellow
The Tate Gallery, London
9300 17″ × 17″ (43 × 43 cm) $14.00

Helen Frankenthaler
Interior Landscape, 1964
San Francisco Museum of Art
5084 24″ × 21¼″ (61 × 54 cm) $12.00

George De Groat
Equestrian Illusion, 1972
7023 30″ × 22″ (76 × 55.5 cm) $16.00
1002 10″ × 7¼″ (25 × 18 cm) $1.50

Tugomir Huberger
Configuration
7035 30″ × 30″ (76 × 76 cm) $18.00

Friedensreich Hundertwasser (Austrian, 1928-)
Downtown Lane
9621 18¼″ × 26″ (46 × 66 cm) $50.00

Hundertwasser Poster - Page 183

Hundertwasser
Island of Lost Desire
9623 25½″ × 20¾″ (65 × 53 cm) $50.00

Hundertwasser
Green Buddha with Hat
9622 21″ × 25½″ (53 × 65 cm) $50.00

Arthur Secunda
Homage to Vasarely (Collage)
Private Collection
7073 28¾″ × 22″ (73 × 56 cm) $16.00
1020 10″ × 7½″ (25.5 × 19 cm) $1.50

Arthur Secunda
Nude Ascending the Staircase
5016 24¼″ × 18″ (62 × 46 cm) $12.00

Secunda Posters - Page 182

Arthur Secunda
Inner Sanctum, (Collage)
Private Collection
5038 21″ × 21″ (53 × 53 cm) $12.00
1021 8″ × 8″ (20 × 20 cm) $1.50

Arthur Secunda
Sunset Mountain (Collage)
Private Collection
5039 21″ × 21″ (53.5 × 53.5 cm) $12.00
1022 8″ × 8″ (20 × 20 cm) $1.50

Franz Joseph Kline
Torches Mauve, 1960
Philadelphia Museum of Art: Given Anonymously
7051 30″ × 20½″ (76 × 52 cm) $16.00
1029 10″ × 6¾″ (25.5 × 17 cm) $1.50

Morris Louis
Alpha (1960)
Albright-Knox Art Gallery, Buffalo, N.Y.
Gift of Seymour H. Knox
7088 21¾″ × 30″ (55 × 76 cm) $16.00
1165 7¼″ × 10″ (18.5 × 25.5 cm) $1.50

Sam Francis
The Whiteness of the Whale (1957)
Albright-Knox Art Gallery, Buffalo, N.Y.
Gift of Seymour H. Knox
7093 28″ × 22¾″ (71 × 58 cm) $16.00
1169 9⅞″ × 8″ (25 × 20 cm) $1.50

Roy Lichtenstein (American, 1923-)
Whaam! 1963
Set of two panels
9632 24¾″ × 58¼″ (63 × 148 cm) $22.00

Vasarely
Gyuru-Mi
9418 19¾″ × 19¾″ (50 × 50 cm) $50.00

Vasarely
Dia Or Cf
9417 22″ × 22″ (56 × 56 cm) $50.00

Victor Vasarely (Hungarian, 1908-)
Cheyt Gordes
9416 22″ × 20½″ (56 × 52 cm) $50.00

Victor Vasarely
Vega-Nor (1969)
Albright-Knox Art Gallery, Buffalo, N.Y.
Gift of Seymour H. Knox
5179 22½″ × 22½″ (57 × 57 cm) $12.00
1171 8″ × 8″ (20 × 20 cm) $1.50

Victor Vasarely (Hungarian, 1908-)
0519 Banya, 1964
The Tate Gallery, London
9236 18″ × 18″ (45 × 45 cm) $12.00

Vasarely
Vega Pauk, 103
9419 28½″ × 13¾″ (72.5 × 35 cm) $50.00

Victor Vasarely
Alom
Museum of Art, Carnegie Institute, Pittsburgh
Gift of Mr. & Mrs. Leland Hazard
5232 22½″ × 22½″ (57 × 57 cm) $15.00
1253 8″ × 8″ (20 × 20 cm) $1.50

Karl Benjamin
#10, 1973
217 22½″ × 22½″ (57 × 57 cm) $16.00
244 8″ × 8″ (20 × 20 cm) $1.50

Karl Benjamin
#15, 1975
5216 22½″ × 22½″ (57 × 57 cm) $16.00
1243 8″ × 8″ (20 × 20 cm) $1.50

Karl Benjamin
#13, 1971
5218 22½″ × 22½″ (57 × 57 cm) $16.00
1246 8″ × 8″ (20 × 20 cm) $1.50

Karl Benjamin
#19, 1975
5219 22½″ × 22½″ (57 × 57 cm) $16.00
1247 8″ × 8″ (20 × 20 cm) $1.50

Gene Davis
Cool Buzz Saw, 1964
San Francisco Museum of Art
5176 23½″ × 24″ (60 × 61 cm) $12.00
1168 8″ × 8″ (20 × 20 cm) $1.50

Karl Benjamin
#8, 1977
7130 30″ × 21¾″ (76 × 55 cm) $16.00
1245 10″ × 7¼″ (25.5 × 18.5 cm) $1.50

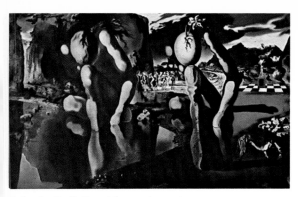

Salvador Dali (Spanish, 1904-)
Metamorphosis of Narcissus, 1938
The Tate Gallery, London
9039 7¾" × 12" (19 × 30 cm) $4.00

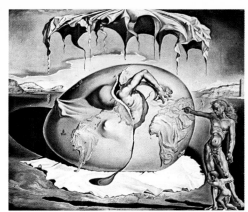

Salvador Dali
**Geopoliticus Child Watching the
Birth of the New Man**
Dali Museum, Ohio
5229 21" × 24" (53.5 × 61 cm) $12.00
1249 8" × 9⅛" (20 × 23 cm) $1.50

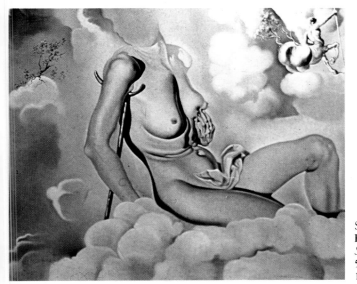

Salvador Dali
Honey is Sweeter than Blood, 1971
Santa Barbara Museum of Art
5060 20" × 24" (51 × 61 cm) $12.00
1069 8" × 9½" (20 × 24.5 cm) $1.50

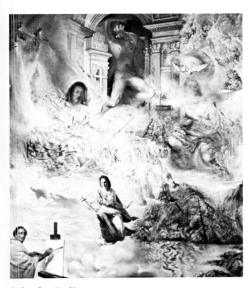

Salvador Dali
Ecumenical Council
Dali Museum, Ohio
7140 27½" × 23¾" (70 × 60.5 cm) $12.00
1248 9⅜" × 8" (24 × 20 cm) $1.50

Salvador Dali
Oeufs Sur Le Plat
Dali Museum, Ohio
5230 24" × 20" (61 × 51 cm) $12.00
1250 9⅝" × 8" (24 × 20 cm) $1.50

FINE ART PHOTOGRAPHY

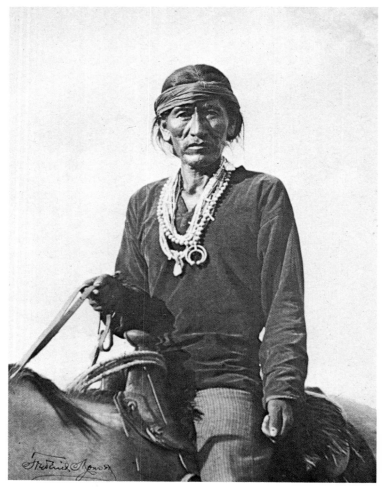

Frederick Monsen
Navajo Chieftain, 1907
Southwest Museum, Los Angeles
4110 15″ × 11″ (38 × 28 cm) **$5.00**
1062 10″ × 7¼″ (25 × 18.5 cm) **$1.50**

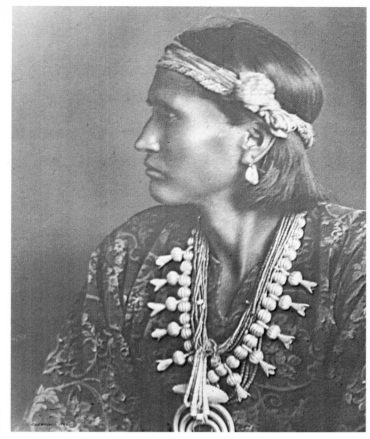

Carl Moon
Do-bazin (Navajo Man), 1906
Southwest Museum, Los Angeles
4112 16½″ × 13½″ (42 × 34.5 cm) **$5.00**
1108 10″ × 8″ (25 × 20.5 cm) **$1.50**

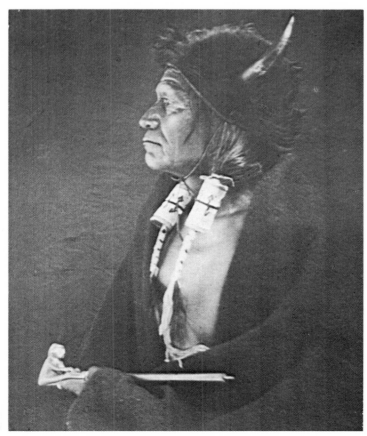

Carl Moon
A Conjurer, 1914
Southwest Museum, Los Angeles
4111 16½″ × 13½″ (42 × 34.5 cm) **$5.00**
1107 10″ × 8″ (25 × 20.5 cm) **$1.50**

Edward S. Curtis
Quniaika (Mohave)
Southwest Museum, Los Angeles
4063 15 ½ ″ × 11 ¾ ″ (39.5 × 30 cm) **$5.00**
1115 10″ × 7 ½ ″ (25 × 19 cm) **$1.50**

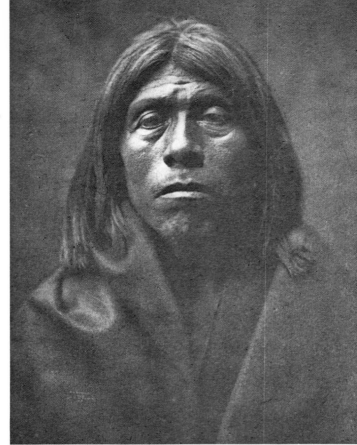

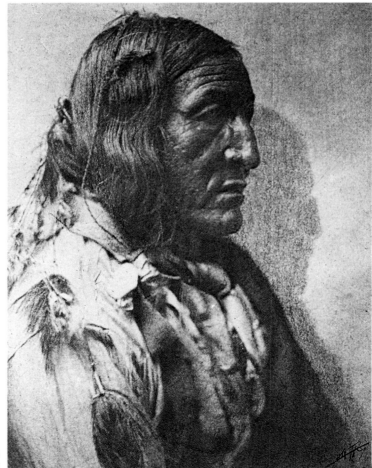

Edward S. Curtis
**Geronimo as an Old Man with
Ceremonial Hat and Lance**
Southwest Museum, Los Angeles
4060 15″ × 11″ (38.5 × 28 cm) **$5.00**
1112 10″ × 7 ¼ ″ (25 × 18.5 cm) **$1.50**

Edward S. Curtis
Chief Little Wolf-Cheyenne
Southwest Museum, Los Angeles
4059 16 ¼ ″ × 12 ¼ ″ (41 × 31 cm) **$5.00**
1111 10″ × 7 ½ ″ (25 × 19 cm) **$1.50**

234

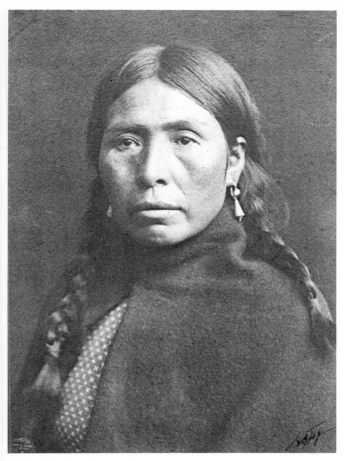

Edward S. Curtis
Vancouver Island Squaw, 1899
Southwest Museum, Los Angeles
4065 15¼″ × 11″ (39 × 28 cm) **$5.00**
1117 10″ × 7¼″ (25 × 18.5 cm) **$1.50**

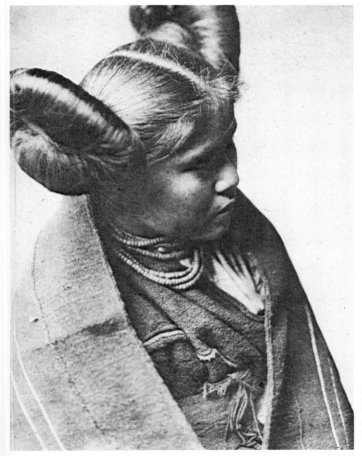

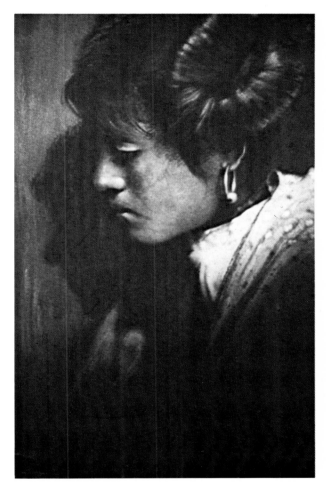

Edward S. Curtis
A Moki Beauty, 1904
Southwest Museum, Los Angeles
4062 16″ × 10″ (41 × 25 cm) **$5.00**
1114 10″ × 6¼″ (25 × 16 cm) **$1.50**

Edward S. Curtis
Chaiwa-Tewa
Southwest Museum, Los Angeles
4057 15½″ × 11½″ (39 × 29 cm) **$5.00**
1109 10″ × 7½″ (25 × 19 cm) **$1.50**

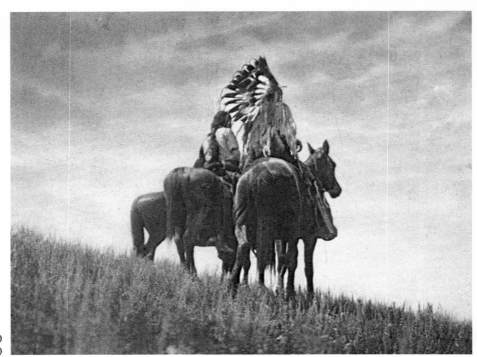

Edward S. Curtis
Cheyenne Warriors
Southwest Museum, Los Angeles
4058 12″ × 15½″ (30.5 × 39 cm) **$5.00**
1110 7¾″ × 10″ (19.5 × 25 cm) **$1.50**

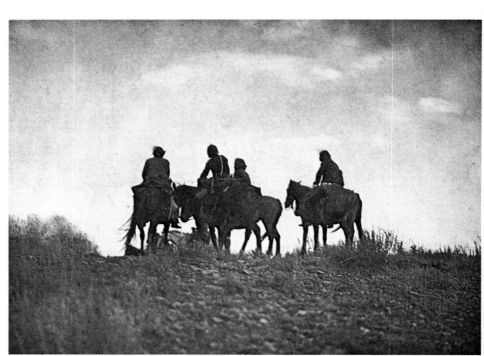

Edward S. Curtis
Sunset in Navajo Land, 1904
Southwest Museum, Los Angeles
4064 11¼″ × 15½″ (28.5 × 39.5 cm) **$5.00**
1116 7¼″ × 10″ (18.5 × 25 cm) **$1.50**

Wynn Bullock
Lobos Rock, 1973
4053 14″ × 12⅜″ (35.5 × 31.5 cm) $5.00

Wynn Bullock
Nude behind cobwebbed window, 1955
4054 17¾″ × 14″ (45 × 35.5 cm) $6.00

Wynn Bullock
Let there be Light, 1954
4052 14″ × 18″ (35.5 × 45.5 cm) $6.00

Wynn Bullock
Woman with Hands over Breasts, 1956
2021 10¾″ × 10″ (27 × 25.5 cm) **$4.00**

Wynn Bullock
Tide Pool, 1970
4055 14⅜″ × 11″ (36.5 × 28 cm) **$5.00**

Wynn Bullock
Child on Forest Road, 1958
4051 18″ × 14¼″ (46 × 36 cm) **$6.00**

Minor White
Beginnings-Frosted Window Rochester,
N.Y., 1962
2068 9½″ × 12″ (24 × 30.5 cm) $4.00

Minor White
Windowsill Daydreaming
Rochester, N.Y., 1958
2069 12″ × 9″ (30.5 × 23 cm) $4.00

Minor White
Lighthouse and Wood, Multiple Image, 1971
2071 5½″ × 8½″ (14 × 21.5 cm) $4.00

Minor White
Car and Bank, San Francisco, 1948
2070 10¼″ × 12″ (26 × 30.5 cm) $4.00

Minor White
Ice Falls, Watkins Glen, N.Y. 1964
4035 14″ × 18¼″ (35.5 × 46.5 cm) $6.00

Minor White
Twisted Tree, Point Lobos, California, 1951
4034 15″ × 11″ (38 × 28 cm) $5.00

Minor White
Frost Wave, Rochester, N.Y., 1959
2072 12″ × 9″ (30.5 × 23 cm) $4.00

Minor White
Moon and Wall Encrustations
Pultneyville, N.Y., 1964
4036 13¾″ × 18″ (35 × 46 cm) $6.00
2073 9″ × 12″ (23 × 30.5 cm) $4.00

Minor White
Sun in Rock, Devil's Slide
Near San Francisco, 1947
2074 9″ × 12″ (23 × 30.5 cm) $4.00

Minor White
Knothole, Dark Canyon Lake
La Sal Mountains, Utah, 1967
2075 12″ × 5½″ (30.5 × 14 cm) $4.00

Minor White
Bird Lime and Surf
Point Lobos, California, 1951
2076 9″ × 12″ (23 × 30.5 cm) $4.00

Don Worth
Rocks and Surf, 1969
4037 18″ × 14″ (46 × 35 cm) **$6.00**

Don Worth
Evening, Ansel Adams' Garden, 1958
4039 18″ × 14″ (46 × 36 cm) **$6.00**

Don Worth
Surf, Point Lobos, 1957
4041 10″ × 15″ (25 × 38 cm) **$4.00**

Don Worth
Tree and Fog, 1963
4042 14″ × 11″ (35.5 × 28 cm) **$4.00**

Don Worth
The Pacific, Muir Beach
4040 14″ × 17¾″ (36 × 45 cm) $6.00

Don Worth
Sun and Water, Mt. Baker, Washington
4043 12″ × 18″ (31 × 46 cm) $5.00

Don Worth
Pines and Fog
4044 11″ × 14″ (28 × 35.5 cm) $4.00

Don Worth
Aspens, Silverton Colorado, 1958
4045 14″ × 11¼″ (35.5 × 28.5 cm) $4.00

Don Worth
Evening, Agate Beach, Oregon
4038 14″ × 18″ (35.5 × 46 cm) $6.00

Don Worth
Succulent: Aeonium Tabulaeforme, 1971
4046 10¼″ × 13¼″ (26 × 33.5 cm) $4.00

Edward Cornachio
Iris
4144 12″ × 18″ (30.5 × 46 cm) $6.00

Edward Cornachio
Gazanias
4143 18″ × 12″ (46 × 30.5 cm) $6.00

Edward Cornachio
Daisy
4141 12″ × 18″ (30.5 × 46 cm) $6.00

Edward Cornachio
Orchid
4145 12″ × 18″ (30.5 × 46 cm) $6.00

Edward Cornachio
Flowers
4142 12″ × 18″ (30.5 × 46 cm) $6.00

Edward Cornachio
Sunset
5041 16″ × 24″ (40.5 × 61 cm) $8.00

Edward Cornachio
Beach Scene
4140 16″ × 14¼″ (40.5 × 36 cm) $6.00

Don Huntsman
Carmel Valley
2053 8″ × 15″ (20 × 38 cm) $4.50

Don Huntsman
Waves
4086 14½" × 18" (36.5 × 46 cm) $5.00

Don Huntsman
Tack Room
4085 18" × 14" (46 × 37 cm) $5.00

Don Huntsman
Monterey Jail
4084 13" × 10¼" (33 × 26 cm) $5.00

Don Huntsman
Point Lobos' Tide Pools
4087 14½″ × 18″ (37 × 46 cm) $5.00

Don Huntsman
The Shepherd
5080 20¼″ × 30″ (51.5 × 76 cm) $10.00
2077 10″ × 14¾″ (25 × 37.5 cm) $4.50

Don Huntsman
Desert Rider
2043 8″ × 13″ (20 × 33 cm) $4.50

Don Huntsman
Sunset
5081 20″ × 22″ (51 × 56 cm) $6.00
2044 10″ × 11″ (25 × 28 cm) $4.50

Don Huntsman
Evening Glow
5082 20″ × 20″ (51 × 51 cm) $6.00
2045 10″ × 10″ (25 × 25 cm) $4.50

Don Huntsman
Grazing Sheep
4088 8″ × 15″ (20 × 38 cm) $4.50

Don Huntsman
Carmel Coast
5083 18½″ × 30″ (47 × 76 cm) $10.00
4089 12½″ × 20″ (31.5 × 51 cm) $6.00
2046 6″ × 9¾″ (15 × 25 cm) $3.50

Don Huntsman
Deer in the Forest
2047 8½″ × 12″ (22 × 30.5 cm) $4.50

Don Huntsman
The Forest
4061 13½″ × 20½″ (34 × 51 cm) $6.00
2048 8″ × 12″ (20 × 30.5 cm) $4.50

Don Huntsman
Utah Forest
2049 12″ × 8″ (30.5 × 20 cm) $4.50

Don Huntsman
Utah Fall
2050 12″ × 8″ (30.5 × 20 cm) $4.50

Don Huntsman
Autumn
4090 11½″ × 14″ (29.5 × 35.5 cm) $4.50

Don Huntsman
From a Memory
2051 8″ × 12″ (20 × 31 cm) $4.50

Don Huntsman
Nude in the Sun
4091 14″ × 11″ (36 × 28 cm) $6.00

Don Huntsman
Navajo Country
4092 11½″ × 13″ (29 × 33 cm) $4.50

Don Huntsman
The Mittens
4093 13¾″ × 18″ (35 × 46 cm) $6.00

Don Huntsman
The Pinnacles
4094 20″ × 13¾″ (51 × 35 cm) $6.00
2052 12″ × 8¼″ (30.5 × 21 cm) $4.50

James Haddad
Windswept Field
4078 12″ × 18″ (30.5 × 46.5 cm) $5.00

James Haddad
The Barn Door
4077 12″ × 18″ (30.5 × 46.5 cm) $5.00

Robert Tracy
The Window
4025 17″ × 9″ (43 × 23 cm) **$4.00**

Terry Wild
Kirsten
2078 6¾″ × 10″ (17 × 25 cm) **$3.50**

Terry Wild
Mixed White Breed
2079 6¾″ × 10″ (17 × 25 cm) **$3.50**

Terry Wild
Autumn Hand
2042 6¾″ × 10″ (17 × 25 cm) **$3.50**

HADDAD'S

CUSTOM

FRAMING

DEPARTMENT

A

Contemporary wide driftwood frame with soft gold bevel. Simple elegance for almost any picture, - 3'' wide.

D

Fruitwood and borghese traditional frame. Fine polished furniture finish to blend with every decor - 2'' wide.

Turn to page XII for further illustrations.

B

Traditional distressed fruitwood and borghese finish. Superior polished furniture finish for that touch of under-stated grace, 3½'' wide.

C

Traditional driftwood with gold panel. Excellent frame for any subject 3'' wide.

Our frames were especially designed to be customized for your particular reproduction and decor. You may make your own choice or we would be happy to do it for you. The frames are all custom made to picture size except the Oriental and Plastic frames which are available only in the sizes shown. The other frames may be ordered in the size required.

Two methods are used for arriving at the price. Standard sizes are noted — if that suits your size needs. United inches are also noted to make pricing easier for non-standard sizes. If your picture is 18½ × 24½ inches, the united inch size is 43″. You must price this at the closest larger dimension 44″. You may elect instead to have the picture aesthetically trimmed to the 18″ × 24″ standard size.

The reproductions are mounted and sprayed with a clear protective coating.

Please add the retail price of reproduction and frame for your completed framed picture. Add the "extras": glass, mat or transfers if desired for your total price. State specifically on your order your complete choice.

We use plastic glass both crystal clear and non glare, in place of regular glass to avoid breakage. Glass is not used on canvas transfers.

Any picture except a canvas transfer may be matted or double matted (twice the mat price) as you desire. Mats require glass. To find the frame size for a 3″ mat add 6″ to each dimension, ie: (12 × 16 becomes 18 × 22 frame, or 28 + 6 + 6 equals 40 united inches.

Our canvas transfer service is a leader in the field, clear full bodied rich colors on high grade artist canvas. All work is done by hand to insure the best results. Canvas transfers are simply the printed surface lifted from the paper and placed on canvas for the "appearance" of an aesthetically pleasing painting.

TERMS:
- Orders of $300 retail or more are packed free of charge.
- Orders less than $300 retail require a $15.00 packing charge. $6.00 charge on single piece orders.
- Orders subject to normal trade discounts.
- F.O.B. Anaheim, California.
- Allow 4 weeks delivery time.
- Prices, styles and colors subject to change without notice.

SEE ORIENTAL FRAME DESCRIPTIONS FOR CORRECT SIZE OF FRAME FOR ORIENTAL REPRODUCIONS.

FRAME ILLUSTRATIONS FRAME ILLUSTRATIONS

Size Standard	United Inches	Custom Frames A-B-C	D-E-F	Metal	Plastic	Oriental	Plastic Glass Clear	Non-Glare	Mat	Canvas Transfer
8 × 10	18	42.00	21.00	12.00	18.00	18.00	3.00	4.00	4.00	15.00
9 × 12	21	45.00	24.00	13.00	—	—	3.00	4.00	4.00	15.00
11 × 14	25	50.00	28.00	14.00	21.00	22.00	4.00	5.00	5.00	16.00
12 × 16	28	53.00	29.00	15.00	—	24.00	5.00	6.00	5.00	16.00
12 × 18	30	56.00	31.00	16.00	—	26.00	5.00	8.00	6.00	16.00
14 × 18	32	58.00	34.00	18.00	34.00	28.00	5.00	8.00	6.00	18.00
16 × 20	36	62.00	37.00	22.00	34.00	30.00	6.00	10.00	7.00	18.00
18 × 24	42	68.00	42.00	26.00	40.00	42.00	8.00	12.00	8.00	26.00
20 × 24	44	72.00	42.00	27.00	45.00	42.00	9.00	15.00	8.00	26.00
16 × 29	45	74.00	44.00	28.00	—	44.00	13.00	18.00	10.00	—
19½ × 26	46	75.00	46.00	30.00	—	44.00	13.00	18.00	10.00	—
12 × 36	48	76.00	46.00	30.00	—	52.00	13.00	18.00	10.00	32.00
20 × 30	50	79.00	50.00	30.00	—	52.00	13.00	18.00	10.00	32.00
22 × 28	50	79.00	50.00	30.00	48.00	52.00	13.00	18.00	10.00	32.00
24 × 30	54	85.00	52.00	32.00	52.00	54.00	13.00	22.00	12.00	32.00
24 × 36	60	92.00	58.00	36.00	—	62.00	17.00	25.00	14.00	38.00
30 × 40	70	104.00	66.00	40.00	—	—	22.00	33.00	14.00	44.00
24 × 48	72	112.00	68.00	40.00	—	—	40.00	60.00	26.00	46.00
34 × 40	74	120.00	70.00	40.00	—	80.00	40.00	60.00	26.00	46.00

E

Understated driftwood and borghese for
single subjects or groupings - 1 ½ ″ wide.

F

Walnut and borghese high style frame.
Fine polished furniture finish 1 ½ ″ wide.

Oriental frame combinations, artist and print
precedes the size. Red sizes with mat, black
sizes without mat.

Chen Yang	#7011 (16 × 29) (24 × 36)
	#1067 (11 × 14)
Chinese Tribute Horse 9580 (single 34 × 40)	
	(24 × 36) pieces paired
Hiroshige	#2080, 2081, 2082, 2095, 2097,
	2098, 2112 (12 × 18)
Hoitsu	#7102 or 7103 (24 × 36)
	#7102 + 7103 combined (34 × 4o)
	#1092 (11 × 14)
Hokusai	#7058 (26 × 19 ½)
	#4083 (14 × 18)
Japanese Falcon 5086 (16 × 29) 4098 (12 × 18)	
	#1071 (11 × 14)
Japanese Matabei - Style #5159 (18 × 24)	
Kiyomitzu	#4102 (14 × 18)
Kunisada	#7154 (24 × 36)
Kyosai	#5088 (16 × 29)
LiLing	#5058 (12 × 36)
Lim	#2087. 2088 (12 × 18)
Lim	#5195, 5196 (16 × 29)
Mei Feng	#7034 (16 × 29) (24 × 36)
	#1097 (11 × 14)
Taito	#5043 (16 × 29)
	#4024 (12 × 18)

G

Oriental frame in natural teak with rounded
corners inside and outside. Excellent for Oriental
and Scandinavian furnishings - 1 ½ ″ wide.

Metal section frames are available in four finishes, silver, bronze, black and gold. Must be ordered with glass, except when used on a canvas transfer.

a) Fall Yellow
b) Burnt Sienna
c) Pongee
d) Teak Black
e) Soft White
f) Brown
g) Pastel Green
h) Blue-Grey
i) Pastel Gold
j) Charcoal Grey
k) Green
l) Blue
m) Ecru
n) Yellow

Mat samples: You may choose any of the above colors most suitable for the picture desired. Double mats (inserts) may be chosen—the second complimentary color being used closest to the picture image. This is a good way to customize a subject. Mats are not used on canvas transfers.

H

Metal section frames. Extremely smart, simple styling for all types of subjects, especially contemporary.

Modern style PLASTIC FRAME, simple elegance at a reasonable price. Requires no glass. Pictures may be tip mounted, over colored mat board for a flush effect.

Post Cards

Durer—100 assorted—$30.00 list
Hummel—100 assorted—$30.00 list
Impressionists—100 assorted—$30.00 list
Modern Masters—100 assorted—$30.00 list
Old Masters—100 assorted—$30.00 list
Note: Assortments can not be broken or mixed—minimum order: $30.00 list